PRINT'S BEST LETTERHEADS & BUSINESS CARDS 5

Copyright© 1998
by RC Publications, Inc.
All rights reserved.
Published by
RC Publications, Inc.
104 Fifth Avenue
New York, NY 10011

No part of this
publication may be
reproduced or used in
any form or by any
means—graphic,
electronic, or
mechanical, including
photocopying, recording,
taping, or information
storage or retrieval
systems—without
written permission from
the publisher.

Manufactured in
Hong Kong.

PRINT's Best Letterheads
& Business Cards 5
Library of Congress
Catalog Card Number
89-091067
ISBN 1-883915-05-8

RC Publications
**President and
Publisher:**
Howard Cadel
**Vice President and
Editor:**
Martin Fox
**Creative Director:**
Andrew Kner
**Project Manager:**
Katherine Nelson
**Associate Art Director:**
Michele L. Trombley

**Writer**
Karen Chambers

**Art Director**
Andrew Kner

**Project Manager**
Katherine Nelson

**Associate Art Director**
Michele L. Trombley

**Published by**
RC Publications, Inc.
New York, NY

*Winning Designs from*
**Print** *Magazine's*
*National Design Competition*

PRINT's BEST
LETTERHEADS
& BUSINESS CARDS 5

USA

USA 32

USA

32

CUMMINGTON MA

MAY 10 1997

AM
01026

**117**
Color

**135**
Literate
Design

**157**
Special
Effects

Despite the proliferation of multimedia and Web projects, stationery programs remain a major design activity. They are also some of the most challenging and personally, if not always financially, rewarding assignments. *PRINT's Best Letterheads & Business Cards 5*, part of PRINT magazine's *Best Book* series, presents the best designs drawn from PRINT's 1996 and 1997 Regional Design Annuals. Although purely typographic and completely straightforward letterheads and business cards still exist and can be very effective design solutions, there are many more options available, as this collection attests. The designs may vary widely, but they have one thing in common: They express the personality of the client.

Rather than categorize the designs by type of client (a full third were by design firms for their own use), the letterheads and business cards shown here are divided into seven sections by stylistic strategy—inspiration source, formal device or conceptual basis. The seven sections comprise: Elegant Solutions, Nostalgia, Illustration, Literate Design, Humor, Color, and Special Effects.

"Illustration" often communicates the nature of the client's business. Because of the variety of the expression represented, this category was broken down into three subdivisions: "Imaginative Images," ingenious uses of illustration that provoke an "ah-ha" experience"; "Naive Images," childlike, primitive, or untutored drawings; and "Photographic Images," ranging from high-definition realism to soft-focus romanticism. "Literate Design" also warranted two subcategories: "Word Pictures" and "Wordplay." In the first, designers employ pictures to tell their clients' stories; in the second, clever tag lines or literary devices convey the message. Nearly 15 per cent of the designs had a touch of "Nostalgia," making reference to everything from 19th-century circuses to '60s TV sitcoms. Other stylistic approaches included "Elegant Solutions" and "Humor." Sometimes the designers relied on "Special Effects," such as die-cuts or unusual inks. At other times, the special effect came from "Color," which ranged from brash and blaring to subtle and sensuous.

Each of these sections opens with an overview of the design approach and includes several examples. More detailed commentary accompanies the individual entries that follow. For each of the selections, all of which are reproduced in large-sized visuals, the designers were asked how the client explained the assignment and if there were any special instructions or constraints that defined the problem. They told how they conceived of the final solution and if there were any other ideas explored, why those were rejected. The designers were also queried about how the design was produced, with attention given to the nitty-gritty details of what types of software were employed, printing processes used, and how any special technical problems were resolved. Finally, they were asked how well the design has been received by the client and the public. Their answers and insights are included in the essays that accompany each entry. Collateral material is also discussed and illustrated where appropriate.

Graphic design is a communication art, and nowhere is that more apparent than on a letterhead or business card. This handbook is intended to document the best recent examples, to tell readers the hows and whys of their design, and to inspire them to create even more innovative designs for the next edition.—*Karen Chambers*

# ELEGANT SOLUTIONS

Like a bargain spotted by a savvy shopper across a crowded selling floor, the "Elegant Solution" is not always the expensive one.

For the start-up financial services company The Penn Investment Group, a simple 1-color offset print job and an image from a clip art book create the impression of a well-established institution. The volute of an Ionic column becomes the initial *P*, and, rendered in gray on white, it represents the new company as heritage-conscious and trustworthy.

A similar effect was required by the young, energetic, and loquacious founder of Critical Communications, a new marketing and Web site design company. Using Bauer Bodoni, Sibley/Peteet Design created a logo based on the firm's initials. Printed in just two colors, the design didn't need any more "production chili" in Rex C. Peteet's estimation.

It doesn't always take a huge budget to achieve graphic sophistication. Premier Design Studio succeeded with distinctively colored stock envelopes and all-purpose pressure-sensitive labels. These were substituted for the more expensive printed number 10 envelopes.

Sometimes elegance is defined by an approach that is the graphic designer's equivalent of a "little black dress." Nothing could be simpler than The Leonhardt Group's logo for Ovid. Specializing in electronic information retrieval software, Ovid wanted a look that was accessible and smart. Originally sketched out on a napkin, the logo is a circle that reads as a sphere because of the inclusion of a slender *I* dropped out of the steel gray.

Subtle refinements can make a large design statement. Matthew S. Gaynor shows an awareness of this in his stationery program for Michael McInturf and Lynn McInturf, a married couple sharing office space. Michael is an architect and Lynn consults with service businesses to improve profitability. The basic composition for their individual letterheads and business cards is the same, but the accents make their individuality clear.

With a company name like lady day communications and a principal named billy holliday, you would expect an elegant design approach. The letterhead is restrained, just the lowercase initials of the firm's name, *l* and *d*, encircled by green to symbolize its youth and eco-conscious attitude.

To replace their temporary stationery, the commercial and residential architects Phil Porter and John Mann asked Working Design to create something that reflected their contrasting personalities. After reviewing the architects' portfolio and interviewing them, says designer Stephanie Hitchcock, "It became clear that the logo needed to be conservative, clean, and very tight."

Ten logos were created. Despite their differences, both Porter and Mann chose the same one, a playful take on their initials. It took only a little refinement to achieve the final design. Hitchcock developed the logo in Adobe Illustrator, skewing the letters with a gradient fill. The final layout was done in QuarkXPress. Working Design reports that the client is pleased with the elegant but friendly look of the new logo.

**Design Firm:**
Working Design, Inc.
Atlanta, GA
**Creative Director:**
Jude Lindquist
**Designer:**
Stephanie Hitchcock

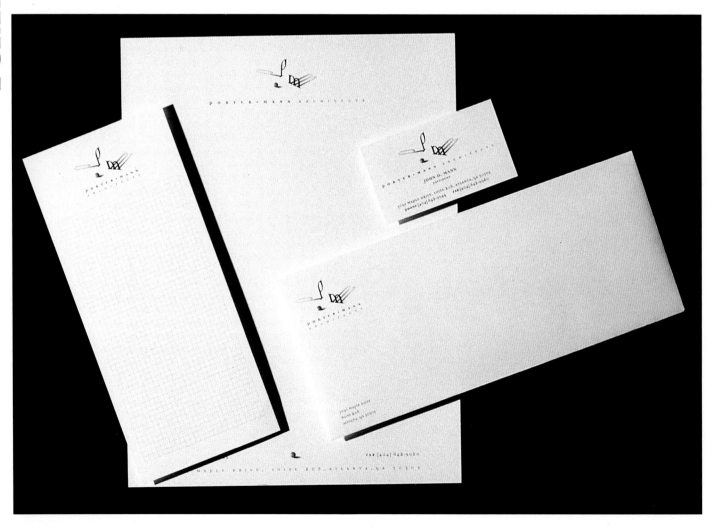

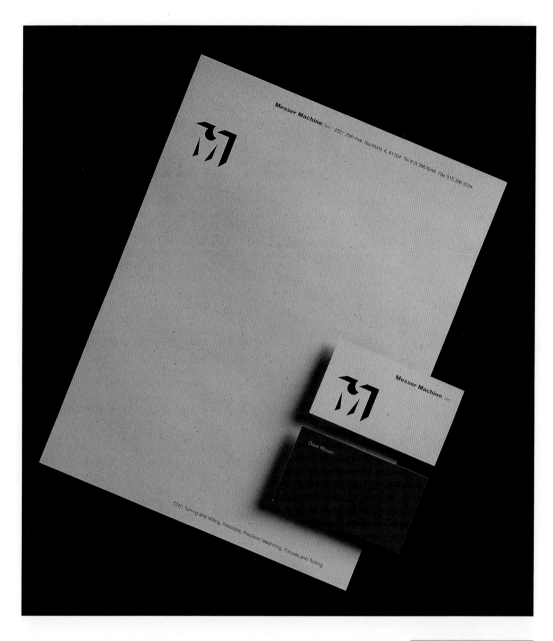

When Versatech Machine changed its name to Messer, a new look was required for this company that specializes in precision machining, turning, milling, and prototyping. "The client wanted a logo that would reinforce the nature of his business," explains Balance Design partner Keith Christianson—as well as remind the viewer of the new company name. Balance Design's solution was a sharply defined monogram *M*. Its crisp geometry recalls a mechanical part and looks machine-made. Thanks to clever use of negative space, the black shapes have a three-dimensional character. For the announcement of the new name, designer Scott Dvorak jumbled the positive elements and die-cut them in a sleeve that holds a card with the company's up-to-date information. A black block on the insert, with minimal type reversed-out, is seen through the die-cuts, transforming negative to positive. Using 2-color lithography, the designer requested adjustments in the red ink to compensate for the natural-color paper.

**Design Firm:**
Balance Design
Rockford, IL
**Designer:**
Scott Dvorak

# LOVELL & WHYTE

When entrepreneurs Jim Fitzmaurice and Doug GeBraad launched their first retail venture—a shop called Lovell & Whyte that features upscale but reasonably priced decorative items for home and garden—they asked their friend Kym Abrams to design the stationery package. The initial concept of a bird's nest seemed too feminine and clichéd. The designers also explored the client's drawing of a chair. Ultimately, illustrator Amy Nathan's simple, silhouetted image of a picket fence was chosen for the logo. The cut-paper illustration fits the style of the store and refers to the fence surrounding the shop's garden area. The logo has a country feel, but is reproduced in sophisticated gray, white, and black and, paired with a classic serif typeface, projects elegance. The designers claim the image is so successful that there are plans to apply it to dinnerware and other products. Because the proprietors of Lovell & Whyte are friends of Abrams, the design fee was bartered. "They got the design," she says. "I get a discount at Lovell & Whyte."

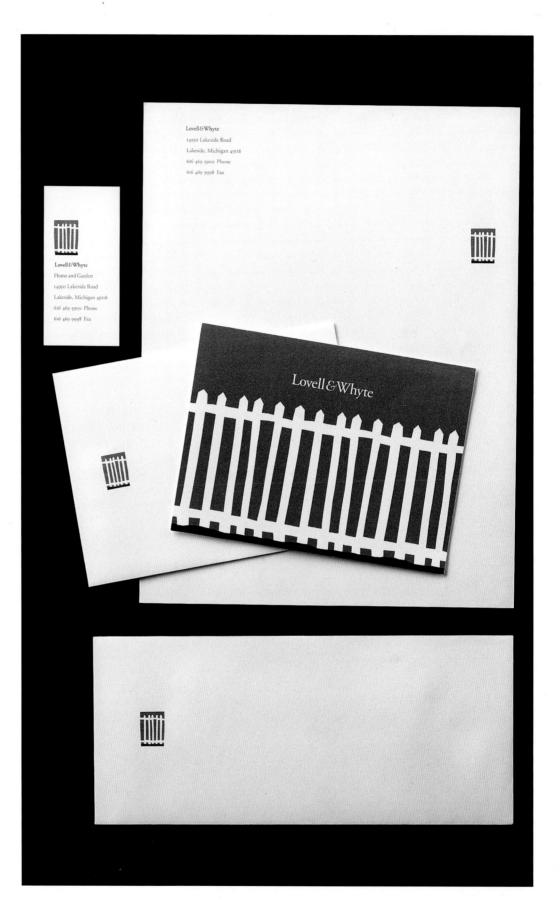

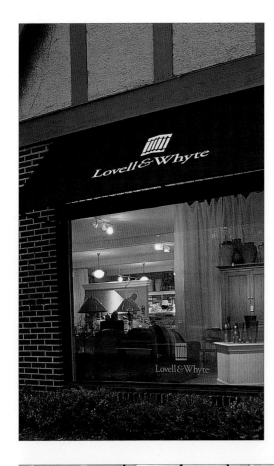

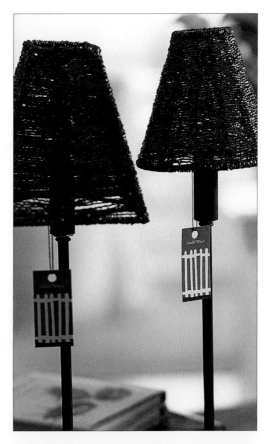

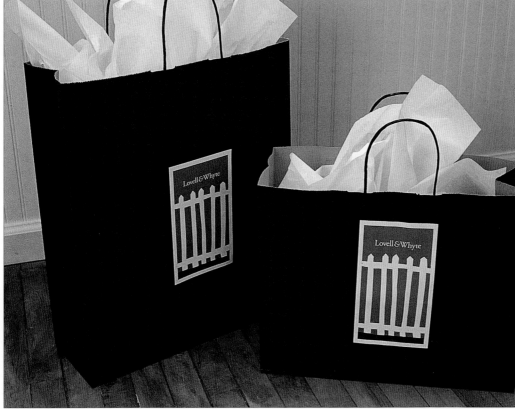

**Design Firm:**
Kym Abrams Design
Chicago, IL
**Art Director:**
Kym Abrams
**Designer/Illustrator:**
Amy Nathan

When replacing his own firm's stationery, designer billy holliday addressed the problems of the previous design. The length of the studio's name—lady day communications—had made the original logo difficult to reduce and still read clearly. He abandoned the idea of using the full name and positioned the lowercase initials of the company against a circle of green to symbolize eco-consciousness and youth. The earth tones with black accents reflect the firm's African-American heritage. The other design challenge was to reflect "lady day communications' simple approach to design and the elegance that simplicity can produce," holliday says. That problem was solved by the use of rectangular swaths of color, thin rules, generously kerned type, and a paper, Neenah Classic Columns, that itself conveys elegance. The design is structured on a seven-column grid, organizing the page while maintaining its asymmetry. Holliday reports that response to the design has been positive. "We've had new clients call, confident in our ability to design for them based solely on seeing a business card or the letterhead. It's a good feeling that a 'non-marketing' piece can generate that kind of response."

**Design Firm:**
lady day communications
Atlanta, GA
**Designer:**
billy holliday

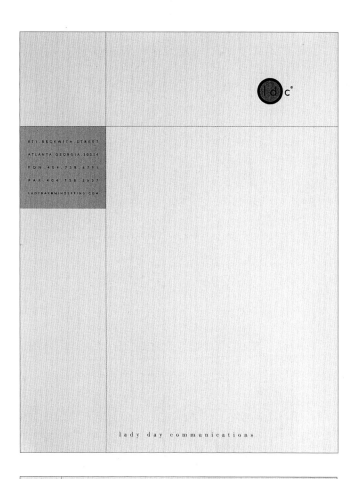

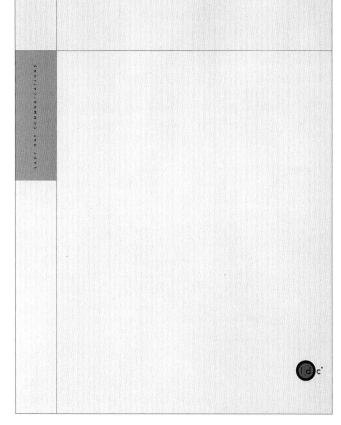

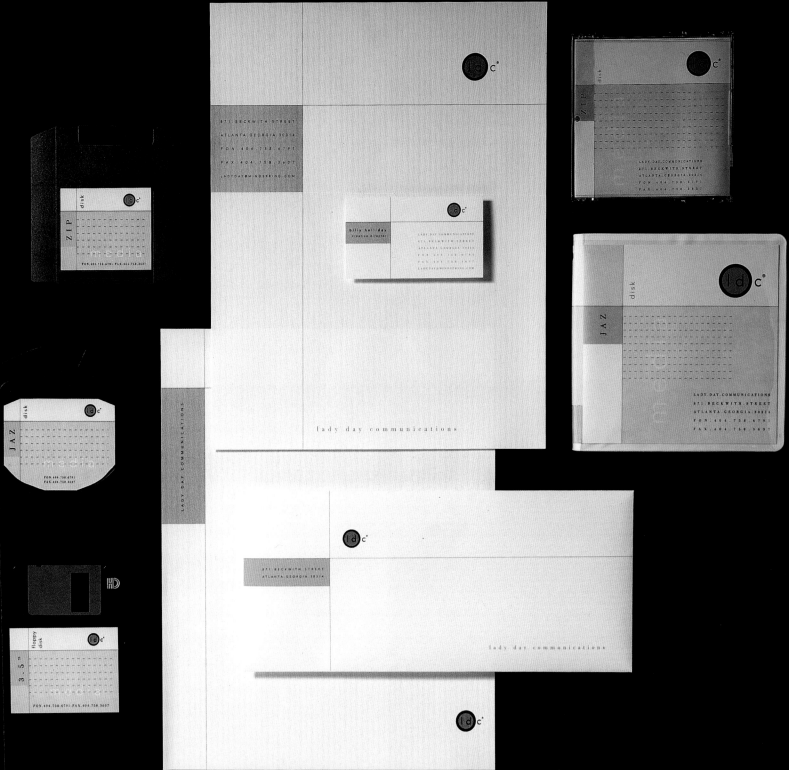

Michael McInturf is an architect "whose work is rooted in the interplay of material, form, and context," according to designer Matthew S. Gaynor. McInturf's wife, Lynn, consults with service-oriented businesses to improve sales and profit performance. The couple share office space, and when it came time to design their business stationery, they asked Gaynor to "create a system which paid homage to the marriage while establishing the individuality of each partner's endeavors," the designer explains. The result was a double duty design approach with individual accents. A creamy white rectangle marks the text area on each letterhead, printed on vellum for Michael and on a slick stock for Lynn. With each logo, three thick vertical bars represent the *M* of McInturf. Three slender parallel verticals stand for Michael's first name while Lynn receives a more feminine script *L*. A simple inverted *V*, representing an *A*, shelters a lowercase *A* to stand for "architect." The same inverted *V* communicates the "Associates" of Lynn's company.

**Design Firm:**
Matthew S.
Gaynor Design
Cincinnati, OH
**Art Director/Designer:**
Matthew S. Gaynor

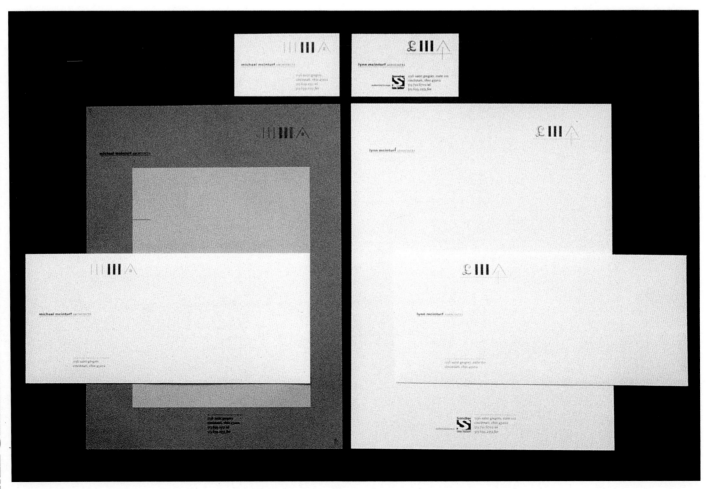

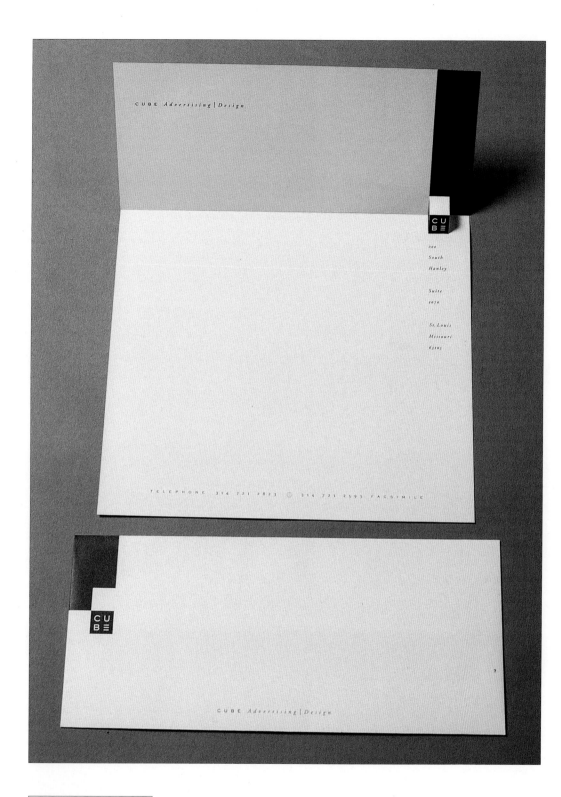

David Chiow, one of CUBE Advertising & Design's three partners, describes CUBE as "the cheapest, most demanding, and least understanding client we've ever had." To update the firm's original design, which had been economically produced ("God-awful ugly, cheap stationery made on our laser printer and cheesy business cards printed at KwikKopy"), the existing logo was given three dimensions. Two die-cuts and a score allow two planes of the cube to pop out to create a sculptural effect. The score also ensures that the fold is 90 degrees to form a cube, "so we can't be mistaken for Rhombus Advertising," quips Chiow. Although the three-dimensional effect is meant to amuse, the black-and-white program is "design at its basic roots," insists Chiow. "It works even on photo-copies or faxes." Although the designers employed Adobe Illustrator and QuarkXPress, the imagery was "created between the designers' ears, with that software called the brain," according to Chiow, who is listed irreverently on his business card as "Visual Yellow Guy," acknowledging his Chinese ancestry.

## CUBE ADVERTISING & DESIGN

**Design Firm:**
CUBE Advertising & Design
St. Louis, MO
**Art Director:**
David Chiow
**Designers:**
David Chiow,
Steve Wienke

# THE PENN INVESTMENT GROUP

"Sophisticated, classy, clean, simple, strong" was the look that The Penn Investment Group wanted for its first stationery system, according to designer Scott Herron. After considering the all-seeing eye of the pyramid on the back of the dollar bill, the designer turned to classical architecture to convey a message of stability and trustworthiness for this new financial services institution. The volute of the capital of an Ionic column became the initial *P* of the company name. Herron took the image from a clip art book of engravings and manipulated it in Adobe Photoshop. The engraved appearance, although achieved through simple 1-color offset printing, communicates a sense of heritage for this start-up company. To effect the faux engraving of the column of the *P*, the designer used Adobe Photoshop to add a special line screen. The page had to be oriented properly in the printing process to ensure that the line screen was vertical, something Herron achieved by trial and error. The patterning of the white paper stock, Classic Columns, with its subtle texture, also helped to establish the proper look for an investment house.

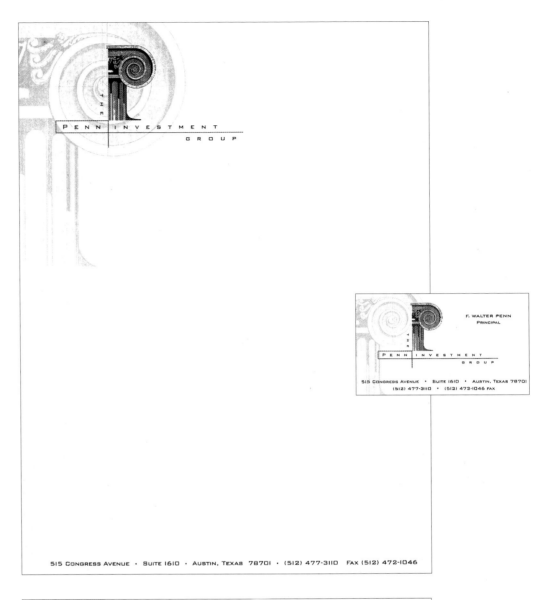

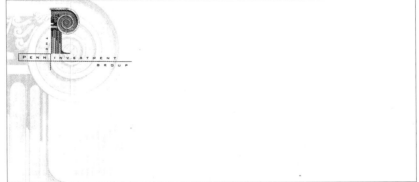

Design Firm:
BAH! Design
Austin, TX
Designer:
Scott Herron

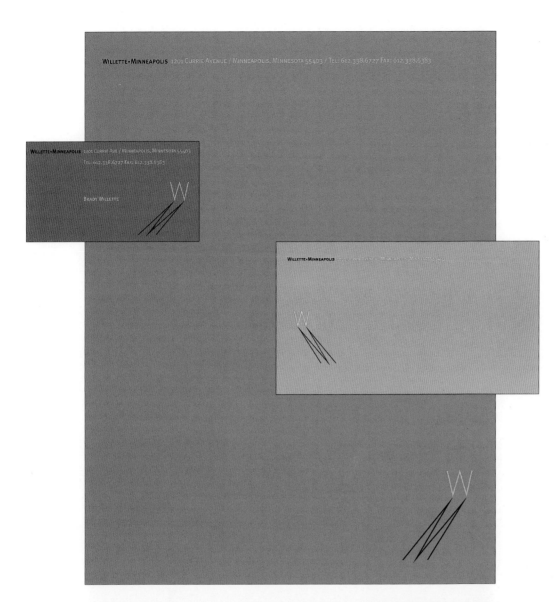

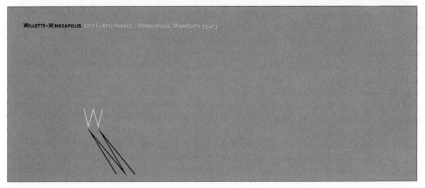

When Willette Photography changed its name to Willette•Minneapolis and moved into a new studio, it was time, too, for a new graphic identity. To appeal to its audience of advertising and design offices and corporate marketing and public relations departments, Willette•Minneapolis decided to replace its cold, corporate-looking stationery with something punchier and more colorful. Using French construction paper, which comes in a wide variety of noncorporate and nonprimary colors, Michael Hall chose an appetizing array ranging from olive for the envelopes to curry for the letterhead. To reflect the name change and allude to the nature of the client's business, he created an initial *W* casting the elongated shadow of an *M*, in Aldus FreeHand 5.0. The orientation of the shadow was changed to the right, or to the left, as the individual layouts of the stationery required. In the offset-printing process, two passes of white ink allowed the paper's color to tint the ink slightly. This was manipulated on press to achieve the desired effect.

**WILLETTE•MINNEAPOLIS**

**Design Firm:**
Hall Kelley, Inc.
Marine on St. Croix, MN
**Designer:**
Michael Hall

# OVID TECHNOLOGIES, INC.

When CDP Technologies decided to change its name to Ovid Technologies in 1995, the company turned to The Leonhardt Group for a new look. Ovid, which creates electronic information retrieval software for libraries and research facilities, wanted to portray its products as up-to-date and easy-to-use. The selected logo—several other solutions were discarded—was first drawn freehand—the old-fashioned way—on a napkin. It was then transferred to computer and finished with FreeHand software. The design is a circle and a bar that can be read as an *O* and an *I*. A 3-color effect is achieved with two colors:

The *I* in the circle is the white of the paper. To introduce the name change and new logo at a trade show, The Leonhardt Group created a black-and-white 3" x 2 ½" flip book in which the old logo is transformed into the new by flipping the pages.

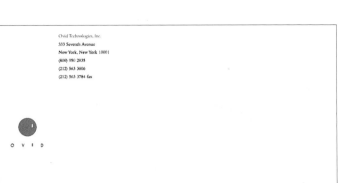

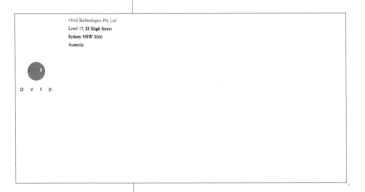

**Design Firm:**
The Leonhardt Group
Seattle, WA
**Designers:**
Ray Ueno,
Candace Morgan

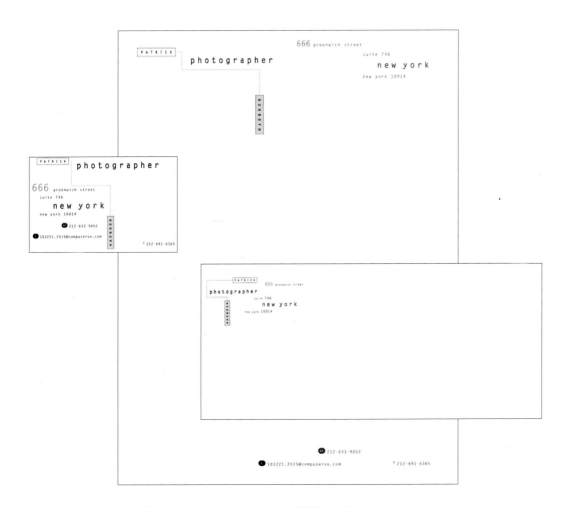

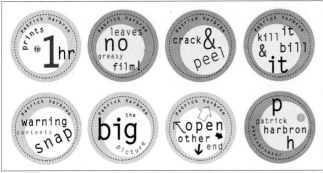

New York portrait photographer Patrick Harbron wanted to replace his outdated stationery system with something "modern, graphically more interesting, and challenging," he explains. Having worked with Frank Viva of Viva Dolan Communications, Harbron turned to him once again to create his new identity. After discarding an idea to use character illustrations with captions underneath, the designer came up with a not-so-straight typographic solution. The crisp design "has a little twist" just like Harbron's photography. The words "photographer" and "new york" are set in bold-face. The photographer's name is set in all-capitals, given emphasis by a dotted line and a hint of subtle color for the surname. Adobe Illustrator and QuarkXPress were used to create the design, which has been applied to all elements of Harbron s promotion and advertising materials. The design fulfills Harbron's brief for an identity that "stands out, is timely, but non-gimmicky."

**Design Firm:**
Viva Dolan
Communications
New York, NY
**Art Director:**
Frank Viva
**Designer:**
Jim Ryce
**Photographer:**
Patrick Harbron

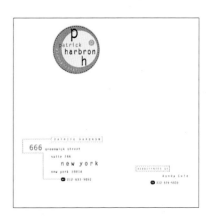

Living up to its name, Premier Design Studio has produced a deluxe-looking stationery program. Although the design seems relatively simple, there are many interesting touches. For example, a stock number 10 envelope uses a custom address label, and the abstract logo is repeated on the flap seal. The envelope is a deep olive green with a pebble texture, to contrast with the smooth-surface of the celadon letterhead. A "bound jacket" carrier is die-cut to hold thank-you cards and memos. The business cards fold over, but leave a margin for the logo. The wraparound band on the envelope is another good touch. It took careful calculations to keep all of these elaborations to a less than lavish budget. Embossing was considered, but rejected as too expensive. To eliminate a separate pass through the press, the wraparound band was printed at the same time as the letterhead. "We took cost and time into consideration and created a piece that could be assembled easily, could accommodate a variety of different pieces, and would be inexpensive to print," according to Randy Fossano.

**PREMIER DESIGN STUDIO, INC.**

DELIVERY RECEIPT

sold to

date

job no.

| QUANTITY | DESCRIPTION |
|----------|-------------|
|          |             |

_____ SKIDS _____ CARTONS _____ PKGS.

delivered to

delivered by

received by

123 S. MAIN ST. · SUITE 100 · ROYAL OAK, MI 48067 · (810) 544-7383 · fax: (810) 544-4557

**PREMIER DESIGN STUDIO, INC.**

PROOF APPROVAL - PLEASE READ

○ approved
○ approved with corrections
○ approved with changes
○ please show new proof

date

job number

signed

Every effort has been made to ensure the accuracy of this project, but it is the ultimate responsibility of our client to *PROOF AND SIGN OFF WITH A FINAL APPROVAL.* Upon doing so, signatory has accepted all liability for any errors or omissions not noted on this proof. Signatory also has the responsibility for obtaining appropriate legal and marketing approvals.

(810) 544-7383 · fax: (810) 544-4557

123 S. MAIN STREET · SUITE 100 · ROYAL OAK, MI 48067

**PREMIER DESIGN STUDIO, INC.**

GRAPHIC DESIGN
ILLUSTRATION
CREATIVE SERVICES
*from concept through printing*

**PREMIER DESIGN STUDIO, INC.**
*123 SOUTH MAIN STREET
SUITE 100 · ROYAL OAK, MI 48067*

(810) 544-7383
fax: (810) 544-4557

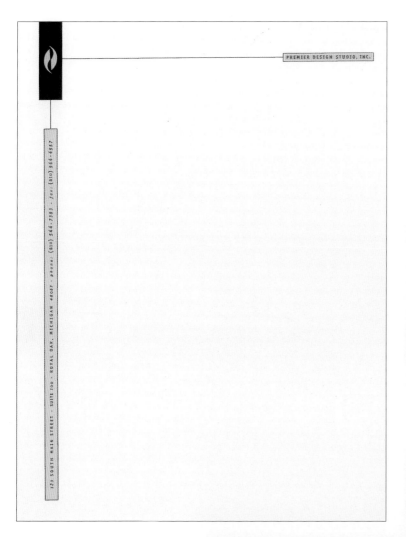

**Design Firm:**
Premier Design
Studio, Inc.
Royal Oak, MI
**Art Director:**
Randy Fossano
**Designer:**
Michelle Lannoo

# CRITICAL COMMUNICATIONS, INC.

Critical Communications was a new marketing and Web site design company founded by "a young, verbose, really smart guy, starting his first company and running it out of his bedroom," explains Rex C. Peteet of Sibley/Peteet Design. Nonetheless, its initial stationery design had to project "a very stable, professional image." Some of the original ideas, such as *C*'s forming mouths and talking, were rejected as too lighthearted. "Professionalism and craft rather than cuteness" was deemed more appropriate to Critical Communications' potential clientele: established corporations. The design's impact comes from the simple sweep of its monogram, a Bauer Bodoni *C* cut in half with points added in Adobe Illustrator. It employs two colors and is printed using the digital letterpress process, which has the quality of letterpress without the constraints of lead type. The printer works directly from disk. Even though the budget for design and production was "tiny," Peteet believes that "more colors or production chili would not have improved the idea, just obscured it."

Critical Communications, Inc.
2800 Barton's Bluff Lane
Suite 1205
Austin, Texas 78746
Voice: 512.306.8765
Data/Fax: 512.306.8766
email: qkroll@eden.com

Critical Communications, Inc.
2800 Barton's Bluff Lane
Suite 1205
Austin, Texas 78746

**Design Firm:**
Sibley/Peteet Design
Austin, TX
**Designer:**
Matt Heck

# NOSTALGIA

The dictionary defines "nostalgia" as "a longing for experiences, things, or acquaintanceships belonging to the past." Judging from the letterheads and business cards included in *PRINT's Best Letterheads & Business Cards 5,* we must be yearning for the turn of the century, the age of industrial deco, the consumerist '50s and the swinging '60s.

It is the Eisenhower era that has been most inspirational to '90s designers. That more optimistic period must be soothing to our premillennial stress. For Brain Wash, a combo laundromat and café, Curium Design's Evan Somstein created a striking design influenced by the owner's collection of vintage detergent boxes.

But just as Brain Wash is a phenomenon of the '90s, so is Manhattan's Honest Baker. Designer Quentin Paul Henry has updated a '50s icon, substituting a slim woman for the pudgy pastry chefs ubiquitous before "nonfat" became the mantra.

Melissa Edwards of Edwards Design presents model and television spokesperson Michele Turis as a leggy '50s pin-up. It is a quaintly sexy image, reminiscent of the period.

This innocence also pervades Werner Design Werks package for copywriter Rachel Eager. The lined school paper and '50s modern design elements bring back memories of a grade school where Beaver Cleaver might have sat behind you. Vintage comic book story characters inspired designer Tyler Young: The valiant fighter pilot on his stationery would have been just the thing for little boys to daydream about in the pre-Vietnam era. Oh Boy, A Design Company, presents a less menacing image in its stationery program. Even so, their freckle-faced mascot has a mischievous gleam in his eye.

But it's not only the '50s we long for. There also is a nostalgia for "industrial deco," inspired by post-revolutionary Russian graphics and American regionalism. This is particularly appealing to '90s high-tech firms. Illustrations of '30s-style factories, as in Labbé Design Co.'s letterhead for Tech Factory, or idealized workers, such as Dreamless Studio's Tekconnect man, give these companies reassuring images for audiences who suffer from computer phobia.

The hand-crafted approach of even earlier times pervades advertising copywriter Steve Dolbinski's letterhead. WORK Inc.'s design presents him as a hard-working, honest wordsmith by evoking a wood-paneled office and visored clerk. The quill and inkwell may have been replaced by a typewriter, but it's still a manual.

That wistful look back to bygone eras has played a big role in the success of the Disney empire. For the new Disney Boardwalk, a recreation of the early 20th-century Atlantic City boardwalk, a vintage postcard motif transports us back to that period.

Similarly entertaining is Sideshow Advertising's circus-themed business card. What began as a sideline project has become the main focus for designer Martin Wilford and his wife, Krista. The strongman on their business card promises to perform amazing design feats, a reassuring identity for Sideshow.

What could be more comforting than to evoke the image of America's best-loved soup as Atlanta's Creative Soup has done for its own letterhead? Also full of familar images is Melinda Beck's design for the Nick-at-Night stationery. Beck conjures up the '50s and '60s through line drawings of iconic images: remote controls and console TVs, ranch houses and backyard barbecues, canapés and TV dinners.

Good designers have always taken inspiration from the past and made something new of it. These letterheads and business cards prove the practice still thrives.

CAFE 222

"The client is a fun-loving, wacky creative person," says MaeLin Levine of San Diego's Visual Asylum about the proprietor of Cafe 222. When it came time to replace the letterhead and business cards for the restaurant and catering business, "she wanted something steeped in the past, but with a funky new attitude," Levine explains. Visual Asylum took stock images that epitomize café culture of the '50s: a percolator, toaster, skillet, stack of pancakes, covered sauce pan. The retro imagery was updated in Adobe Illustrator. For the 3-color lithographic printing, broad bands of color, nostalgic chartreuse and apricot, border the writing area of the letterhead. For the business card, an icon in a chartreuse block balances the individual's name. Blocky sans-serif type looks generic, evoking a time when comfort food was not a trend, but a staple on every American menu.

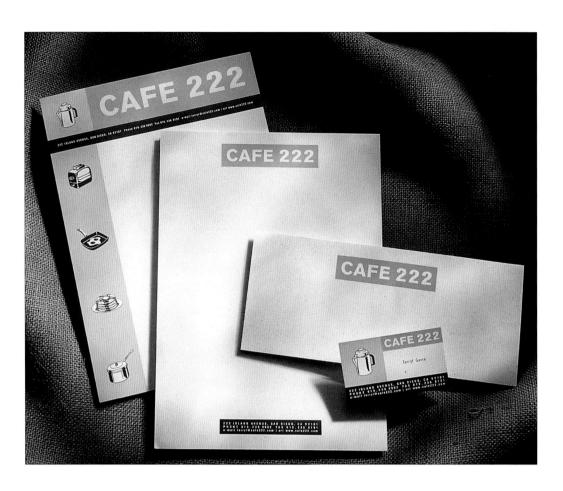

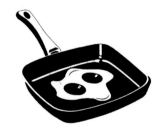
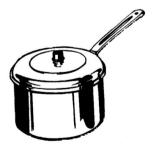
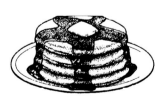

**Design Firm:**
Visual Asylum
San Diego, CA
**Art Directors:**
MaeLin Levine,
Amy Jo Levine
**Designer/Illustrator:**
Joel Sotelo

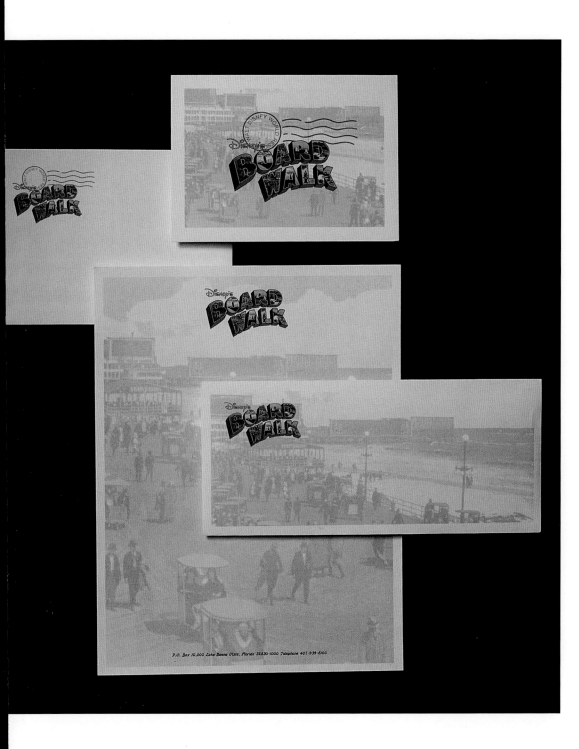

A new addition to Disney's resort and tourism empire, Disney's Boardwalk recaptures the aura of the Atlantic Seaboard Amusement Park of the '20s and '30s. Postcards first gained popularity during this period, so the designers used early postcard imagery for inspiration. Archival postcards, scanned and manipulated in Adobe Photoshop, were the visual resource for the stationery package. An early idea for the letterhead, proposed by the in-house design team, was a horizontal, two-sided "postcard" design with artwork on the front and a correspondence area on the back. The finished package features a ghosted image from a 1920s boardwalk postcard with the company's name emblazoned in vintage lettering. Other postcard artwork fills the lettering and is reproduced in garish 4-color, reminiscent of the color printing of the time. All other parts of the stationery package keep to the postcard theme, including a mailing label with a postmark from Walt Disney World Resort.

**Design Firm:**
Disney Design Group
Lake Buena Vista, FL
**Art Directors:**
Jeffrey Morris,
Renee Schneider
**Designer:**
Bob Holden

# PAUL GEHLSEN FURNITURE & DESIGN

Paul Gehlsen is a maker of finely crafted wooden furniture as well as an engineer for Boeing. For his first letterhead, he wanted to communicate that he was a craftsman concerned with the hand-made quality of his work, attentive to detail and design. Art director Hank Kosinski took the flavor of the old Sweets tool catalog as his inspiration for the design. An old-fashioned workbench from Gehlsen's studio adds to the craft feel. An image of a workbench from a book on woodworking and fine carpentry was scanned into Adobe Photoshop. The layout for the stationery was done in QuarkXPress. The chipboard look of the papers is in keeping with the traditional materials Gehlsen uses to create his furniture. The 2-color job cost under $500 for 1000 business cards and 500 sheets of letterhead. In line with old-fashioned business practices, Gehlsen bartered for Kosinski's design services. The woodworker got a well-designed stationery system and the designer got well-crafted furniture for his office.

**Design Firm:**
Hank Kosinski/
art director
San Francisco, CA
**Art Director/Designer:**
Hank Kosinski
**Printer:**
Kennedy-ten Bosch

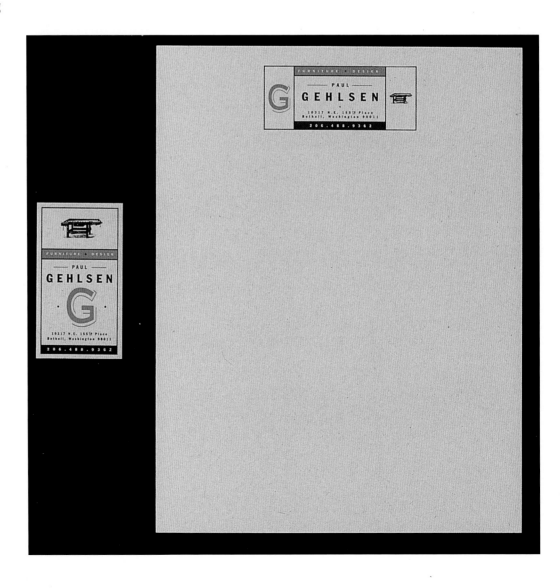

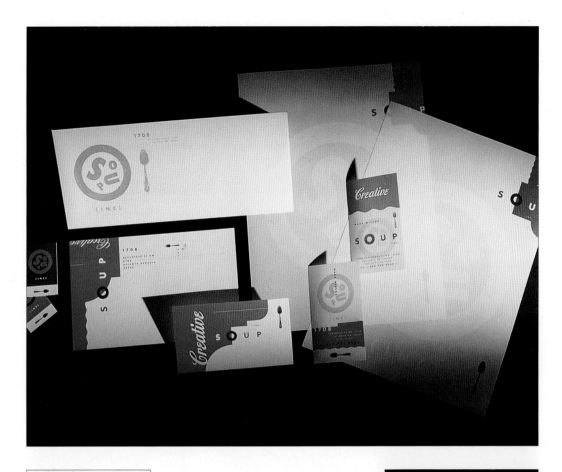

When this Atlanta advertising and graphic design firm changed its name to Creative Soup, a new stationery system was needed. The new name also provided the design direction—a take-off on that venerable soup brand was irresistible. But unlike Pop artist Andy Warhol who simply appropriated the Campbell's package, Creative Soup altered the design. The type appears on a cream background. The letters of "soup" float in a silver bowl. The metallic ink for a spoon and the soup logo on the envelopes add a touch of whimsy. The system required two PMS matte colors plus the metallic silver. One of the design challenges faced by designer Mark Wilcox was matching the cream base on three different papers, including the translucent stock of the letterhead.

**Design Firm:**
Creative Soup, Inc.
Atlanta, GA
**Art Director/Designer:**
Mark Wilcox

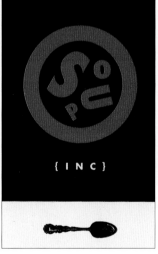

Tekconnect Internetworks of Cherry Hill, New Jersey, is a newly established provider of Internet solutions including connectivity, Web site design, and multimedia. They asked Dreamless Studios, a Cherry Hill neighbor, to create an identity that would communicate "the Internet as a public utility necessary to run a business," explains designer David DeCheser. Tekconnect wanted to convey that the Net was as essential as electricity in today's world. Illustrator Joseph Hasenauer devised an image that coupled the idea of "industrial strength with the metaphor of global connectivity," according to DeCheser. Using a bold representional style reminiscent of Soviet Socialist Realism or American regionalism of the '30s, Hasenauer drew an arresting image of a construction worker standing on a globe holding a giant electrical plug. Printed in a high-powered palette of black and yellow, the illustration clearly represents the client's aim. Tekconnect Internetworks has gone for a more humanized image for its identity, with a nostalgic nod to a time when technology wasn't so baffling to the average person.

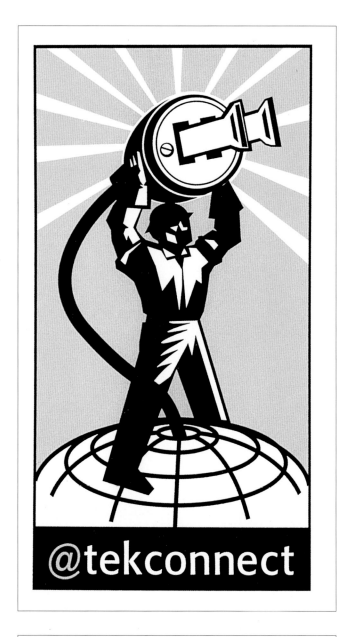

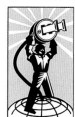

tekconnect
1 keystone avenue . building 36
cherry hill, nj 08003

Dreamless Studios
Cherry Hill, NJ
**Art Director/Designer:**
David DeCheser
**Illustrator:**
Joseph Hasenauer

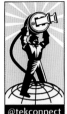

Michael Craig Amper
Coordinator of Internet Services

amper@tekconnect.net

1 keystone avenue
building 36
cherry hill, nj 08003

phone . 609.751.9595 x223
fax . 609.751.8989

http://www.tekconnect.net

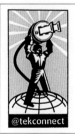

1 keystone avenue
building 36
cherry hill, nj 08003

phone . 609.751.9595
fax . 609.751.8989

http://www.tekconnect.ne

tekconnect
1 keystone avenue . building 36
cherry hill, nj 08003

# TIM ALLEN SIGNATURE TOOLS

The client, developers and distributors of carpentry tools, "wanted something that would 'wow' people," says designer Dan Mobley. The design had to "look industrial and still appeal to the common man." Mobley created a memorable package featuring custom die-cuts. For the letterhead, evenly spaced holes run along the left-hand side of the French Paper sheet. The rounded corners on the right-hand side recall the pages of loose-leaf equipment catalogs. The 100# coverweight business card stock is punched as if for a binder, and has a die-cut tab reinforcing the catalog feel. Even though the stationery package was geared to the "common man," it has also appealed to a more specialized design audience. French Paper was so impressed, it asked to use reprints for a national promotion, a request that the company's head, TV's *Home Improvement* star Tim Allen, signed off on.

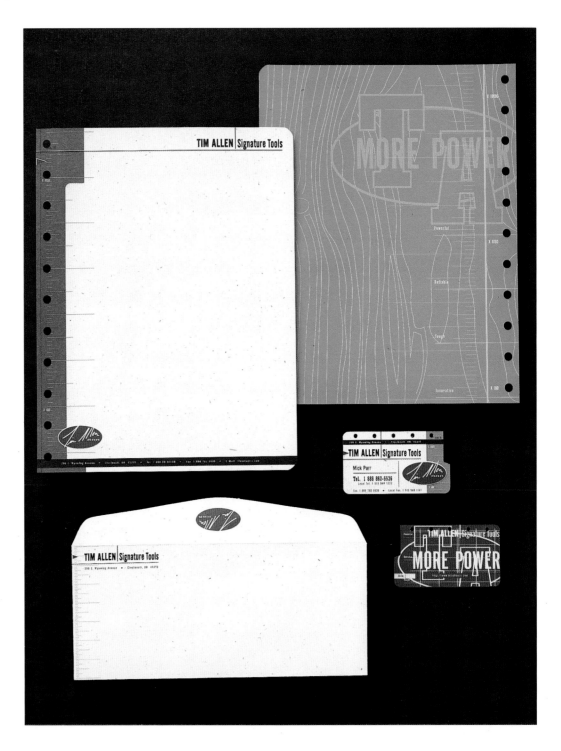

**Design Firm:**
Blue 707
Fort Wayne, IN
**Art Director:**
Dan Mobley

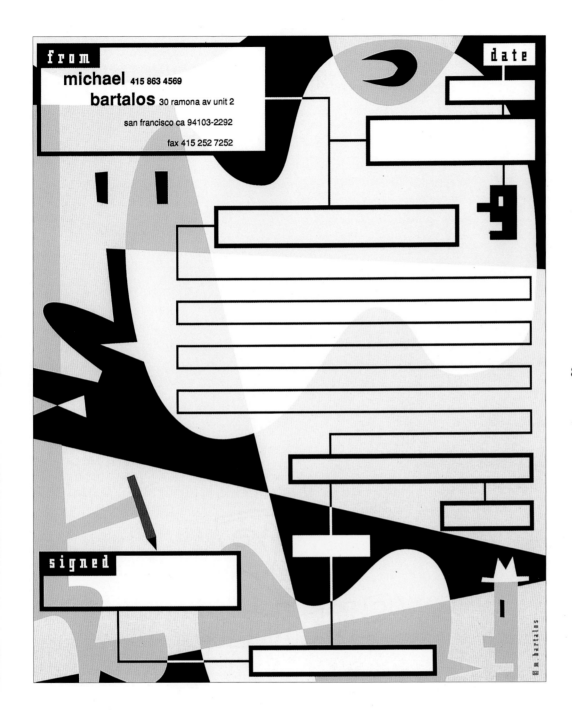

from

**michael** 415 863 4569

**bartalos** 30 ramona av unit 2

san francisco ca 94103-2292

fax 415 252 7252

date

signed

When illustrator and designer Michael Bartalos moved, he decided it was time to redesign his stationery. He opted for a more graphic and less illustrative design with an updated, even if retro, color palette. Colorful paper and texture were rejected because of the complexity of the design, which plays biomorphic shapes off of distinctly defined blocks of color. Because Bartalos has many clients in Japan, he used the Japanese letter size of 21 cm x 26 cm, instead of the American standard of 8 1/2" x 11" for his stationery. This sets him apart in the U.S. but makes a polite bow to Japanese sensibilities. The strong graphic elements and 4-color printing on the lightweight paper stock help to turn this letterhead into a promotion piece. And despite the active and colorful surface, it works just fine for letters done on a typewriter or laser printer.

**MICHAEL BARTALOS**

**Design Firm:**
Michael Bartalos
San Francisco, CA
**Art Director/Designer/**
**Illustrator:**
Michael Bartalos

## TYLER YOUNG

Freelance art director Tyler Young has "a fascination with artwork from the '40s and '50s." Creating his own stationery and business cards gave him "a perfect opportunity to try this look and feel." Young acknowledges that there is "a ton of campy '50s clip-art design work," much of it "tired and not implemented well." He vowed to attempt something fresh and inventive. Using artwork from artists' storyboards from a '50s comic book, he created a clever stationery program. On his letterhead, the face of a fighter pilot appears in a target-like motif. Although the image is printed, it looks as if it were rubber-stamped on the rough brown paper stock. Related imagery appears on his business cards, which were printed on chipboard that the printer was discarding. That 2-color offset print job ended up costing Young only $230.

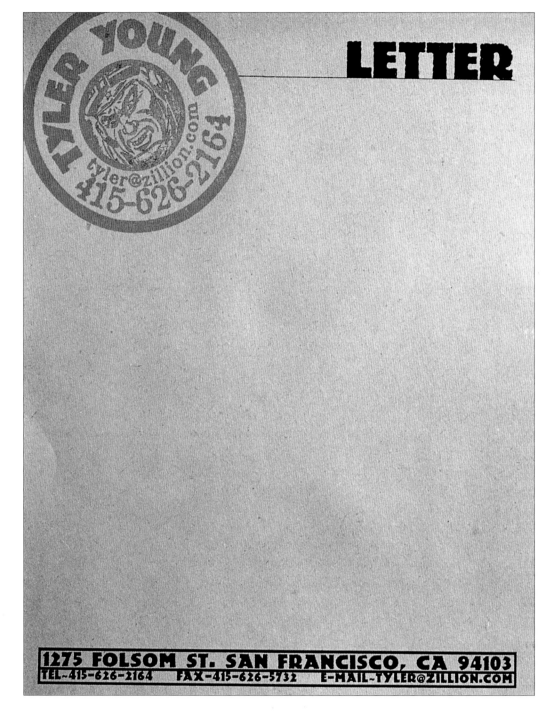

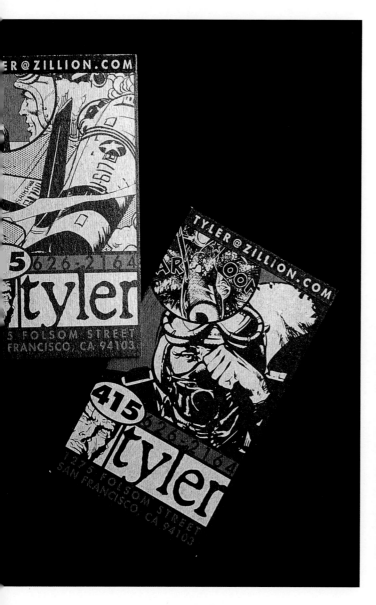

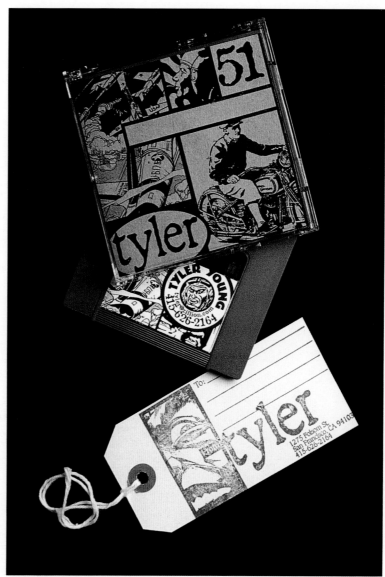

**Design Firm:**
Tyler Young
San Francisco, CA
**Art Director/Designer:**
Tyler Young

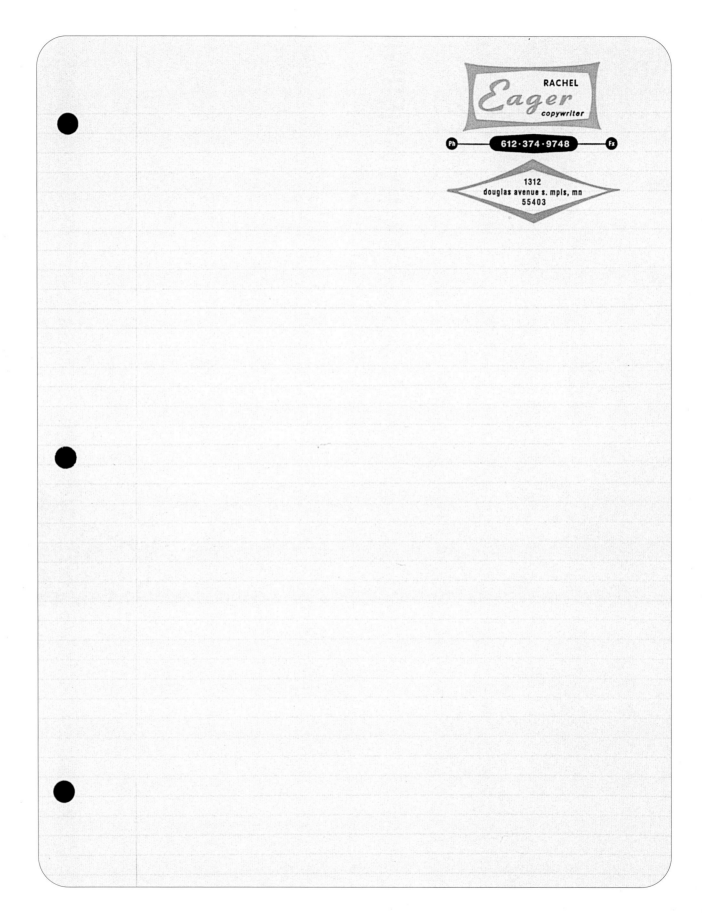

RACHEL

*Eager*
copywriter

Ph  612·374·9748  Fx

1312
douglas avenue s. mpls, mn
55403

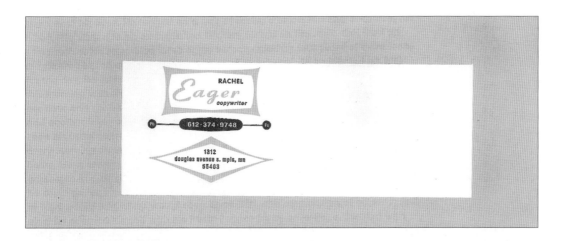

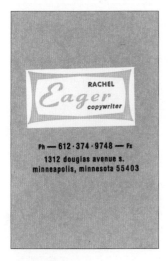

Ah yes...the composition
book. How noteworthy of me
to scrape up those years of
handwriting class. The flood
of angst and anxiety in Ms.
Radich's class right after
recess that felt more like a
long-term prison sentence.
Slinging ink from left to right
in hopes to just fill the space
on the page. A triple-dog-
dare that the prison guard
goose-stepping past your
desk won't notice the particu-
larly LARGE PENMANSHIP
you're adjusting to. The
steely sweetness of her smile
as she tersely points to the
clock quickly ticking and tick-
ing. You have milleseconds to
smear more ink from margin
to margin which feels like for-
ever. But now you're all
grown up and can unveil that
you were never a knight of
the plume. Your pencil dri-
ving couldn't pass a behind
the wheel test. Ms. Radich
could even read between
those lines. And so can I.
Allow me to sharpen your
pencils and ink your well.
My number's on the front.

**Design Firm:**
Werner Design Werks,
Inc. Minneapolis, MN
**Art Director:**
Sharon Werner
**Designers:**
Sharon Werner,
Sarah Nelson
**Copywriter:**
Rachel Eager

Copywriter Rachel Eager's coordinated stationery system, created by Werner Design Werks, delivers her contact information and promotes her writing. Instead of a conventional business card, Werner designed a tiny composition book with a lined composition sheet and laser-printed text. The text can be easily changed. One version ends, "Allow me to sharpen your pencils and ink your well." The calling card slips into a sleeve reminiscent of report card covers. In keeping with the school-days theme, the letterhead is printed on lined, three-hole composition paper. Because the only paper heavy enough to go through Eager's laser printer lacked the familiar red line marking the left-hand margin, the line was added when the letterhead was printed. Werner chose a stock manila-colored envelope with string closing and a pressure-sensitive label. Letterpress text by Eager is debossed into the envelope.

# OH BOY, A DESIGN COMPANY

"We pretty much knew what we wanted and went to it," is how David Salanitro of Oh Boy, A Design Company, describes his firm's first stationery system. On the debossed letterhead is Oh Boy's clever logo of a freckle-faced kid centered at the top of the sheet. The second part of the firm's name is subtly illustrated with two line drawings. These show how to accordion-fold the letterhead so that it can be inserted into an envelope with the logo showing. The sketches graphically illustrate the firm's attention to detail. Opting for an unexpected but not unfamiliar visual, Oh Boy's business cards are printed on coated card stock and are long and narrow with a perforation to allow the logo to be detached, just like a ticket or claim check. As Salanitro, a principal in the firm, says, "When someone can take an object and immediately create their own meaning for it, they become instantly comfortable. Too much obscurity makes people uncomfortable."

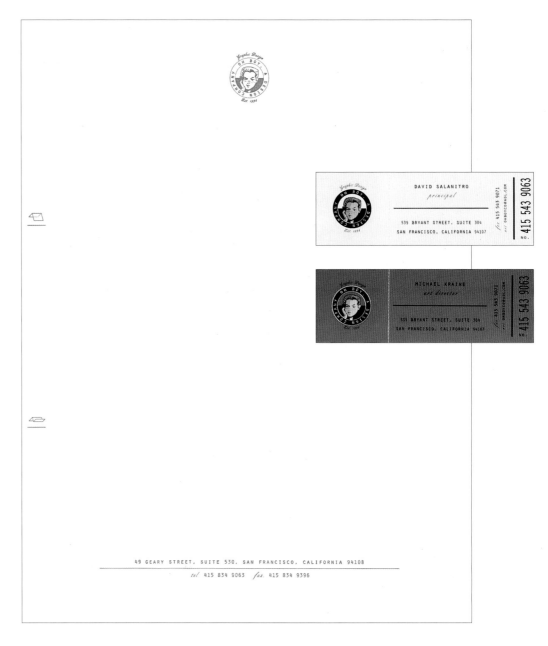

**Design Firm:**
Oh Boy, A Design
Company
San Francisco, CA
**Art Director/**
**Illustrator:**
David Salanitro
**Designer:**
Mike Kraine

For Silver Screen, a retailer of movie memorabilia, collectibles, and gifts, it seemed natural to look back to a time when movies were the dominant entertainment medium. The challenge for Group C Design was to evoke the past as well as to capture some of the fun involved in collecting memorablilia. Using traditional celluloid images or glossy press pix of movie stars required usage approvals and would have strained the budget. Instead, Jenny Azubike developed a logo that combines a starburst image with schematically drawn tickets and bold sans-serif type for the company's name. The logo has the flavor and palette of '50s illustration and is perfectly representative of the shop's specialty. To describe the shop's stock, the tagline of "Film Collectibles and Gifts" meanders across the page, reminiscent of film trailing off a reel. The vintage typeface on letterhead, envelope, and business card adds a casual touch. Some of the stationery elements have been adapted for other merchandising aids including hang tags, signage, and even Web page graphics.

**Design Firm:**
Group C Design
St. Louis, MO
**Creative Director:**
Tom Croghan
**Designer/Illustrator:**
Jenny Azubike

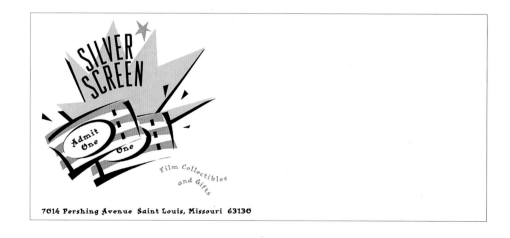

SILVER SCREEN, INC.

(314) 727.0077

7014 Pershing Avenue Saint Louis, Missouri 63130

7014 Pershing Avenue Saint Louis, Missouri 63130

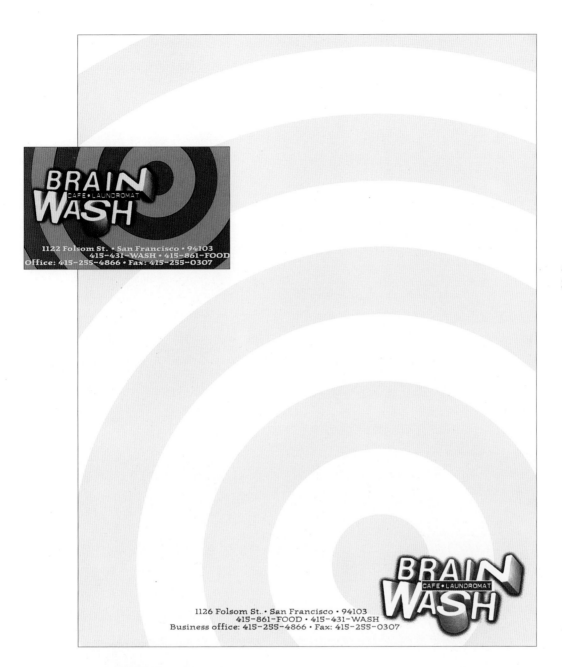

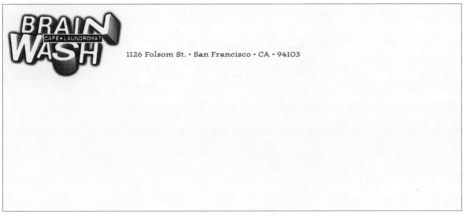

The Brain Wash Cafe & Laundromat combines the services of a laundromat, open from 7:30 A.M. daily, with a café, presenting live music three nights a week. When the owner decided to replace its in-house-designed logo, he wanted a "cohesive, multifaceted look that was hip, singular, expressive, weird, legible, young, completely new but accessible," according to art director Evan Somstein. Curium Design created a graphic identity that is retro-'50s yet also up-to-date. The type for the Brain Wash logo came from three-dimensional department store display lettering, which was photographed and reshaped in Adode Photoshop. The manipulated photograph was then printed with colors inspired by a vintage Oxydol detergent box from the collection of Brain Wash's owner. The letterhead paper, Simpson Evergreen Aspen, mimics the color and tactile qualities of '50s cardboard packaging. Although the printing on the business card was only 2-color, the logo was printed in registration, using 100 per cent of each color. This created the muddy shadow and gave the appearance of a 3-color job, thus stretching the budget.

<div style="writing-mode: vertical">BRIAN WASH CAFE & LAUNDROMAT</div>

**Design Firm:**
Curium Design
San Francisco, CA
**Art Directors:**
Evan Somstein,
Joy Somstein

# NICK AT NITE

Nick at Nite updates its media kit stationery every two years. Yet its latest design has a deliberately retro look, in keeping with the cable channel's programming: TV shows that were popular when the baby boomers were growing up. Designer/illustrator Melinda Beck chose the "moderne" color combinations of the '50s and '60s. Using Adobe lllustrator and QuarkXPress, she did line drawings and silhouettes of icons from the dawn of the TV age: remote controls, big-screen televisions in bulky furniture cabinets, TV trays and tables, and canapés that smack of the time—crackers, chunks of cheese, pigs in a blanket. Beck used 2-color offset printing with Pantone inks. The four sheets of the set feature four different pairings of hues: a margarine yellow with a blued gray, not-quite-lime green with eggplant, a nut brown with a dirty baby blue, and avocado with tangerine. The sheets of Cougar are printed on both sides, with a random patterning of icons on the reverse. This patterning highlights the entertaining imagery and draws attention to the information presented on the front.

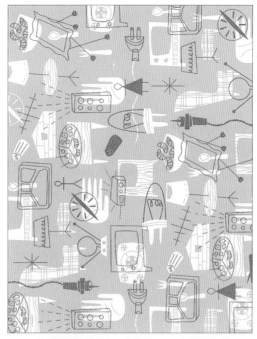

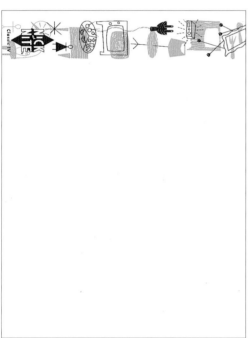

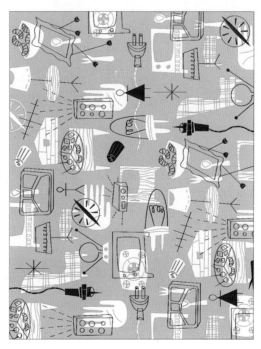

**Design Firm:**
Melinda Beck Studio
Brooklyn, NY
**Art Director:**
Kenna Kay,
Laurie Hinzman
**Designer/Illustrator:**
Melinda Beck

For Honest Baker, an upscale Madison Avenue bakery and coffee bar, designer and illustrator Quentin Paul Henry looked through books of logos from the '50s. However, Honest Baker is of its time, featuring low-fat goodies, not the high caloric fare of the bygone '50s. Working with Adobe Illustrator 6.0 and using a style and pose borrowed from that era of optimism, Henry created a slim woman baker presenting an appetizing, if low-cal, treat. Because Honest Baker is owned by a woman, the feminine figure seemed appropriate. The wholesome quality of the Honest Baker's offerings is reflected in the use of recycled papers for all parts of the identity system including packaging. The letterhead features a 2-color representation of a chef's toque that also looks as if it might be some puffy pastry.

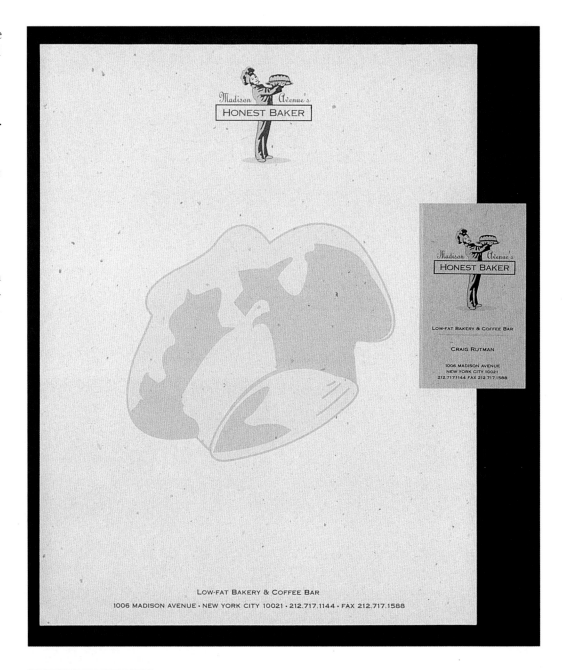

**Design Firm:**
Quentin Paul
Henry Design,
New York, NY
**Art Director/Designer/**
**Illustrator:**
Quentin Paul Henry

**Design Firm:**
WORK, Inc.
Richmond, VA
**Art Director:**
Cabell Harris
**Designer:**
Tom Gibson

When advertising copy-writer Steven Dolbinski came to WORK, Inc. for his first stationery, their approach was to "create a letterhead that looked as if it belonged to a respectable 19th-century businessman or gentleman." The flavor of that era is captured with the taglines "A Writer For General Hire" and "Of the Finest Credentials" flanking an old-fashioned typewriter. Dolbinski's writing skills are also demonstrated on the folded business card. The designers hand-set the type using a font from an old metal specimen book. The "cloud" behind "wordsmith" was created in Adobe Photoshop. As the engraved effect was difficult to scale, the logo had to be recreated for each application.

# STEVEN DOLBINSKI

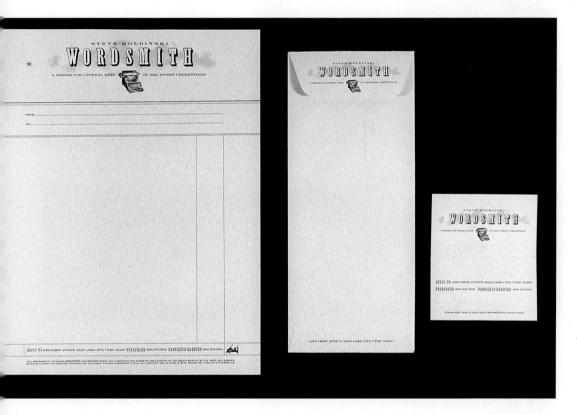

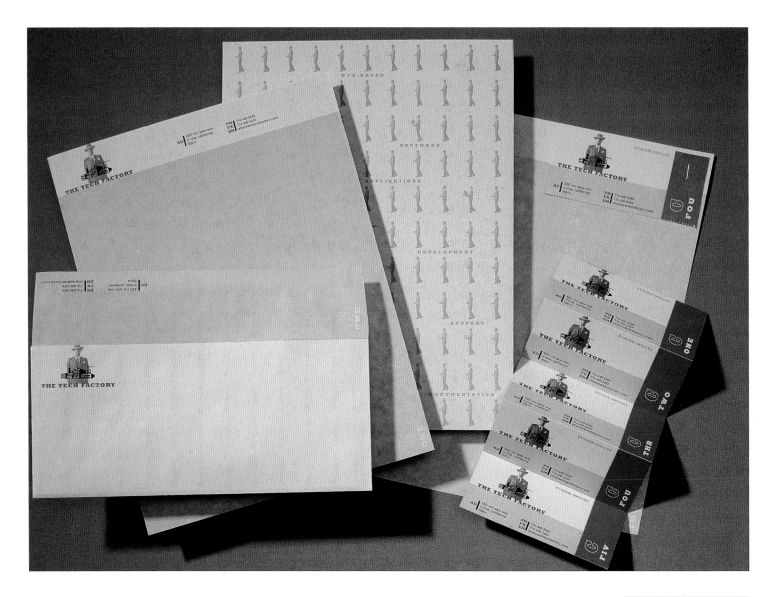

**Design Firm:**
Labbé Design Co.
Corona del Mar, CA
**Art Director/Designer:**
Jeff Labbé
**Photographer:**
Kimball Hall
**Paper:**
French Paper Co.

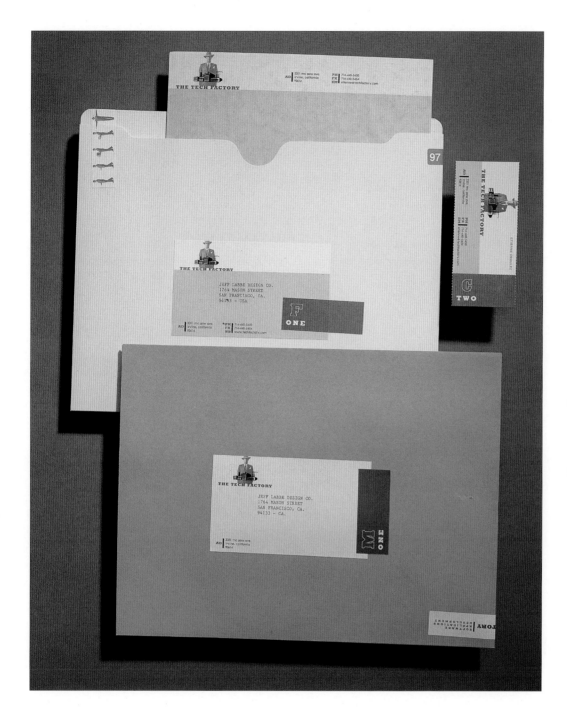

Even though The Tech Factory develops computer hardware and software that links businesses globally, owner Etienne Droulez "didn't want to continue the typical computer look that typifies his industry," according to designer Jeff Labbé. Droulez also wanted to present "a larger than life appearance," even though The Tech Factory has only two employees. After researching Swiss and industrial design, Labbé devised a stationery system notable for its industrial imagery and variety of elements. In addition to the letterhead, second sheets, custom-converted envelopes, perforated sheet of business cards, and two mailing labels, there are pressure-sensitive labels to use for a variety of decorative and practical purposes such as sealing envelopes. The basic elements of the design include photographic portraits of "The Tech Factory Man," a fedora-hatted figure in a gray flannel suit, and a stylized illustration of a factory. These motifs appear in the various applications including minature profiles of The Tech Factory Man ghosted on the reverse of the letterhead.

"Model, Actress, TV Spokesqueen" reads the placard held by the leggy '50s-style pin-up on Michele Turis's letterhead. To appeal to Turis's audience of art directors and modeling/acting agencies, designer Melissa Edwards rejected traditional and corporate ideas for the performer's first stationery. "The client wanted something campy and fun," according to the designer. The answer was to employ a sexy character who poses tantalizingly and totes a placard announcing Turis's talents. Using colorized black-and-white line art, Edwards created three different treatments of the logo for Turis's stationery, envelope, and business card. To complement the yellow and black of the placard, ruby red, French blue, and swimming-pool turquoise were chosen as evocative of the '50s. A different color was used for each of the elements of the stationery system as spot-color in the offset printing. In keeping with the retro feel, Edwards printed a period television set in a ghostly gray on the stationery sheet and envelope. Edwards says the design "accurately depicts my client to a T."

Design Firm:
Edwards Design
Boulder, CO
Designer:
Melissa Edwards

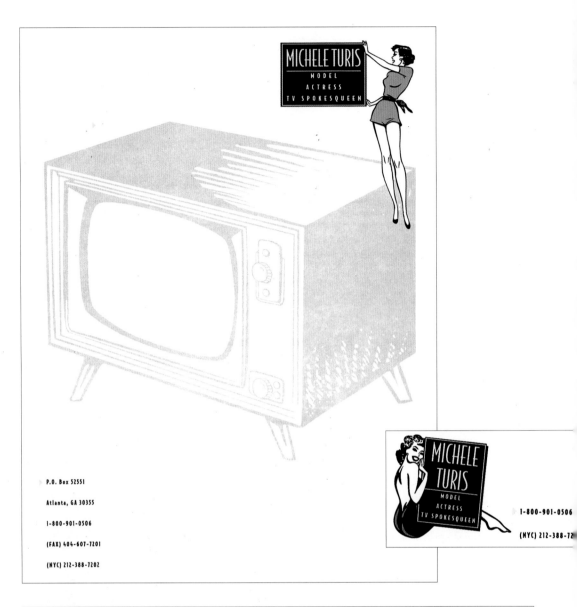

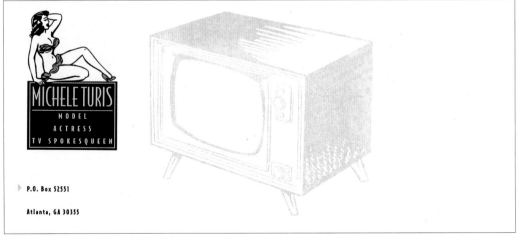

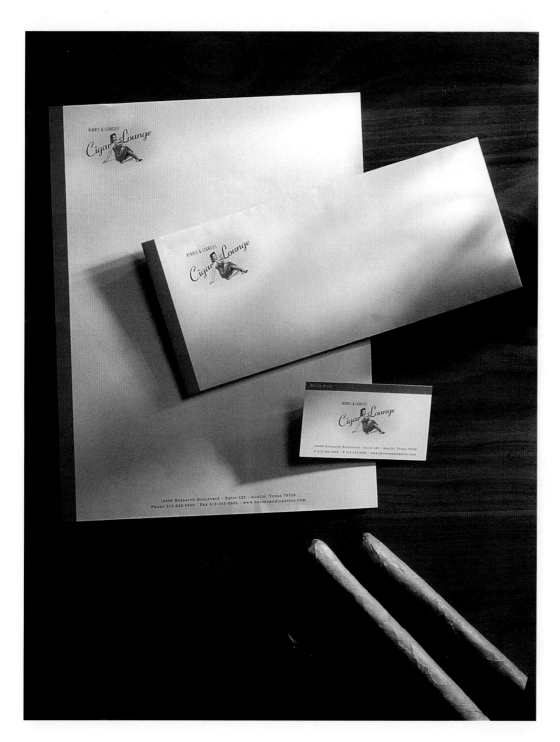

One of the most publicized phenomena of the mid-1990s is the revival of cigar smoking. Aficionados are lighting up all over the country, and in Austin, Texas, they can retire to Heroes & Legacies Cigar Lounge. Even though it is a new establishment, the Lounge wanted to evoke the heritage of cigar culture, according to Brett Stiles of GSD&M, who designed its first stationery package. Although other approaches were tried, the final design focuses on a leggy brunette in a tight red dress, cigar in hand, drawn by illustrator Mike Griswald. The treatment is realistic and reminiscent of pulp fiction book covers. In keeping with the period look, the type might have come from a 1940s or 1950s cocktail lounge matchbook cover. Four-color offset printing was used with a coarse line screen to add to the nostalgic look. The paper, French Duotone Newsprint Aged, also helps to give the package a vintage feel.

**Design Firm:**
GSD&M
Austin, TX
**Art Director/Designer:**
Brett Stiles
**Illustrator:**
Mike Griswald

"My wife and I began this business on the side while we both held other full-time jobs, and we jokingly referred to it as our side-show," recounts Martin Wilford. "When we decided to devote both of our efforts to it full time, we knew what the name had to be: Sideshow Advertising." For Sideshow's first stationery system, the designers considered using an "Admit One" ticket as a business card. Instead, Wilford opted for a circus-themed card. Using an image of a strong-man taken from a historical reference, Wilford reworked it in Adobe Photoshop 6.0.1 for stylistic consistency. The initial *S* was designed in Adobe Dimensions 2.0 and exported to Illustrator. The words "admit one" came from a stock photography CD, PhotoDisc. Wilford passed on die-cut shapes, deciding instead to use 4-color printing. Knowing that this business card was "the first and perhaps most important demonstration of our capabilities," Wilford feels it succeeds. "When we hand out our cards, two out of every three people say, 'Wow.' The third inevitably says, 'It would've been neat if your business card was a big Admit One ticket.'"

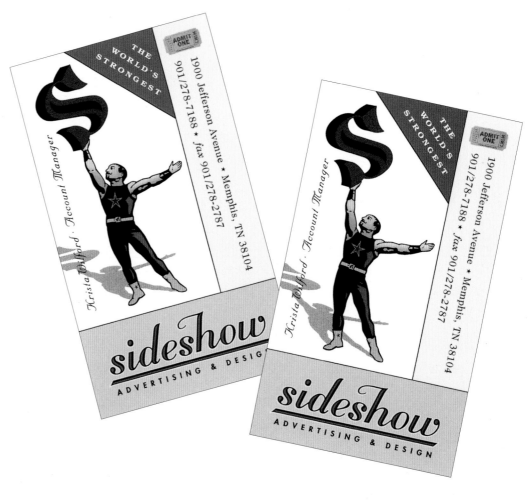

**Design Firm:**
Sideshow Advertising
Memphis, TN
**Art Director:**
Martin Wilford

# ILLUSTRATION

Pictures communicate globally without needing to be translated. When French-born graphic designer Elisabeth Paymal set up business in Ann Arbor, Michigan, she told the story of her life in pictures on her letterhead. The Eiffel Tower, the Golden Gate Bridge, and a leafy shade tree connected by dots, describe her journey eloquently. You don't have to read her text of "from Paris via San Francisco to Ann Arbor" to know her career path.

To create distinctive and effective stationery systems, graphic designers have turned to illustration in all of its manifestations, from childlike sketches to complex 4-color renderings. Illustrations may be small and emblematic or may dominate the design. Designers commission or do drawings in all media. They use photography, exploiting its range of effects from realistic to more impressionistic representation. They rely on illustration to give more information about their clients and their clients' businesses than a purely typographic treatment could.

In organizing this book, a large number of entries, 22, fell into a category called "Imaginative Images." Not related stylistically or compositionally, these letterheads and business cards employ illustration ingeniously.

Silvia L. da S. Victoria's business card for Fabio Malavazzi Victoria, a professional basketball analyst, leaves no doubt as to what he does. The card looks like a detail from a basketball, having borrowed the coloring, type styles, and textures of a real ball.

To make shopping at the upscale Bridge Market look like fun, Right Angle chose a cheery but sophisticated palette of scarlet and honey-bee yellow with a charming line drawing of the covered bridge that leads to the 50,000-square-foot mall. It's an engineered experience but Right Angle's apparently artless approach tells a different tale.

Perhaps it is the complexity of today's world that makes the naive approach in illustration so appealing. It can conjure up memories of a carefree childhood when work was play.

Naive is also a word used in the art world to mean primitive or untrained academically. There is the implication that it is art made from the heart, out of a need for self-expression. It also implies pure creative impulse. Supon Design Group conveys this feeling in its new stationery package. Sharisse Steber's mixed media drawings have all of the energy of impulse, and they work well with Supon's original logo of stylized initials.

In graphic design today photography is tool that offers a vast range of effects. For Skolos/Wedell, a design and photography studio, it was natural to use a photographic image on its new stationery program. Thomas Wedell's shots of vinyl sheets covered with a dot pattern generated in Adobe Illustrator read both photographically and graphically, making the studio's design message clear.

Also evocative of the client's business is A E R I A L's design for photographer R. J. Muna. Displaying both his commercial and fine art interests, Muna's soft-focus, romantic photos are integral to the design compositionally, while also proclaiming his identity as a photographer.

The Imaginative Images included in this section are as diverse as energetic line drawings or meticulously rendered representations. They have been reproduced in 1- or full-color, relegated to a corner or taken over a design. The illustrations themselves may be specially commissioned or come from existing sources.

In one instance, Rick Eiber Design (RED) started with the illustrations already commissioned by his client, the AIGA. For the 1995 Biennial National Design Conference held in Seattle, he was asked to incorporate four images done by different illustrators to represent the topics of the meeting. He met the challenge unconventionally by highlighting Studio MD's photographic montage of baby doll's arm, green eyeball, white-feathered wing, and old-fashioned electrical plug against a watery background. Eiber incorporated three more graphic symbols as compositional accents. It is a complicated package, both in terms of esthetics and production, but its impact depends on Eiber's inventive combination of images.

At the other end of the design spectrum is Sagmeister Inc.'s stationery for landscape architect Alexander Gröger's firm Green City. A clichéd look for the urban gardener was avoided with Veronica Oh's inventive and illustrative black-on-ivory logo of the Empire State Building casting the shadow of a leafy tree. Even though the production is uncomplicated and the image minimal, the impact is strong and memorable.

In a letterhead and business card package, an illustration can communicate more information about the client and the client's business than simply name and location. For Eagle River Interactive, John Brady Design Consultants used an illustration from Frank Frisari's portfolio to convey that the company was small but aggressive, just like Frisari's gaily colored fish going after a bigger but more complacent fish.

For the type foundry Tower of Babel, it was a natural to use the company's own typefaces as graphic elements rather then organize them into words. They signify the company and its product.

One imaginative image can capture myriad ideas: not only the nature of the client's business, but also the client's aspirations and work ethic.

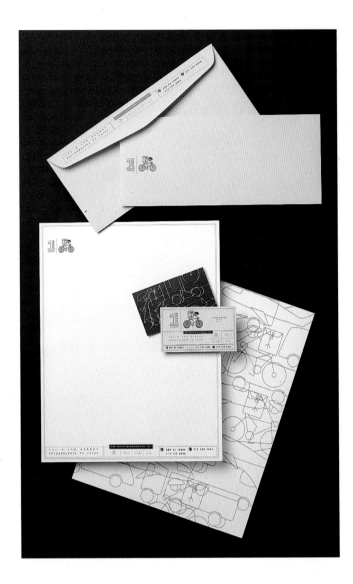

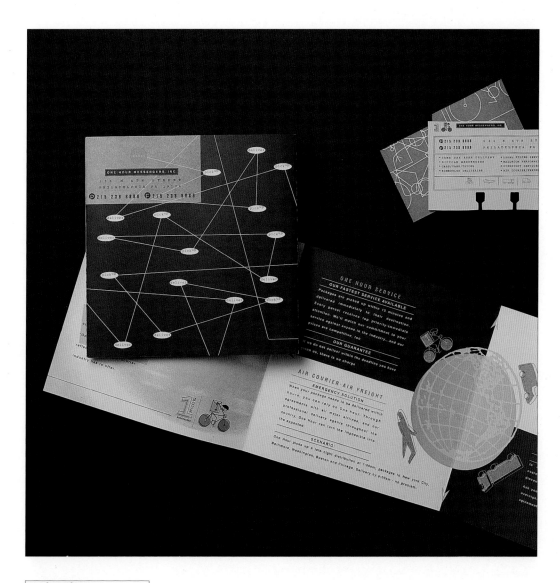

**Design Firm:**
Hansen Design
Philadelphia, PA
**Art Director/Designer/
Illustrator:**
Jennifer Hansen
**Illustrators:**
Mary Jo Ames,
Jennifer Hansen

# ONE HOUR MESSENGERS, INC.

For a new Philadelphia company providing messenger, overnight, and shipping services, Jennifer Hansen, who had worked with the client before, suggested only one concept. It was readily accepted because "he trusted me," she confides. The logo focuses on the company's name—One Hour Messengers—and one of its prime areas of service—bicycle messengers. Using Adobe Illustrator, Hansen made a whimsical line drawing of a bike messenger, helmeted for safety, and then asked freelance illustrator Mary Jo Ames to employ the same style to create icons for One Hour's other delivery methods: airplane, cross-country truck, and van. The icons appear flanked by the address and telephone number on each component of the stationery package. On the reverse of the letterhead sheet, larger versions of all four drawings overlap and fill the page. They also appear dropped out of the background of the reverse of the business card and Rolodex card.

Catering to affluent pet owners, the recently opened Alpha Dog Omega Cat shop needed "a mark that was fun and intriguing yet had the feel of an upscale retail store," according to art director Gil Shuler. Hand-scribbled dogs and cats and vintage pet product labels were discarded in favor of a more unusual approach. Inspired by M. C. Escher's experiments with positive and negative space, Gil Shuler Design came up with a logo that combines two black dogs nose to nose with the bewhiskered face of a white cat. Like an Escher, it's easy to recognize one in the other. For the 3-color offset stationery program, the drawing was done in Adobe Illustrator, and the layout in QuarkXPress. Two biomorphic shapes in avocado and yellow add a playful design element to the overall composition. Complementing the usual components of the stationery package is a registry card for each pet that includes such vital information as the pet's "Turn Ons" and "Turn Offs."

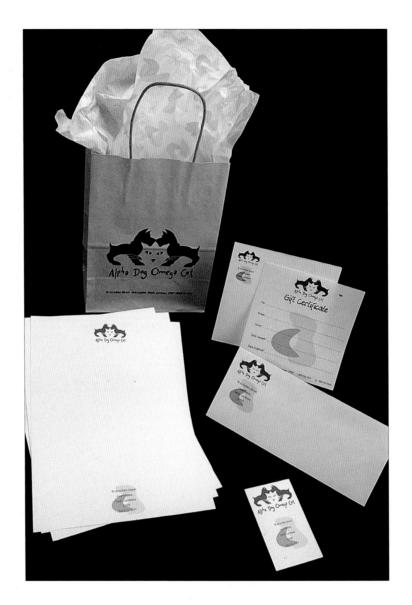

**Design Firm:**
Gil Shuler Graphic Design, Inc.
Charleston, SC
**Art Director:**
Gil Shuler
**Designer:**
Jessie McClary

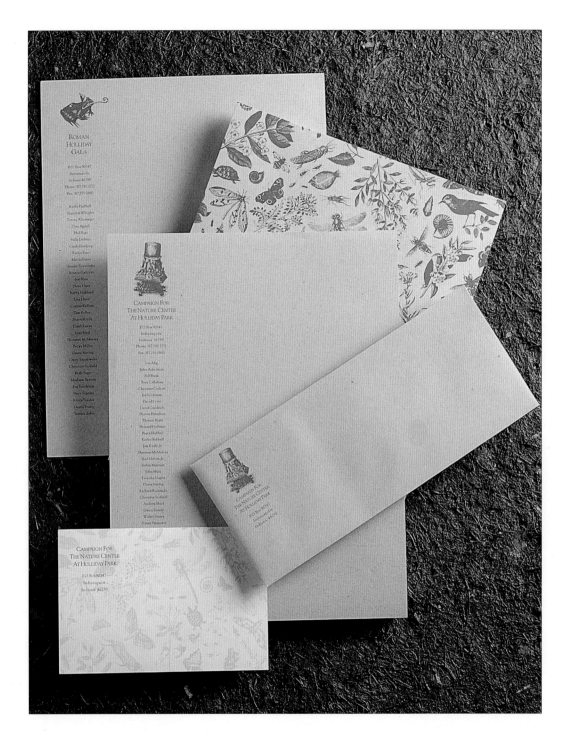

As a pro bono assignment, Young & Laramore was asked to design two letterheads to help raise funds for a new nature center at Holliday Park, Indianapolis. Using clip art manipulated in Adobe Illustrator, the designers created two distinctive but related stationery packages. A realistically rendered frog with a party favor was used as the key image to publicize a gala event. He looks as if he might have jumped from the pages of a 19th-century album of natural history plates. The letterhead for more general solicitation correspondence features a composite of natural motifs, all piled on a turtle's back. The reverse of the stationery sheet shows a variety of specimens of flora and fauna. The 1-color printing and engraved quality of the illustrations lend a genteel flavor to a package intended to raise money for a good cause.

**Design Firm:**
Young & Laramore
Indianapolis, IN
**Art Director:**
Courtney Ryan
**Creative Directors:**
David Young,
Jeff Laramore

The nonprofit organization Clothes the Deal provides business clothing to needy men and women to help prepare them for the work world. For a new stationery program, Clothes the Deal wanted to project the image of an established and trustworthy corporation to aid in soliciting clothing and cash donations. The designers created a logotype that appeared "professional, credible, efficient, approachable, contemporary, clean, and simple," according to designer Mamoru Shimokochi. The symbol is a red button with crossed threads representing stability and "people helping people," says Shimokochi. A classic serif typeface in all-capitals projects the idea of a large, efficient corporation. Working with a limited budget, Shimokochi/Reeves restricted the palette to two colors and reproduced the symbol in a single color. The white paper stock also communicates professionalism. Founder and president of Clothes the Deal, Ann Gusiff, says, "The identity sums up all our objectives in one easy to understand visual image."

**Design Firm:**
Shimokochi/Reeves
Los Angeles, CA
**Art Directors:**
Mamoru Shimokochi,
Anne Reeves
**Designer:**
Mamoru Shimokochi

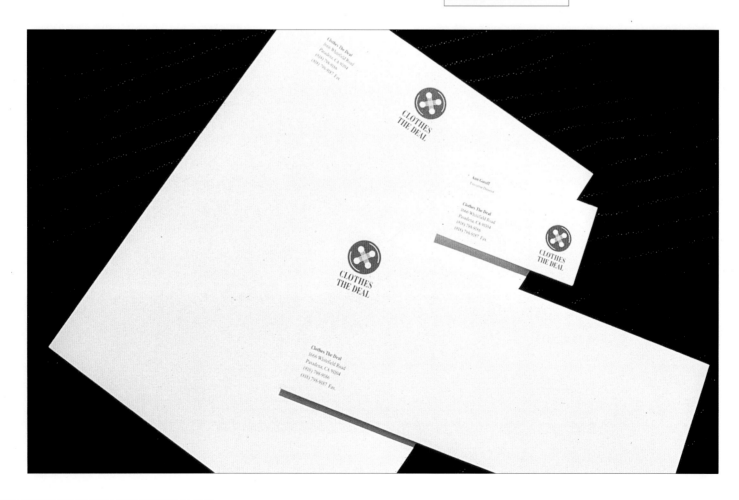

For the initial stationery package for Manifesto Interior Design, Scott Adams was asked to develop "an extremely bold solution." Adams complied, "but also presented some ideas that were more witty and refined, which I felt better reflected Manifesto's clientele," he says. Keeping the company's name in mind, Adams balanced silhouettes of furniture on pointed "constructivist shapes." The color? Revolutionary red. Photographs of furniture found in books and magazines provided the source for the black images. An overstuffed armchair, a table with elegantly curving legs, and an aristocratic daybed suggest tradition ready to topple. The photographs were scanned into Adobe Photoshop and silhouetted using the paint brush tool. With 2-color offset printing, the backs of the letterhead and business card were flooded with red. The envelopes also feature a red interior, printed before the envelopes were converted.

**Design Firm:**
Scott Adams Design
Columbus, OH
**Designer:**
Scott Adams

# TOWER OF BABEL

Tower of Babel is a digital type foundry. For its initial business card, the company employed a sampling of letterforms from its own type releases. In keeping with its name, the letters are a jumble, readable only as abstract forms. Four different cards, variations on the same theme, were created in Macromedia FreeHand 5.0, and the typefaces themselves in Macromedia Fontographer 4.1. Offset lithography was used for the four versions of the cards, which were printed four up in two colors. Overlaid on the red letters is the firm's logo, a stylized presentation of what archeologists hypothesize the Biblical Tower of Babel to have looked like, a stepped pyramid or ziggurat. On the letterhead, the symbol's orientation is on its side, appropriately characterizing a confusion of language. The pyramid image also dominates a promotional poster. A clay model was photographed in the studio and combined with existing photographs, with other effects added in Adobe Photoshop. Using metallic ink, duotones and overprinting, the designer achieved a richly layered composition, one pertaining to the company's namesake.

**Design Firm:**
Tower of Babel
Asheville, NC
**Designer:**
Eric Stevens

# m . y . design

*miyoung kim*
*designer*

*38-25 150th street*
*flushing, new york*
*11354*
*tel: 718 886 2788*

When Miyoung Kim set up m.y.design in Flushing, Queens, it was important to create an image that communicated "up-to-date computer-oriented design solutions," in Kim's words. The result is refreshingly simple. Using Adobe Illustrator 6.0, Kim took the familiar image of a computer mouse and combined it with the image of a lead pencil. Adding a touch of energy, the "tail" of the mouse trails off the top edge of the vertically-oriented business card. To balance the whimsy of the logo, Kim set the company name and other pertinent information in Garamond, roman and italic, centering the elegant type beneath the image. The business card was offset printed in two PMS colors—50 per cent black and 50 per cent blue.

**Design Firm:**
m.y.design
Flushing, NY
**Designer:**
Miyoung Kim

Although illustrator Mary Grand Pré's name suggested a play on auto racing, it was quickly scrapped for something that was more in tune with her style, taste, and personality. "Mary's work is very conceptual, soft and expressive," designer R. Bruce Armstrong explains. "All elements involved in creating her identity—the paper stock, the portion of her self-portrait, and the color palette are reflective of her work." The stationery package developed by Armstrong is at once whimsical and sophisticated and showcases Grand Pré's look and feel. A key component is her own artwork, which is used prominently as the logo on all elements. A fanciful rendition of an Old-Master frame surrounds a fragment of a pastel-hued self-portrait, eyes focused in a Mona Lisa-like gaze. Speckletone cream stock (4-color plus PMS charcoal black) in the offset-printing process, the color scheme is typically Grand Pré. On all of the components, a border of buttery buff reinforces the frame motif.

**Design Firm:**
Armstrong Graphics
Minneapolis, MN
**Art Director/Designer:**
R. Bruce Armstrong
**Illustrator:**
Mary Grand Pré
**Printer:**
Challenge Printing, Inc.

# GRAND RAPIDS CHILDREN'S MUSEUM

For a $4-million capital campaign for the newly established Grand Rapids Children's Museum, a non-profit interactive museum, designer Krystn Sawyer created something unusual. To court donors, the client wanted "to capture the essence of what the Children's Museum is all about, while also portraying a professional image to reach the intended audience of business and community leaders," Sawyer explains. For the logo, the designers employed elements from the museum's exhibit "Funstruction" to build a fanciful castle. In-process shots appear in the fund-raising brochure, and the completed castle becomes the logo on letterhead and envelopes. The letterhead was die-cut so that it locked over a Lego block glued to the brochure cover. Working with Adobe Photoshop and QuarkXPress, Sawyer output from a Scitext DoPlate 800 computer directly to plates, a "filmless" process. HiRez images were scanned using APR. The success of the design can be measured by the fact that $3.8 million was raised in 14 months. Some of the contributions came without the donors having visited the site; they just received the fund-raising package.

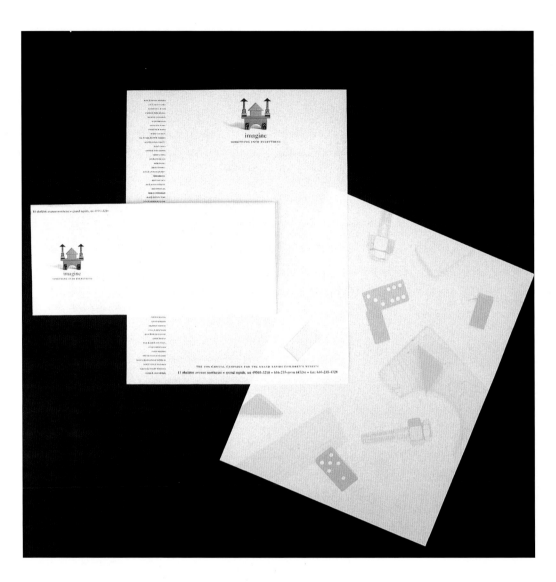

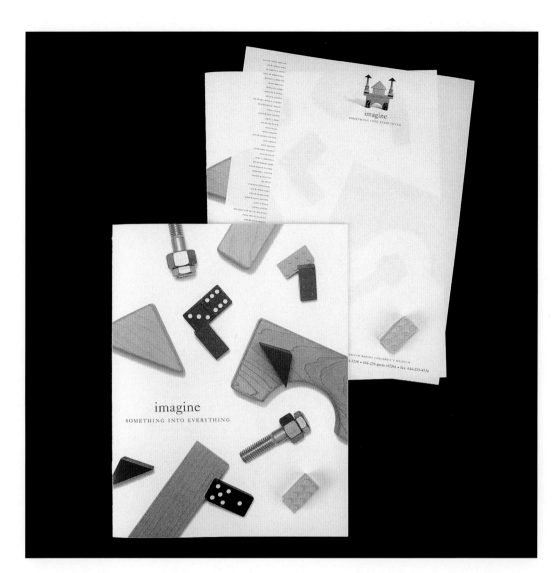

**Design Firm:**
Berkel & Co. Advertising
Grand Rapids, MI
**Art Director/Designer:**
Krystn Sawyer
**Photographer:**
Andrew Terzes
**Printer:**
Gilson Graphics
**Paper:**
Central Michigan Paper

imagine

When Jan Staller, a commercial photographer, expanded his business to include designing and selling objects in the home furnishings field, he needed a new identity. With a tongue-in-cheek attitude, he named his new venture Staller Industries. For the stationery program, the design-savvy Staller suggested an iconic factory image, perhaps one borrowed from 19th-century advertising, to designer Ria Shibayama. After an extensive search of library archives, Shibayama reverted to her original concept of layering images from Staller's own collection of catalogs and advertising materials. Her selection of a wrench seemed too "mechanical" to Staller, and he suggested an illustration of calipers to connote design and fabrication, consistent with his self-image. For the business card, Shibayama laid an "exploded view" illustration of a complicated assembly of nuts and bolts over the ghosted calipers. It dominates the front of the card with the requisite information relegated to a single line of type on the back. For the letterhead and envelope, only the schematic assembly appears.

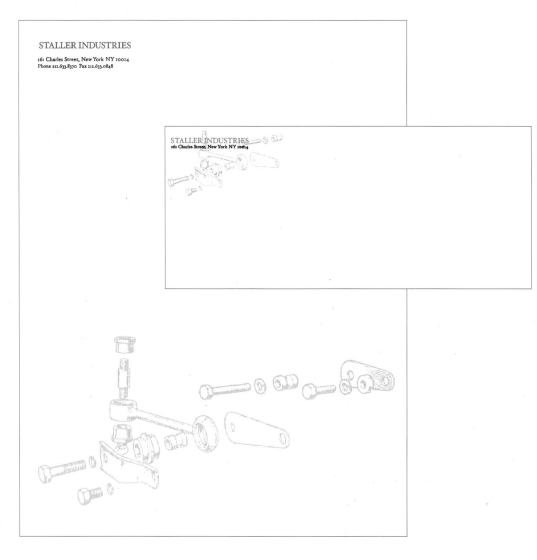

**Design Firm:**
Ria Shibayama
New York, NY
**Art Director/
Designer/Illustrator:**
Ria Shibayama

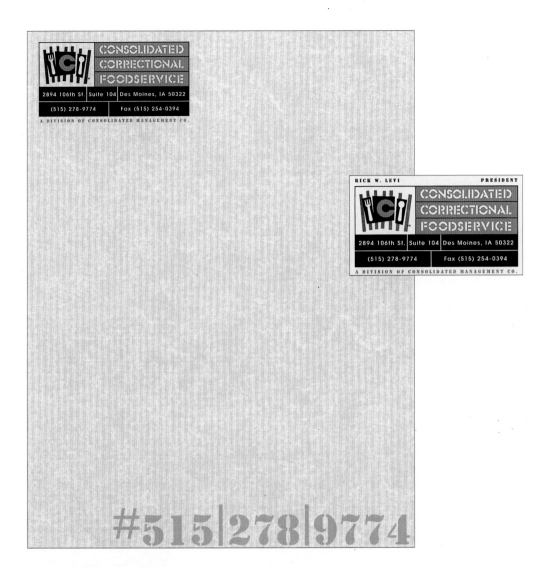

CONSOLIDATED MANAGEMENT CO.

When Consolidated Management, a food management company, decided to expand into correctional institutions, they asked Sayles Graphic Design to create the initial stationery package. "Correctional institutions are by nature somber places," Sayles says. "A fun and lively letterhead design would not be appropriate." But it was also inappropriate, in creating a new identity program, to ignore Consolidated's special focus. Illustrating the specific nature of this new division, the result manages to be appealing. The company's name, Consolidated Correctional Foodservice, is set in a bold, stencil-like type and reversed out of the wide orange and black bars. A fork and spoon and blocky *C* on a striped place mat become the logo. For the letterhead, printed on gray riblaid paper, the phone number reads like a prisoner's number.

**Design Firm:**
Sayles Graphic
Design, Inc.
Des Moines, IA
**Art Director/
Designer/Illustrator:**
John Sayles
**Designer:**
Jennifer Elliott

# EAGLE RIVER INTERACTIVE

For a start-up interactive design company, the challenge for John Brady Design Consultants was to create the look of an established firm. Two tactics were used: 4-color printing and a clever, narrative illustration that sends a strong visual message about Eagle River Interactive. Frank Frisari's bold and playful illustration depicts a small fish eagerly going after a larger, more lethargic one. The illustration communicates that though Eagle River is small, it can move quickly to meet clients' needs. The illustration was part of Frisari's portfolio and permission to use it was purchased outright. Specializing in corporate communications, Eagle River has two sister companies with the same corporate identity: Eagle River Communications and Eagle River Productions. Different stationery packages were developed for each of them. The placement of the logo varied on the individual letterheads and business cards. The 4-color illustration was preprinted with different flat and black imprints for the three companies.

> P.O. Box 3600 > 1060 West Beaver Creek Blvd. > Avon, CO 81620.8162

> P.O. Box 3600 > 1060 West Beaver Creek Blvd. > Avon, CO 81620.8162

> P.O. Box 3600 > 1060 West Beaver Creek Blvd. > Avon, CO 81620.8162

**Design Firm:**
John Brady Design
Consultants
Pittsburgh, PA
**Illustrator:**
Frank Frisari

EAGLE RIVER INTERACTIVE
P.O. Box 3600 > 1060 West Beaver Creek Blvd.
Avon, CO 81620.8162 > Phone 970.845.8300

**Christopher Briggs**
Vice President & Creative Director

Phone 970.845.2108 > Fax 970.845.2150
Email briggs@eagleriver.com

**Christopher Briggs**
Vice President & Creative Director

Phone 970.845.2108 > Fax 970.845.2150
Email briggs@eagleriver.com

EAGLE RIVER INTERACTIVE
P.O. Box 3600 > 1060 West Beaver Creek Blvd.
Avon, CO 81620.8162 > Phone 970.845.8300

**Christopher Briggs**
Vice President & Creative Director

Phone 970.845.2108 > Fax 970.845.2150
Email briggs@eagleriver.com

EAGLE RIVER INTERACTIVE
P.O. Box 3600 > 1060 West Beaver Creek Blvd.
Avon, CO 81620.8162 > Phone 970.845.8300

When a Rockville, Maryland, company specializing in personal training, injury rehabilitation, children's fitness, weight management, corporate health promotion, and facility design sought a new logo, there were a lot of conditions. It had to be bold, memorable, hold up at small scale, emphasize the medical aspect of the company, and convey a caring quality. The mark designed by Good Dog Studio is immediately recognizable as an electrocardiogram record of a heartbeat that leads seamlessly into the legs of a runner, and it would be hard to imagine a more apt image for a company called Fitness for Health. This striking design, created in Adobe Illustrator, was used on all components of the updated stationery package. For the presentation folder, the pockets were custom die-cut to reflect the shape and angle of the logo. Azure and aquamarine hues were used in the 2-color offset printing, reinforcing the health-consciousness of the company.

**Fitness for Health**℠

Personal Training
Injury Rehabilitation
Children's Fitness
Weight Management
Corporate Health Promotion
Facility Design

11140 Rockville Pike
Suite 103
Rockville, MD 20852
301.231.7138

**Fitness for Health**℠

**Marc Sickel, A.T.C.**
President
Certified Athletic Trainer

11140 Rockville Pike
Suite 103
Rockville, MD 20852
301.231.7138

Personal and Corporate
Fitness Programs

**Design Firm:**
Good Dog Studio
Kensington, MD
**Art Director/Designer:**
Richard Barnes

**Design Firm:**
Rick Eiber Design (RED)
Preston, WA
**Art Director/Designer:**
Rick Eiber
**Illustrators:**
Studio MD, Hornall
Anderson Design Works,
Werkhaus,
Ed Fotheringham

Rick Eiber designed the stationery for the AIGA 1995 Biennial National Design Conference. Not only was he creating something for his peers, but he also had to work with four different symbols by four different illustrators representing the themes to be addressed at the conference. And he had to incorporate verbal descriptions of each theme into the design. For the letter-head, Eiber placed Studio MD's symbol in the center of the sheet of Classic Crest Writing in Bisque from Neenah Paper. Representing "Seattle Design Unplugged," the illustration was printed 4-color with density reduction so as not to interfere with the legibility of any message written over the image; the image was used alone on the second sheet. The three other illustrations anchored the corners, balanced by the address block at the upper left. For the envelope, the four illustrations were spaced along a horizontal band dividing the envelope in half. Although unusual, it complied with postal standards. A subtle touch was the change in eye color from green to blue in the "Seattle Unplugged" illustration.

Brooklyn-based landscape designer Alexander Gröger specializes in roof gardens. In designing the logo for his business, Green City, Veronica Oh of New York's Sagmeister Inc. created an ideal solution twinning urban environments and gardens: an image of the Empire State Building casting the shadow of a leafy tree. Offest-printed on the horizontally-oriented business card is Green City's vital information in a delicate, sans-serif face reversed out of a black block. This is balanced against the strong, black-on-ivory graphic image, created in Adobe Illustrator. The treatment is simple and straightforward, but sophisticated, and absolutely appropriate for an urban gardener.

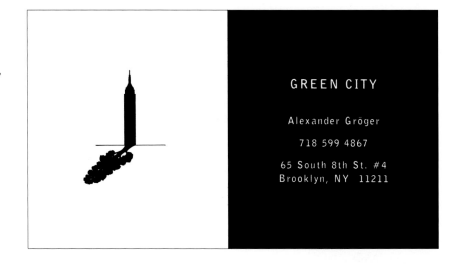

GREEN CITY

Alexander Gröger

718 599 4867

65 South 8th St. #4
Brooklyn, NY 11211

**Design Firm:**
Sagmeister Inc.
New York, NY
**Art Director:**
Stefan Sagmeister
**Designers:**
Stefan Sagmeister,
Veronica Oh
**Illustrator:**
Veronica Oh

For basketball analyst Fabio Malavazzi Victoria's first business card, Silvia L. da S. Victoria got down to basics: the ball. The designer used the familiar curved seams of the ball, the characteristic stippled surface, and the unmistakable color to convey her client's identity as a professional basketball broadcaster. The information was set in actual basketball typefaces, instantly recognizable to Victoria's audience of sports professionals. The design was created in Adobe Illustrator. Three spot colors, two PMS colors and black, were used to simulate a portion of the ball. The designer created the stippled effect by using an Illustrator pattern, manipulated to match the texture of an actual basketball. A sense of dimensionality is achieved through the curving lines that mimic those found on real balls. Silvia Victoria admits that it took imagination and a few tries to get it right.

**Design Firm:**
Silvia Victoria Design
New Milford, CT
**Designer:**
Silvia L. da S. Victoria

FABIO MALAVAZZI VICTORIA

Funded by federal and local agencies, Project New Directions is a three-year initiative administered by the Art Education Department of the Rhode Island School of Design. The program aims to raise the standards of art education in Rhode Island. Designer Katie Chester faced a tough and design-savvy audience of art educators and policy makers when she was given the assignment to design the letterhead for the new program. She came up with a sophisticated yet friendly design on her first go. "I wanted to address the human element and the process inherent in art education, hence the pencil handwriting and the gestural arrow," she explains. For a subtle touch, the handwriting of RISD's president, Roger Mandle, was scanned into Adobe Photoshop. Taking the name of the program literally, Chester changed the orientation of the letterhead from vertical to horizontal. Since the client used a laser printer, this did not cause any practical problems.

CENTER FOR THE ADVANCEMENT OF ART & DESIGN EDUCATION  RHODE ISLAND SCHOOL OF DESIGN  TWO COLLEGE STREET ▲ PROVIDENCE, RI 02903 ● PHONE 401.454.6695 ■ FAX 401.454.6694

John Doe
Director
Village Arts
111 High Street
Village, RI, 02222

March 15, 1996

CENTER FOR THE ADVANCEMENT OF ART & DESIGN EDUCATION  RHODE ISLAND SCHOOL OF DESIGN  TWO COLLEGE STREET ▲ PROVIDENCE, RI 02903 ● PHONE 401.454.6695 ■ FAX 401.454.6694

Dear John,
We have had great success with our recent Project New Directions workshops and have received wonderful feedback from many of the participants. I am including Manette Jungels' letter as an example. Manette is a visual arts educator at the Camden Avenue Elementary School here in Providence. Her letter follows:

"I am writing to express my enthusiasm and support for the Center for the Advancement of Art and Design Education. It feels very timely for those of us in the field to come together to create a voice for ourselves. Public education in general is under close scrutiny and the arts are in a precarious position in the upcoming changes. It is up to us to make ourselves an integral and essential part of those changes. I believe that the center will provide a powerful vehicle for this need.

In bringing together every art teacher in the Providence School system for three professional days and a week long workshop during the summer, the center will help to engender a solidarity amongst our community that does not exist at this time. We need each other. We need an opportunity to know what is happening at other schools, to share information about grants and other resources, to help each other cope with problems that sometimes seem to be to big, etc.. From the simple starting place of shared information we begin to build a voice that is our own. We clarify our most immediate needs and goals and we strive to meet them. All of this empowers us in small and immediate ways and hopefully in larger more long term ways such as curriculum and equity in our schools.

In closing I would like to speak personally about being a new teacher and how much this has meant to me. I am the only art teacher in my building. I see 900 children in a two week period. I am teaching elementary school which means I see children once every other week. Half of the children I teach do not use English as their first language. These things and more can add up to a high stress level. I was feeling very isolated and in truth discouraged. These

opportunities to talk to others with more experience in the field, to be with people who think art is important just for its own sake, to be part of a group that plans to make changes, all infuse me with an energy and excitement that I can't begin to express. If the Center for the Advancement of Art and Design Education fulfills its aspirations, the Providence School Department and all the children in the system stand to benefit.

CONTINUED . . .

I would like to thank, RISD, and the other members of the Advisory Committee for the effort being put into this wonderful and hopeful project."

I'm sure you will agree it is hard not to be moved by such a letter. It gives me great hope that we may indeed be able to break the downward spiral of art education in our public schools.

I frequently find myself rereading the report from the National Committee for Standards in the Arts. One sentence keeps jumping out at me: "A society and people without the arts are unimaginable, as breathing would be without air."

Talk to you soon.

Sincerely,

Jane Smith

project new directions

CENTER FOR THE ADVANCEMENT OF ART & DESIGN EDUCATION  RHODE ISLAND SCHOOL OF DESIGN  TWO COLLEGE STREET ▲ PROVIDENCE, RI 02903-2789

**Design Firm:**
Rhode Island
School of Design,
Publications Office
Providence, RI
**Art Director/Designer:**
Katie Chester
**Handwriting:**
Roger Mandle

When Pam Paulson established Paulson Press to do fine art printing for artists, it was important that she communicate to her audience—artists and galleries—that she specialized in intaglio printing. Using Adobe Illustrator, designer Michael Osborne created a stylized representation of a printing press that also reads wittily as a human figure. Printed in black, it expresses both the mechanical aspect and the human quality of printing from engraved or etched plates. To reflect the venerable printing process, Garamond Light was chosen. A steely blue was used for the copy, including the descriptive line "intaglio printing" to identify Paulson Press's specialty. To further reinforce the fine quality of the Press's work, the stationery and business cards were printed letterpress. Every element of this apparently simple design solution—classic type centered with a bold graphic logo—supports the identity of the client.

PAULSON PRESS
INTAGLIO PRINTING

1150 55th Street Studio E, Emeryville, CA 94608 Ph/Fax 510 653 9607

**Design Firm:**
Michael Osborne Design
San Francisco, CA
**Art Director/Designer:**
Michael Osborne
**Printer:**
One Heart Press

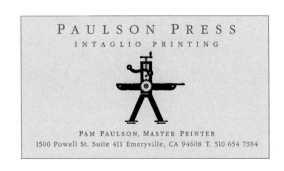

PAULSON PRESS
INTAGLIO PRINTING

PAM PAULSON, MASTER PRINTER
1500 Powell St. Suite 411 Emeryville, CA 94608 T. 510 654 7384

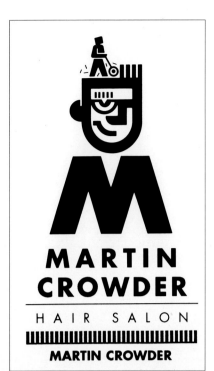

When hair stylist Marty Crowder wanted a makeover for his business card, he turned to John Sayles, who had done the original design. Even before the request came in, says Sayles, he had already sketched out the concept. He brought it out when Crowder called for an appointment. Retaining the black-and-white sense of the original styling, Sayles fashioned a muscular line drawing of a figure, using a bold *M* as the body. The figure's flat top is being trimmed by a silhouetted man with mower. At the bottom of the vertical card, an elongated and stylized comb device separates the name from the image. That same motif is used on the back of the card, this time reversed out of a black ink bleed, to frame the phone number. The business card also serves as an appointment reminder.

**Design Firm:**
Sayles Graphic Design, Inc.
Des Moines, IA
**Art Director/Designer/Illustrator:**
John Sayles

MARTY CROWDER HAIR SALON

Perfectly Round Productions specializes in film and video production. A new company, it wanted "an innovative, bold image that could be easily animated and visually communicate the nature of its business," according to designer Sonia Greteman. After rejecting the concept of a mechanical head for the logo, she devised a simple 2-color illustration. The cube, a play on the pure geometric form of the circle, offers two faces, one a stylized television, the other a piece of sprocketed film stock. The two faces represent the two areas of Perfectly Round Productions' business. The cube is topped by a halo, a metaphor for perfection. To further emphasize what the company does, various words defining its areas of expertise such as copy, video, lighting, and consulting were set in an apparently blown-up and ragged typewriter script. In the lithographic printing process, the entire sheet was flooded and the typographic images reversed out of it. Thus, they read almost subliminally. For a firm using sophisticated technology, the Greteman Group came up with a visually bold and contemporary solution that is not sterile or mechanical.

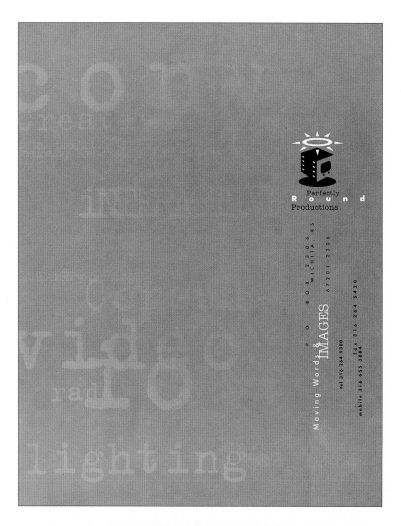

**Design Firm:**
Greteman Group
Wichita, KS
**Art Director/Designer:**
Sonia Greteman
**Designer:**
James Strange

**Design Firm:**
NBBJ Graphic Design
Seattle, WA
**Art Director:**
Susan Dewey
**Designer:**
Daniel Smith

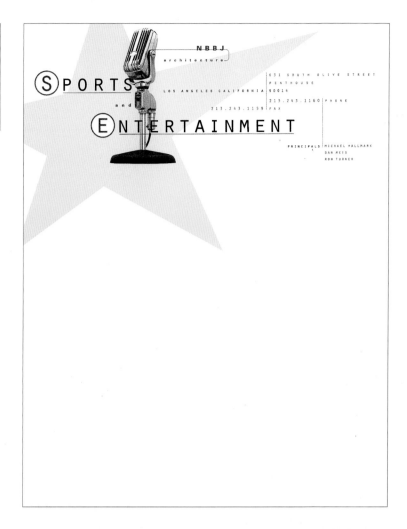

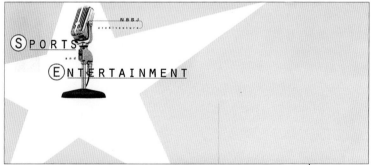

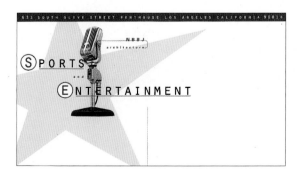

NBBJ Sports and Entertainment is a new division of the second largest architectural firm in the country. Established to attract business from major league teams, college athletic directors, and stadium and entertainment venue developers, the division required a graphic identity distinct from the parent company's low-profile, corporate look. An earlier version of the stationery design incorporated vintage sports photographs. Instead, a photo CD stock image, a microphone superimposed on an exuberant gold star, was selected to represent both the entertainment and sports markets. On the letterhead, the star extends beyond the paper to convey a dynamic image of this new architectural practice based in the entertainment capital of Los Angeles. The logo is just off-center on the second sheet, again suggesting an energetic company. Many of the components of the stationery package were printed in the basement of NBBJ's corporate headquarters in Seattle on a 1-color Heidelberg 46 GTO, an unexpected piece of equipment to find in an architectural office.

*2000 is a new company with an innovative concept intended to make life a little easier for the traveler on the highway: two- or three-digit dialing to connect via cellular phone to hotels and restaurants. For its initial stationery program and promotional materials, Gil Shuler Graphic Design needed to create a "forward thinking design that immediately screamed 'new,' 'different,' 'exciting.'" By overlaying images of cellular phones, touch-tone keypads, and highway shots from the driver's seat with straight-ahead typography and an asterisk "star" with petal-like points, the designers lucidly conveyed the company message: telecommunicating, ease of remembering, and an allusion to the millennium. The repetition of *2000 reinforces marketing appeal to potential subscribers. The design balances the complicated composition of images against clarity of typography, and the flower-like form of the star adds a gracious tone befitting the hospitality industry, *2000's projected client base.

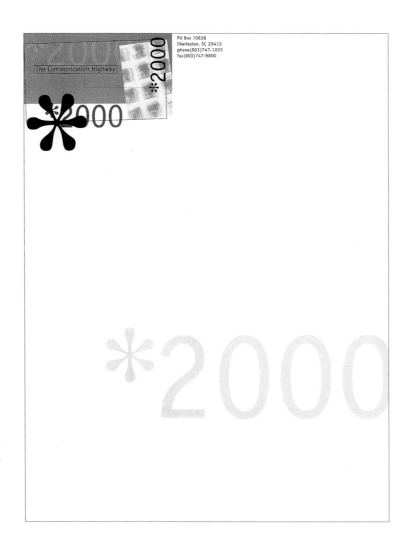

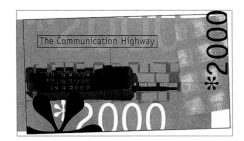

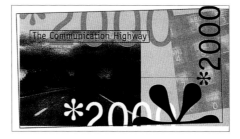

**Design Firm:**
Gil Shuler Graphic
Design, Inc.
Charleston, SC
**Art Director:**
Gil Shuler
**Designer:**
Jessie Thomson

# Q A

**What is *2000?**
Star 2000 is a cellular communications company which provides rapid access numbers used in conjunction with outdoor advertisers.

**What is a "rapid access" number?**
A rapid access number is a one or two digit number preceded by the # or * sign which allows the cellular phone user to quickly dial a number without having to remember seven or more digits.

**How does it work?**
The rapid access number is posted on your outdoor advertisement within a special logo. When the cellular subscriber dials the rapid access number, it is automatically forwarded to a regular phone number you designate, typically your main phone number. Your staff answers the call just like any other, offering information, directions or the opportunity to make reservations. The advantage over your competitors is obvious.

**How will this help me generate sales?**
Outdoor advertising is a passive form of advertising. Star 2000 communications, through its rapid access cellular numbers, seeks to transform this passive medium to an active one-on-one, customer-on-the-phone, sales call. It is an excellent way to differentiate your outdoor advertising program from your competitors.

Communication

No matter how sophisticated we appear, there is always a part of us that responds to the childlike, the untutored, the naive. Forget that nearly every illustration in this volume has been created on, or at least tweaked on, the computer: There is still an allure about the hand-drawn.

In the '96-'97 Regional Design Annuals, the seductive innocence of the naive was revealed in different manifestations, ranging from the light-heartedness of children's drawings to the sometimes darker visions of Outsider Art, the latter produced by untrained artists who feel compelled to create paintings or sculptures to fulfill some inner need.

The naive is frequently whimsical. For the Wildflower Bread Company, a puffy slice of bread with an exuberant posy offers "a slice of the good life." The design was irresistible when executed with all the delight and innocence of a children's drawing. The bakery's apparently hand-printed name was actually created with Macromedia Fontographer.

That same homey appeal is what illustrator Jeanna Pool was asked to create for DeVries Design's stationery system for Bethany House in Denver. The client is a nonprofit organization dedicated to securing housing for HIV/AIDS patients and Pool's drawing of the awninged entrance to the first building renovated by Bethany House is a welcoming one. A more complicated approach would have sent the wrong message about the charitable group.

Food stylist Mary Kiesau

may work with photographers but for her first stationery system, her long-time friend Susan Reed gave her three vignettes that might have been sketched with a child's carefree abandon. To communicate photographer Tod Martens' good-guy personality, Dean Johnson Design replaced the O in his name with casually drawn illustrations that reinforce the 18 different texts on his business cards. More formally drawn, the tagline "needs money" would have been too heavy-handed.

The vitality and creativity of the untutored artist is what makes this approach work for the Washington, DC, design firm Supon Design Group. The vivid colors of its stationery system may be sophisticated, but the drawing style of Sharisse Steber pays more homage to Outsider Art than to inside-the-Beltway design.

A different kind of creative expression in the direct naive manner is used by Crabtree+ Company. Icons of creativity dot its new stationery.

Even in our technology-driven and sophisticated, even jaded, times, the naive is still a valid design choice for the visually savvy.

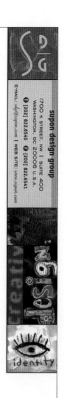

When it came time to replace Supon Design Group's stationery package, the goal was to create "a letterhead that was more playful, one that would more truly reflect our workspace, our clients, and the type of work we do," explains principal Supon Phornirunlit. It needed "to grab attention" but also be "acceptable in the corporate world." The solution was to use rectangular boxes for formal organization, but fill them with "unexpected, 'nontraditional' images," representing the different aspects of the full-service design company. Designer and illustrator Sharisse Steber drew the images, using everything from traditional media to tape and wire on a variety of supports including wood and metal. They have the quality of art made by untutored artists or urban graffitists. For a series of second sheets, she created charming line drawings focusing on the human tools of design: hand, eye, head, brain. The various elements of the 4-color design have been used for numerous applications including to enforce brand identity for Supon's Web site. Phornirunlit believes that this new "less traditional" design is "a better fit with the character of our studio."

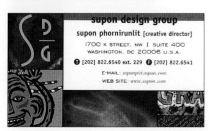

**Design Firm:**
Supon Design Group
Washington, DC
**Art Director:**
Supon Phornirunlit
**Designer/Illustrator:**
Sharisse Steber

After many years of working for a local studio, Tod Martens had an established client base when he struck out on his own as a commercial photographer. To take advantage of that equity, Dean Johnson Design "didn't want to create some kind of false, 'new' identity, but rather just to present him as the nice guy we all know." Various approaches for the new identity included a take-off on a type of bird, the Martin, and using the initials ™ as a logotype. The solution involved exchanging playful drawings for the *O* in Tod. Designer Scott Johnson explains, "Everyone knows him as 'Tod,' a friendly, trustworthy, easy-going guy." The line drawings illustrate taglines on 18 different business cards. The one used for the letterhead and envelope looks like a view camera and complements the text "shoots cool stuff." The drawings were refined in Streamline and Adobe Illustrator, and then placed in QuarkXPress with the type. The fact that there were 18 separate cards did not increase the cost of the offset production. The cards have proved to be a cost-effective way of creating agency interest, with different ones sent to different art directors.

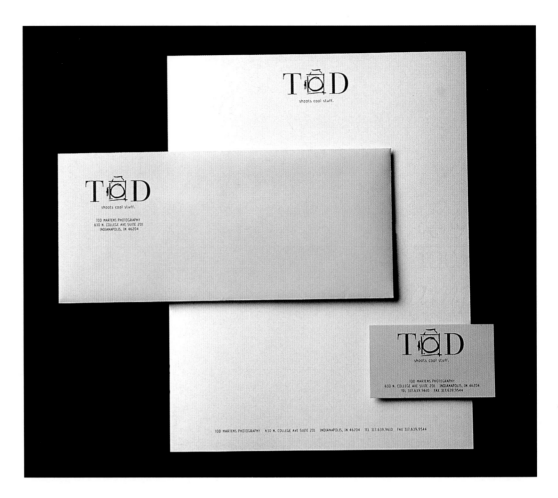

wants you to call now.

TOD MARTENS PHOTOGRAPHY
630 N. COLLEGE AVE SUITE 201   INDIANAPOLIS, IN 46204
TEL 317.639.9610   FAX 317.639.9544

TØD

won't shoot that.

TOD MARTENS PHOTOGRAPHY
630 N. COLLEGE AVE SUITE 201   INDIANAPOLIS, IN 46204
TEL 317.639.9610   FAX 317.639.9544

TOD

communicates.

TOD MARTENS PHOTOGRAPHY
630 N. COLLEGE AVE SUITE 201   INDIANAPOLIS, IN 46204
TEL 317.639.9610   FAX 317.639.9544

thinks you're ugly.

TOD MARTENS PHOTOGRAPHY
630 N. COLLEGE AVE SUITE 201   INDIANAPOLIS, IN 46204
TEL 317.639.9610   FAX 317.639.9544

shoots cool stuff.

TOD MARTENS PHOTOGRAPHY
630 N. COLLEGE AVE SUITE 201   INDIANAPOLIS, IN 46204
TEL 317.639.9610   FAX 317.639.9544

TOD

can't remember.

TOD MARTENS PHOTOGRAPHY
630 N. COLLEGE AVE SUITE 201   INDIANAPOLIS, IN 46204
TEL 317.639.9610   FAX 317.639.9544

feels your pain.

TOD MARTENS PHOTOGRAPHY
630 N. COLLEGE AVE SUITE 201   INDIANAPOLIS, IN 46204
TEL 317.639.9610   FAX 317.639.9544

works hard.

TOD MARTENS PHOTOGRAPHY
630 N. COLLEGE AVE SUITE 201   INDIANAPOLIS, IN 46204
TEL 317.639.9610   FAX 317.639.9544

needs money.

TOD MARTENS PHOTOGRAPHY
630 N. COLLEGE AVE SUITE 201   INDIANAPOLIS, IN 46204
TEL 317.639.9610   FAX 317.639.9544

**Design Firm:**
Dean Johnson Design, Inc.
Indianapolis, IN
**Designers:**
Scott Johnson,
Bruce Dean,
Mike Schwab
**Illustrator:**
Bruce Dean

Stormy Weather Press is an independent, author-driven company publishing fiction, poetry, and limited-edition handmade books. The initial logo and stationery program was designed to "establish an identity and reflect the spirit and personality of this new company," according to designer/illustrator Sheryl Jenkins. The storm cloud and lightning bolt were hand-drawn with a calligraphy pen and then refined in Adobe Illustrator. They may be obvious choices to illustrate the company's name, but Jenkins has given them an unexpected twist by using a copper ink instead of silver for the bolt in contrast to the metallic Pantone blue of the cloud. Jenkins rejected the idea of embossing the logo, due to the high cost, and instead added drama to the design with the metallic blue and copper inks. The paper stock gives the look and texture of handmade papers, a reference to the limited editions published by Stormy Weather. The flecked paper also relates to the logo with its pattern of multi-colored "rain." Jenkins recalls that a meteorologist friend told her that the fluffy cloud used in the logo "is the right kind. Maybe that's why it rained so much while I designed it."

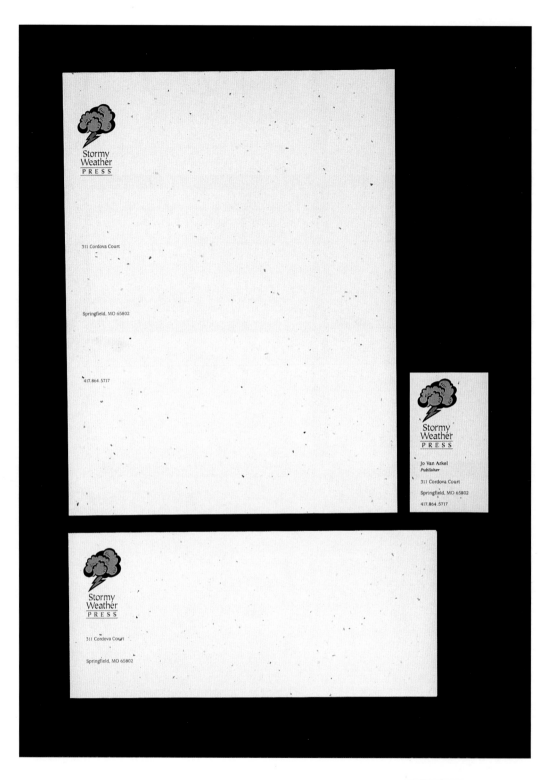

**Design Firm:**
Jenkins Studio
Springfield, MO
**Art Director/**
**Illustrator:**
Sheryl Jenkins
**Printer:**
John Tranbarger, Color-
Graphic Printing, Inc.

When Crabtree+Company changed their name and expanded their services into the marketing and interactive arenas, it was time to create a new "identity that would bring forth the varied areas of communication we operate within," according to principal Lucinda Crabtree. After treating the word "vision" as a symbol and creating a corresponding mark, the designers decided to use several icons of creativity to punctuate the components of the stationery program. Highly graphic symbols in two colors, developed in Adobe Illustrator, were used as decorative motifs on the letterhead, envelopes, and business cards. Each has the directness of a child's drawing. There is an eye, a hand, a head, radiating lines for sound, and an exclamation point to illustrate the various aspects of creativity needed in a full-service marketing communications firm. Bright colors add a touch of sophistication and contrast with the brilliant white of the paper stock. These multiple images stand for the "many different symbols or icons from which we all draw our own thoughts and design," explains Crabtree.

**CRABTREE+COMPANY**

**Design Firm:**
Crabtree+Company
Arlington, VA
**Art Director:**
Greg Whitlow
**Designer:**
Dave Wiseman

Although Mary Kiesau is an established photographic food and prop stylist, she opted for charmingly stylized illustrations for her first stationery system. Designer/illustrator Susan Reed, who knows Kiesau well, was given free rein in the design. After considering other approaches, she presented her favored one to Kiesau—a slightly retro look, reflecting Kiesau's interest in the 1940s and '50s. The color scheme of green and grape, found in the stylist's home, is obviously to her taste. The three illustrations used in the stationery program are all simply drawn still-lifes, similar to what Kiesau might arrange for a photo shoot: a blender with a tall drink for the letterhead, a cutting board with a colander filled with fresh vegetables on the envelope, and a fruit-and-cheese platter for the business cards. Reed's fluid and economical line captures the essence of these little vignettes. Adding another design element are geometric blocks of opaque white ink on the business cards over which the illustration is offset printed in black ink.

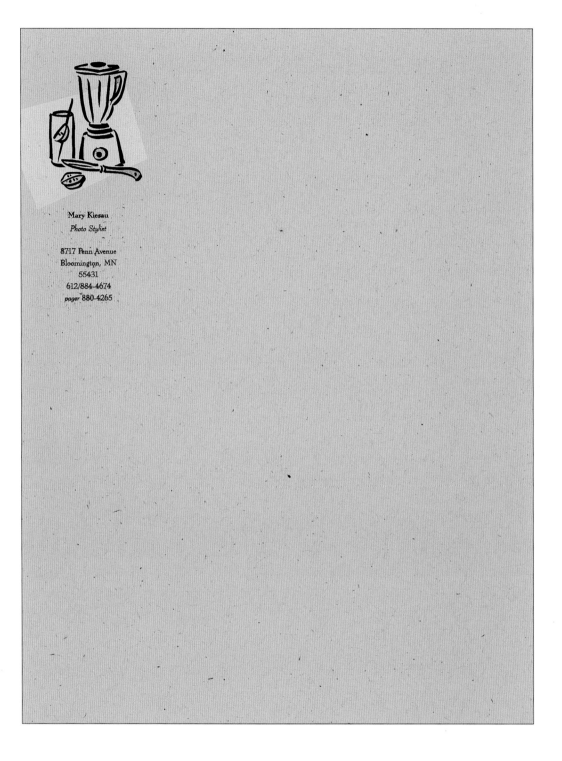

Mary Kiesau
*Photo Stylist*

8717 Penn Avenue
Bloomington, MN
55431
612/884-4674
*pager* 880-4265

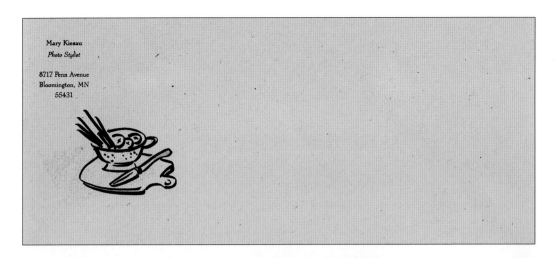

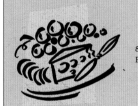

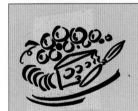

**Design Firm:**
Susan Reed Design
Minneapolis, MN
**Designer/Illustrator:**
Susan Reed

Illustrator Jeanna Pool's naive drawing style communicates the caring attitude of Bethany House, a not-for-profit corporation whose mission is to locate, purchase, and renovate apartment buildings to shelter HIV/AIDS patients. The tag line used on the stationery and business cards designed by Diane DeVries tells the story: "A haven—a home." Pool attempted several different views, both complete and partial, of the first building renovated to provide housing for the organization's constituency. A cropped version, focusing on the awning, conveys the message completely. Originally drawn by hand, it was converted for separation by Adobe Streamline and Illustrator. QuarkXPress was used for page layout. The paper (Neenah Environment, Moonrock, 24# writing and 80# cover) and inks (Pantone 336 and 1807) match the color scheme of the first building the company redecorated. DeVries' choice of Garamond Book Condensed, Book Italic Condensed, and Bold Condensed as the typefaces was in keeping with the hospitable quality of the logo.

**Design Firm:**
DeVries Design
Denver, CO
**Designer:**
Diane DeVries
**Illustrator:**
Jeanna Pool

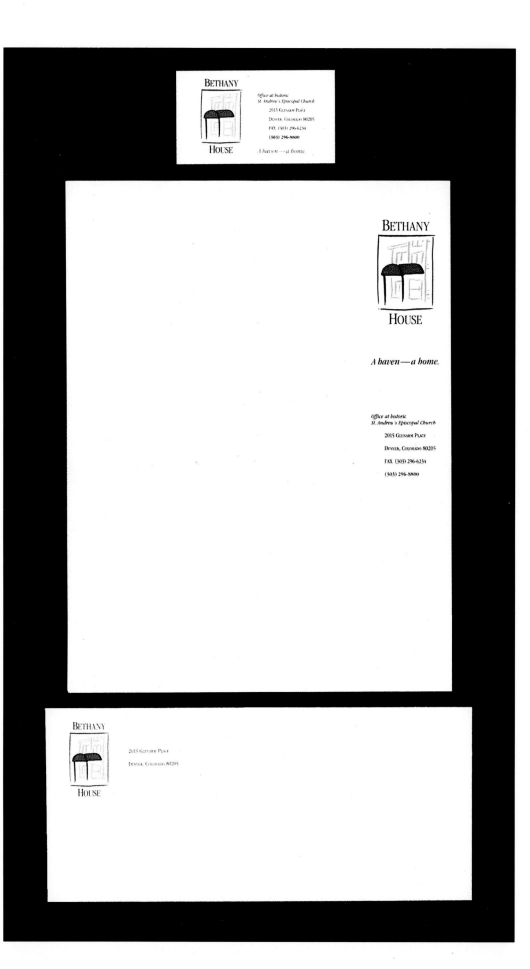

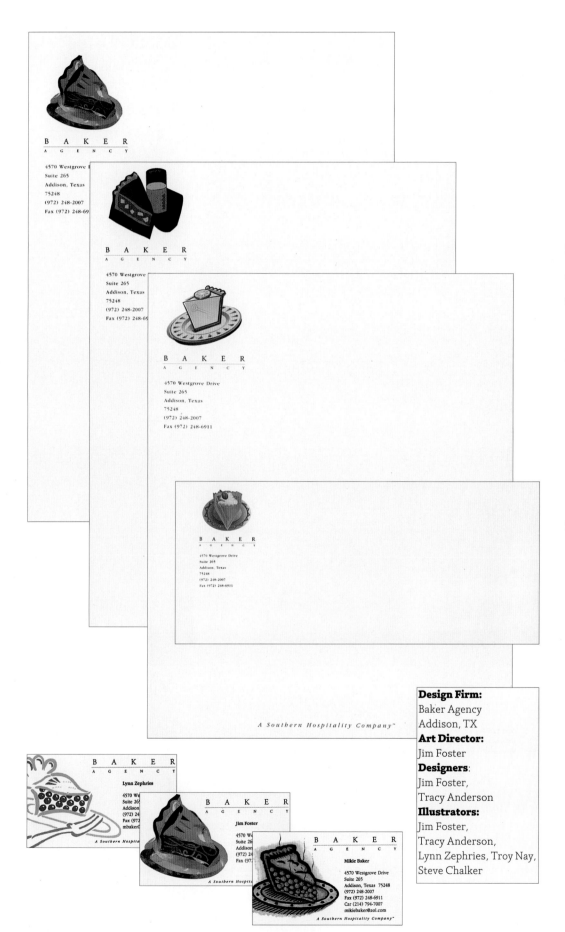

The Baker Agency presents itself as "A Southern Hospitality Company." The Addison, Texas, firm specializes in marketing and design for the hospitality industry, creating menus, promotions, employee incentives, point-of-purchase materials, and all related collateral. To replace existing stationery, the agency came up with a plan to market itself "in a creative but effective way through basic business collateral," explains art director Jim Foster. It was also important to express "the individual talents of the people within the company." The idea of using appetizing illustrations of pies was immediately hit upon to represent the company. Five illustrators drew various baked goodies, including a translucent key lime pie complete with the subtle subliminal image of a key inside. The company's letterhead and business cards feature seven 4-color images of pies from pumpkin with whipped cream to blueberry. The illustrations were created in-house, by hand using a variety of media including marker and watercolor, as well as by computer. "It makes a great statement to hand out a different card to individuals in a group," Foster reports. "People like to pick their favorite kind of pie."

**Design Firm:**
Baker Agency
Addison, TX
**Art Director:**
Jim Foster
**Designers**:
Jim Foster,
Tracy Anderson
**Illustrators:**
Jim Foster,
Tracy Anderson,
Lynn Zephries, Troy Nay,
Steve Chalker

# WILDFLOWER BREAD COMPANY

For Scottsdale's Wildflower Bread Company, Estudio Ray wanted to create a "user-friendly and credible look" and to "avoid looking like a sterile chain." The illustration by Joe Ray used for the logo is whimsical and homey, the colors lighthearted and Southwestern. Everything about the new bakery's graphics system was designed to evoke the product—"fresh baked artisan breads, specialty bakery items"—and the café serving "gourmet sandwiches, homemade soups, tempting salads." Even the paper used for the stationery system, Fox River Paper's Confetti in Kaleidoscope, evokes the texture of home-baked bread. The typeface was designed using Macromedia Fontographer and has all of the delightful energy of a child's lettering. The *D* of "wildflower" and the *B* of "bread" are colored in, a small touch in keeping with the entire visual approach. The trademarked logo, drawn in Adobe Illustrator, shows a posy on a slice of bread that could also be seen as a zaftig torso. Everything about the design reinforces the company's slogan: "A slice of the good life."

**Design Firm:**
Estudio Ray
Scottsdale, AZ
**Art Directors:**
Christine Ray, Joe Ray
**Designers:**
Joe Ray, Christine Ray,
Leslie Link
**Illustrator:**
Joe Ray

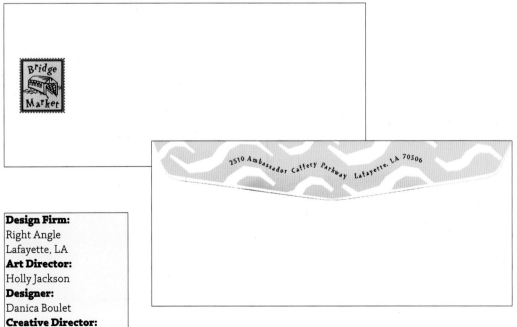

The covered bridge that crosses the creek to reach The Bridge Market was to be the symbol for the new venture, a geographical landmark. The owner of the newly constructed, 50,000-square-foot shopping and entertainment center wanted "to evoke the image and feeling of heartland America, while capitalizing on the popularity of the best-selling novel and film, *The Bridges of Madison County*," according to Cheryl Taylor of Right Angle. Utilizing the bridge image, art director Holly Jackson and designer Danica Boulet created a logo that is both striking and straightforward, contemporary and nostalgic. Using Adobe lllustrator, they achieved the effect of a simple 2-color linoleum or woodcut, "framing" the design with the perforated edge of a postage stamp. Printed in three PMS colors and black on Elements Solid Bright White, it makes a cheery logo for this new mini-mall. In keeping with the appearance of a hand-cut print and reinforcing the bridge motif are wave-like shapes on the envelope flap, letterhead, and business cards. Rather than use a predictable blue, Right Angle opted for the yellow of the logo. Aimed at potential tenants and customers, the design communicates fun, vitality, and optimism.

**Design Firm:**
Right Angle
Lafayette, LA
**Art Director:**
Holly Jackson
**Designer:**
Danica Boulet
**Creative Director:**
Carol Ross

Although the visual effects of photography can run the gamut from highly realistic to highly impressionistic, the design stories photography can tell are different from other illustrative media because of the documentary quality of photography. Of course, there have always been ways to enhance images or combine negatives to add what was never there. And today, with Adobe Photoshop, the opportunities for manipulation are limited only by the designer's imagination.

Minneapolis's Haley Johnson Design Co. seamlessly added a second spout to a teakettle to symbolize the communications and design consultancy Tea for Two. While the concept would have been effective in a hand-drawn image, the photograph adds impact, making the image seem more "real."

Similarly, French-born Elisabeth Paymal, for the new stationery for her new design business, transformed photographs into evocative impressions, but retained the sense of actual place. The stationery traces her odyssey from Paris to San Francisco to Ann Arbor, Michigan, using images from her personal archive of snapshots. Again, the documentary aspect of the photographic image helps to make her journey more real.

For photographer R. J. Muna, it was a natural for the design firm A E R I A L to use his soft-focus photography as the dominant feature in a new stationery package. The image, printed on the reverse letterhead as duotones in dust steel and ocher, reinforces Muna's romantic photographic vision.

In contrast, Boston's Cipriani Kremer opted for a completely unromantic image, a computer monitor displaying the Lotus logo. The twine-wrapped monitor, promoting bundling of Lotus software with computer hardware, provides a perfect symbol for the Lotus OEM program. The twine has been enhanced in Photoshop.

After Hours Creative used a similar type of manipulation to create the logo of a neon sign for Culinary Arts & Entertainment. The sign spells "cafe" with a burnt-out F. The Phoenix, Arizona, designers manipulated both black-and-white and color photographs in Adobe Photoshop and then maximized the amount of PMS red used in the offset lithography process. The result: a bright neon sign.

Photography's malleability makes it a powerful tool when graphic designers construct identities and express them in letterheads and business cards.

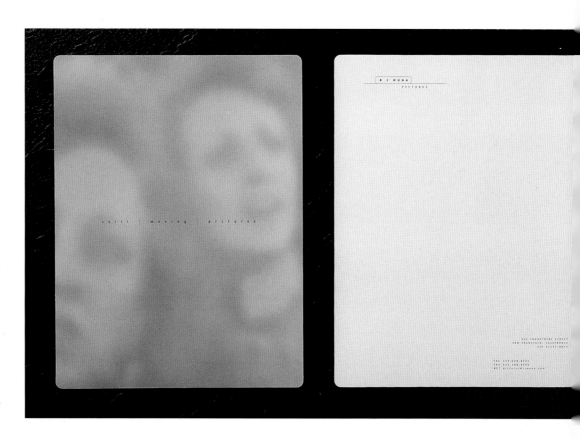

When commercial and fine art photographer R. J. Muna expanded his business to digital and animated media, he changed his business name from R. J. Muna Photography to R. J. Muna Pictures. It was also time for a new visual identity. The challenge, as designer Tracy Moon saw it, was "to better reflect his personal style and taste, as well as to subtly communicate that the range of his work is far broader than any one assignment or photograph." The new stationery package features romantic, soft-focus photographs shot by Muna. "We both gravitated toward those which were more indirect, left more to the imagination, the ones which revealed something new every time you looked at them," explains Moon. On each component of the system, a photograph dominates, sometimes on the front with the business information or overprinted on the back as with the letterhead. They are printed with lithography, using a dust steel or dust ocher ink combined with black for duotones. The images were drum scanned and manipulated in Live Picture and color-corrected in Adobe Photoshop. The photographs also bear a single line of type: STILL/MOVING/PICTURES.

**Design Firm:**
A E R I A L
San Francisco, CA
**Art Director/Designer:**
Tracy Moon
**Photographer:**
R. J. Muna
**Copy:**
Tracy Moon, R. J. Muna

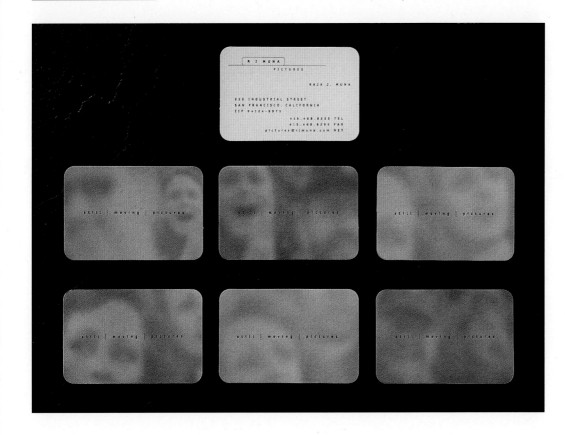

When Bill Maneri opened his practice, he asked Gil Shuler Graphic Design "to come up with an idea that would set him apart from other landscape architects in the Charleston area," explains Shuler. One of Shuler's early ideas solved the problem elegantly: He developed a logo of palm tree fronds topping a pencil. "The use of the palm tree designated him as a Charleston coastal architect," notes Shuler. The pencil line drawn horizontally across the stationery is an obvious reference to design. Adobe Photoshop melded two images for the logo—one a black-and-white photograph of a palm found in the city, and the other, the image of an actual pencil. Only one color was needed in the offset lithography process. The design has been successful for both client and designer, who reports he's had calls from larger landscape architecture firms inquiring about design work.

**Design Firm:**
Gil Shuler Graphic
Design, Inc.
Charleston, SC
**Art Director:**
Gil Shuler
**Designer:**
Jay Parker

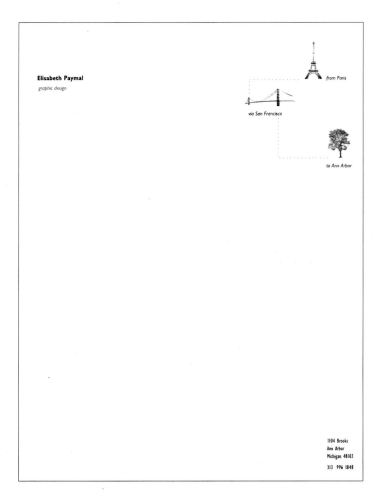

Elisabeth Paymal
graphic design

from Paris

via San Francisco

to Ann Arbor

1104 Brooks
Ann Arbor
Michigan 48103

313 996 1848

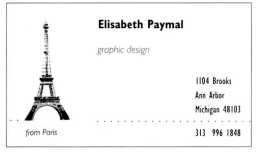

**Elisabeth Paymal**

graphic design

1104 Brooks
Ann Arbor
Michigan 48103

from Paris

313 996 1848

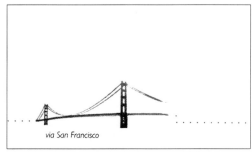

via San Francisco

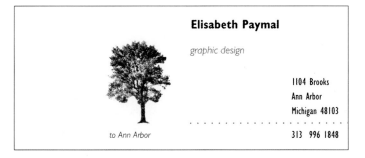

**Elisabeth Paymal**

graphic design

1104 Brooks
Ann Arbor
Michigan 48103

to Ann Arbor

313 996 1848

**Design Firm:**
Elisabeth Paymal
Graphic Design
Ann Arbor, MI
**Designer:**
Elisabeth Paymal

Graphic designer Elisabeth Paymal's first stationery system tells her life story: "From Paris via San Francisco to Ann Arbor." It's a career odyssey as well as a geographic one. Paymal was a clinical psychologist, first in her native France and then in San Francisco. She then shifted focus to graphic design and moved to the university town of Ann Arbor, Michigan, to earn a B. F. A. On each of the components of her 2-color stationery package, three icons appear: the Eiffel Tower, the Golden Gate Bridge, and a shady tree. The images were taken from Paymal's photograph collection and manipulated in Adobe Photoshop. Paymal's aim in this design was to generate interest in a new freelance designer in town. She considered various ways to convey her French background, including emphasizing the French spelling of her first name, or using other archetypically French symbols before settling on the narrative approach. "The solution seeks to tickle curiosity through an unusual life-story telling," she explains. "It stimulates 'small talk' during initial contacts with prospective clients."

**ELISABETH PAYMAL GRAPHIC DESIGN**

# THE WHITE ROCK COMPANY

Specializing in real estate renovations, the newly formed White Rock Company of New Orleans views itself as bridging the gap between contractors and designers. Its initial stationery program, created by Zande Newman Design, includes the descriptor "Design/Construct." Designers Adam Newman and Michelle Zande wanted to acknowledge the client's appreciation for the contrasts that define this city of the Old South with its French heritage, a city of "layering and textures." They explored ideas illustrating old versus new, coarse versus fine, common versus precious, residential versus industrial. After the client rejected a purely typographic solution, it was decided to explore photography, including photo CD stock. The bands of black-and-white photographs are close-up, but recognizable, images of urban textures. They include a crumbling brick wall, a window with wire glass, and a wooden wall with peeling paint. To complement the photographically rendered textures, the logo, "white + rock," is blind debossed on the crisp white stock of the program elements. It evokes the notion of stone engraving as well as impressions of light and shadow.

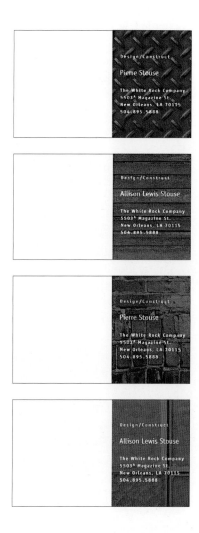

**Design Firm:**
Zande Newman Design
New Orleans, LA
**Designers:**
Adam Newman,
Michelle Zande
**Photographer:**
Arthur S. Aubry

The Lotus OEM Program targets computer hardware manufacturers and aims to convince them to bundle Lotus software with their equipment. Boston's Cipriani Kremer Design was asked to design a logo and stationery package that would communicate this specific marketing objective and complement the company's existing corporate identity. After experimenting with several typographic and other solutions, a photographic treatment was developed. The full-color photograph by John Shotwell of a computer monitor features the existing Lotus logo on screen; the monitor's back is seen on the reverse of the letterhead sheet. The twine that wraps the monitor effectively conveys the concept of bundling. The rough, low-tech twine was silhouetted using Adobe Photoshop to enhance its realistic quality. The stationery was offset printed using laser-sensitive inks on 24th Gilbert Correspond white wove. Designer René Payne reports that "Lotus was delighted that a concept as complex as bundling software could be communicated 'so simply and elegantly.'"

The Lotus OEM Program

Lotus Development Corporation
55 Cambridge Parkway
Cambridge, MA 02142
1.617.693.6134

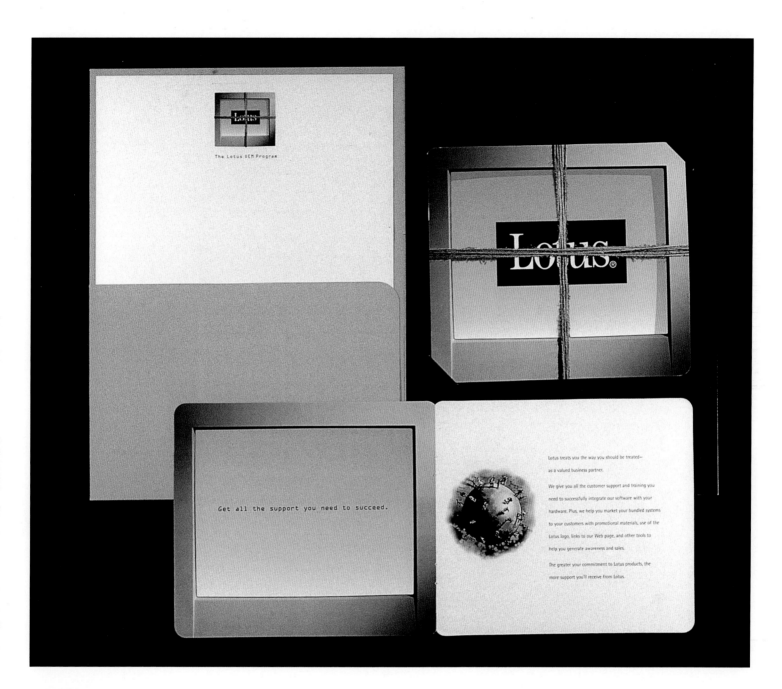

**Design Firm:**
Cipriani Kremer Design
Boston, MA
**Art Director/Designer:**
René Payne
**Copywriter:**
Brian Flood
**Photographer:**
John Shotwell

When the restaurant guide-book publisher Taste of Phoenix changed its name to Culinary Arts & Entertainment and expanded its services to producing food-related events, a new graphic identity was required that incorporated its new initials. In devising a solution, After Hours Creative emulated a generic neon sign spelling out "cafe," with the *F* burnt-out. The solution was not simple to achieve. First, a three-foot-tall neon sign was fabricated and photographed in black-and-white and color. The images were then scanned into the computer and manipulated independently. The effect of glowing neon was created using Adobe Photoshop and working with only magenta and black; airbrushing was used to add and subtract highlights. During printing, the maximum amount of PMS red was employed in the offset lithography process to achieve the effect of neon. This required "a staggering number of matchprints," according to Russ Haan, owner and creative director of After Hours Creative. The $3000 budget did not cover the actual costs of design and production, but After Hours Creative still considers the project "worth the trouble. The client and their customers love it," reports Haan. "And the sign is now part of their lobby."

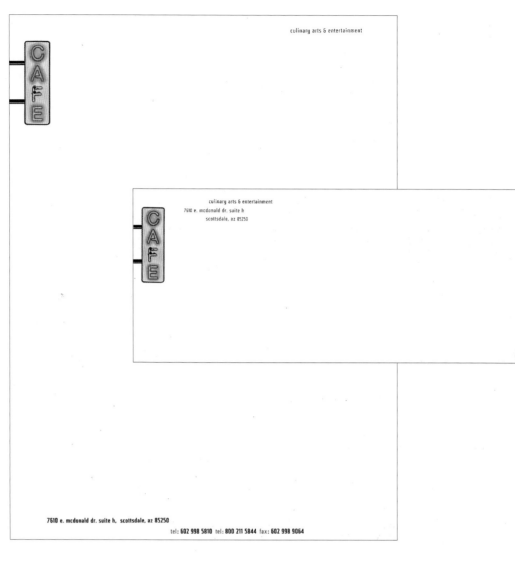

culinary arts & entertainment

culinary arts & entertainment
7610 e. mcdonald dr. suite h
scottsdale, az 85250

7610 e. mcdonald dr. suite h, scottsdale, az 85250

tel: 602 998 5810  tel: 800 211 5844  fax: 602 998 9064

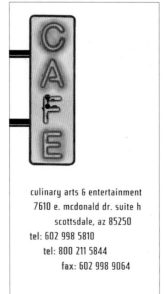

culinary arts & entertainment
7610 e. mcdonald dr. suite h
scottsdale, az 85250
tel: 602 998 5810
tel: 800 211 5844
fax: 602 998 9064

**Design Firm:**
After Hours Creative
Phoenix, AZ
**Illustrator:**
Art Holeman

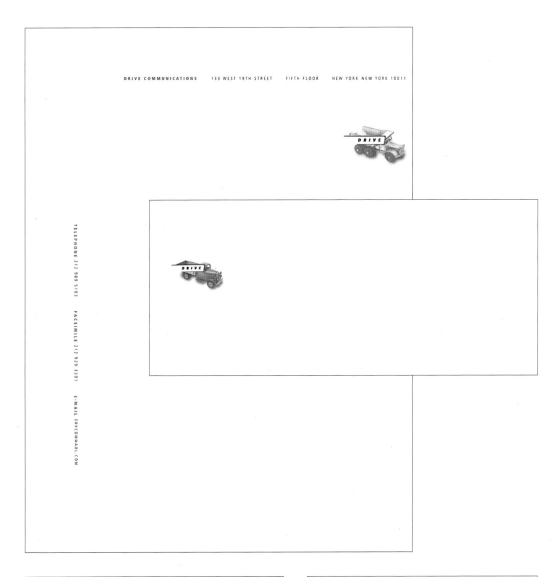

DRIVE COMMUNICATIONS    133 WEST 19TH STREET    FIFTH FLOOR    NEW YORK NEW YORK 10011

TELEPHONE 212 989 5103

FACSIMILE 212 929 3391

E-MAIL DRVECOM@AOL.COM

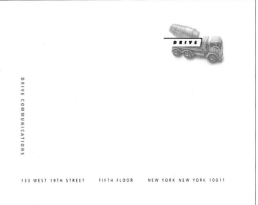

DRIVE COMMUNICATIONS

133 WEST 19TH STREET    FIFTH FLOOR    NEW YORK NEW YORK 10011

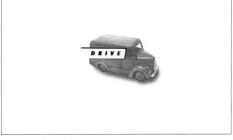

When Michael Graziolo named his graphic communications and design company Drive, he wanted to convey "momentum, self-will, impetus," while avoiding associations with automotive companies. For Drive's new identity, Michael Watson photographed antique toy trucks. "The vehicles illustrate the concept of motivation and motion," Graziolo says. The cars bought for the shoot now serve as company mascots. The truck images appearing on the letterhead, envelope, business card, and mailing label were printed in 2-color lithography with four different combinations of black and a metallic halftone. The images were scanned at the highest resolution and then retouched in Adobe Photoshop. Contrast and highlights were exaggerated to accommodate dot gain on the uncoated papers. The placement of the company's name, set in Frutiger Condensed Italic, overlays the photo and with a sense of forward movement, makes Graziolo's graphic message clear. The concept was so well received that Graziolo employed it in a subsequent paper promotion.

**Design Firm:**
Drive Communications
New York, NY
**Art Director/Designer:**
Michael Graziolo
**Photographer:**
Michael Watson

Jespersen, Gustafson, Hannan, Choe is a new communications agency specializing in building relationships between pharmaceutical corporations and the medical community. The four partners believe that the most important thing about the company is its people. Since they focus on fostering relationships, the design solution for the initial stationery program was, in designer Sharon Occhipinti's view, simple: Show the people instead of the names. All elements of the stationery package feature portraits of the principals printed as duotones in black and PMS 423. For the letterhead on Mohawk Option Inkwell and notepaper, the casually posed full-length shots by Roy Gumpel are featured at the top, punctuated by bold commas and a period. Each partner's business card shows his or her photo with the individual's and company name. The sunny gold reverse gives all the business information.

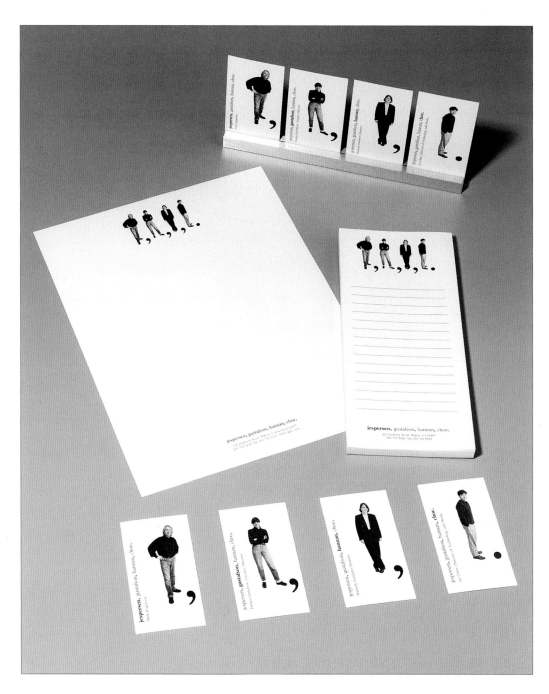

**Design Firm:**
JOE ADVERTISING
Wilton, CT
**Art Director/Designer:**
Sharon Occhipinti
**Photographer:**
Roy Gumpel
**Printer:**
Standard Printing
**Card Stands:**
Ernie Kinkel, Astra Tool

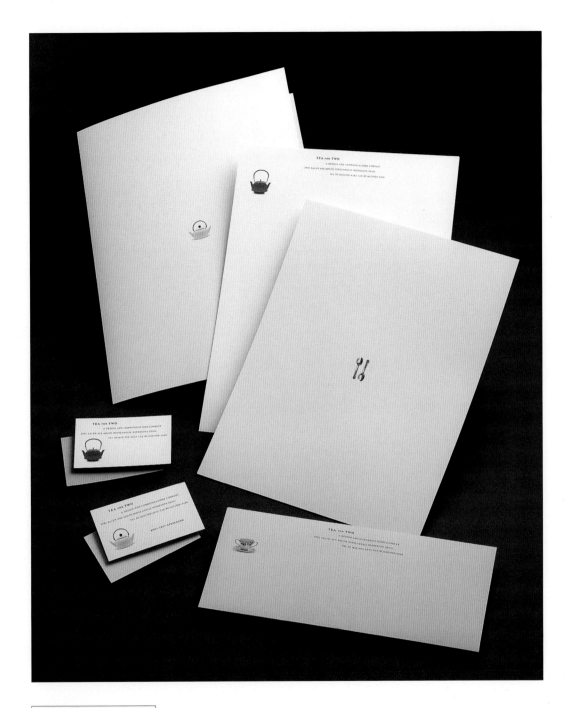

When the strategic communications and design consultancy Tea for Two moved from moonlighting to becoming a full-time business, it needed a more corporate and sophisticated identity. It also wanted a touch of whimsy. Haley Johnson provided a photographic logo of teakettles with dual spouts. Stock and commissioned photography of various tea-related objects (kettles, cups, and spoons) were manipulated in Adobe Photoshop and printed offset. One engraving die was used for the address information, and by strategic placement, all elements could be printed on one press sheet. All elements of the stationery system have multiple uses depending on the stock. The letterhead design on text-weight stock for stationery is used for folders in cover weight. Notecard and mailing label designs do double duty for business cards that feature various crops, stocks, and weights.

**TEA FOR TWO**

**Design Firm:**
Haley Johnson Design Co.
Minneapolis, MN
**Art Directors:**
Haley Johnson,
Richard Boynton
**Illustrator:**
Richard Boynton
**Photographer:**
David Sherman
**Design Director:**
Andy Levy-Stevenson

## SKOLOS/WEDELL

When the graphic design and photography studio Skolos/Wedell decided to redesign the company stationery, they wanted to use it "as a vehicle for showing our studio's capabilities, especially our interest in fusing two-dimensional and three-dimensional elements using photography and typography," explains Nancy Skolos. To create a jazzy, Constructivist-looking image, thin Mylar sheets were overlaid with a dot pattern created in Adobe Illustrator and then output on vinyl sheets by a signmaker. The cast shadows were then photographed by Thomas Wedell. This created a dimensional effect without resorting to the embossing or die-cutting that Skolos/Wedell has used in the past. To have embossed this design would have brought the printing costs up to $9000. By employing photography, it was possible to print 1500 letterheads, envelopes, business cards, and labels for $1900 and still achieve a dimensional effect. While there have been some comments about legibility, Skolos shrugs them off, saying, "If you have to experiment, it might as well be on yourself."

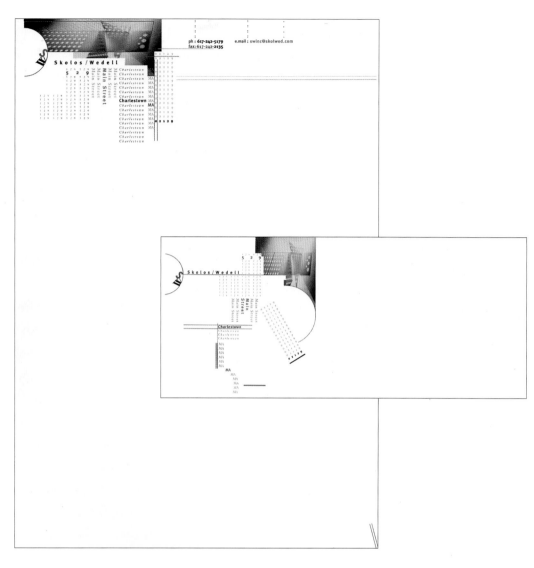

**Design Firm:**
Skolos/Wedell
Charlestown, MA
**Art Director/Designer:**
Nancy Skolos
**Photographer:**
Thomas Wedell

# HUMOR

While designing an effective and distinctive letterhead and business card package
is no laughing matter, some of the examples included in the '96-'97 Regional Design
Annuals prove that humor can help. A design that provokes a giggle can be memo-
rable, even for those of us who can't remember a punchline.

For copywriter Lisa Katz, writing is serious business. She needed a business card
that would set her apart from other pens for hire. Graphic designer Guillermo
Salazar came up with a clip art cartoon showing a suburban mom serving up a hot
meal to her hungry family. Salazar replaced the steaming dish with a portfolio, and
Katz contributed the tongue-in-cheek text: "But, we had copy yesterday."

The use of words distinguishes Studio A's design for The Dog School of Leesburg.
While a silhouetted canine does play an important role, standard obedience orders
are also integral to the design. Who wouldn't smile getting a communiqué on a let-
terhead with "speak" written on the bottom? And who could resist flipping a business
card with the legend "roll over?" Of course, the capper may be "stay" emblazoned on
the rear of The Dog School's van.

For illustrator Coco Dowley, who licenses the use of her whimsical characters,
frolicking puppies convey her message nonverbally. Simply printed in black on a
speckled gray stock, each sheet is personalized by Dowley who hand colors the col-
lars and balls the frisky pups pursue. The low-cost solution offers high returns.

The same could be said about Gloria Lau's witty design for the Swiss Emporium
D.J.'s, a couple of disk jockeys who go by the names of Monteray Mark and Big
Gouda. Whatever the rationale behind the name of the company, the cheese allusion
was impossible to avoid. A mouse spins a wheel of brie on the turntable, and the
letterhead and business cards are riddled with holes, hand-done by punch, not die-
cut.

For anyone who has suffered through a bad haircut, trying a new hairdresser can
be an awful experience. When the Design Guys created Sheryl Sikora's business,
appointment reminder, and referral cards, they worried that their humorous approach
might not be appreciated. The package was memorable—an acid green and cream card in
a zip-lock bag with a lock of red hair. The handsaw and the tagline "quality craft-
manship" could be considered a bit much, but even Sikora's most conservative cus-
tomers have found the cards "a hoot."

As a "humorous illustrator," Ann Reinertsen Farrell's stationery had to be funny.
Because her initials spell out "arf," a dog-related image proved irresistible for
designer David Tran. Farrell's simple line drawing of a pup straining at his leash
and sniffing the hand-drawn initials is a guaranteed laugh.

The Hive Design Studio owners Amy Bednarek and Laurie Okamura present their com-
pany as a buzzing center of creativity. The yellow-and-black typographic treatment
of the name says "hive" in more ways than one. A line of type with the address and
phone information meanders off lazily, punctuated by a whimsical, stylized bee. For
the number 10 envelopes, a two-color rendering of a more realistic bee still pro-
vokes a smile when recipients turn to read the address on the back flap.

For The Finish Line, Ltd., Witt/Rylander Advertising lifted a 19th-century
engraved image of a jockey and plopped him on a video cassette to show that the
post-production house is a winner in the race to complete video assignments. It
definitely is a witty and wry solution.

Creating a successful stationery system may not be a joke, but some of the best
do leave you laughing.

# THE DOG SCHOOL OF LEESBURG

The Dog School of Leesburg is exactly what its name implies. But in addition to dog training, The Dog School does grooming and sells pet supplies. A design goal was to differentiate the school from other animal-related services such as veterinarians, pet supply stores, and humane societies. The designers rejected myriad concepts including fire hydrants, dogs with mortar boards or diplomas, dogs ringing school bells, or wearing glasses, smoking pipes, and reading Homer. Finally, the designers settled on a primarily typographic approach employing standard commands appropriate to each application. "Fetch" is set in Franklin Gothic Bold on envelopes and mailing labels. For the letterhead, the command is "speak." On the front of the two-sided business card is the company name and the command to "roll over" to the back to find the contact information. The concept was extended to refrigerator magnets, mugs, T-shirts and sweatshirts, coffee bags, and even the school's van. Emblazoned across the rear is "stay!" One of the challenges facing designer Antonio Alcalá was to create a "friendly" graphics program for this new company. "Humor helped," he says.

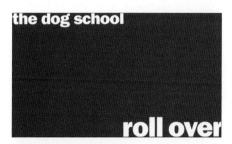

**roll over**

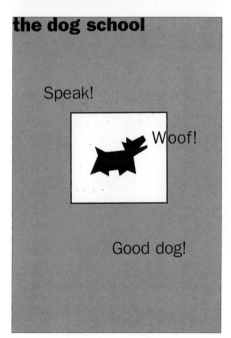

the dog school

Speak!

Woof!

Good dog!

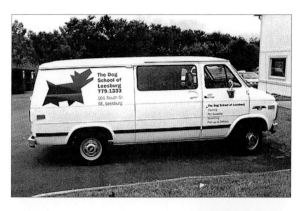

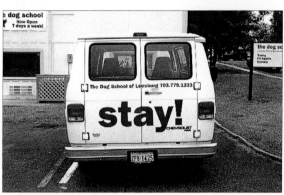

the dog school

The Dog School of Leesburg
101 South Street, SE Leesburg VA 22075

**fetch**

**Design Firm:**
Studio A
Alexandria, VA
**Art Director/Designer:**
Antonio Alcalá
**Illustrator:**
John Jackson
**Production:**
Caroline Woods,
Robin Patton

To launch his own business specializing in direct-response marketing, copywriter and designer Martin Alpert faced a tough challenge. "I knew that everything I sent out had to showcase what I was about," he says. "To achieve results, I had to show that my stuff works." The concept for his amusing and effective stationery program started with the words "Gorilla marketing . . . it's what I do." Then Alpert came up with the appropriate image. Having seen a quick "thank-you" sketch at a local graphics/copy shop, he called illustrator Mel Casson who, in one take, sketched Alpert's endearing gorilla. The bananas that dangle tantalizingly at the end of a fishing line on the envelope and letterhead are Alpert's own work, done the "old-fashioned way—by hand." He used black and yellow markers and then adjusted the sketch in Adobe Photoshop. Although the budget for production was tight, Alpert chose an expensive paper, Strathmore Elements, for its silky feel and richness. It complements rather than competes with the words. The package of multi-purpose elements has been successful. When Alpert makes his follow-up calls after sending out a mailing, he circumvents the secretary by saying, "Tell them it's the Gorilla."

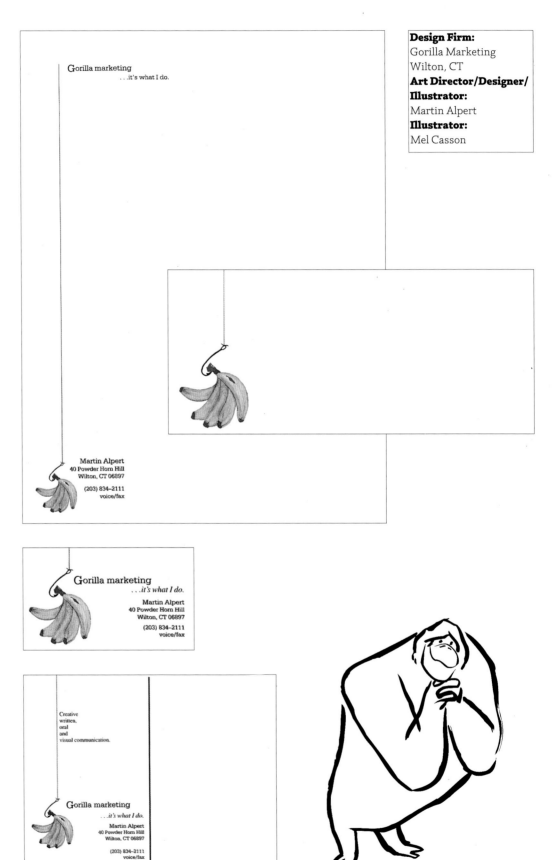

**Design Firm:**
Gorilla Marketing
Wilton, CT
**Art Director/Designer/Illustrator:**
Martin Alpert
**Illustrator:**
Mel Casson

**Designer/Illustrator:**
Gloria S. Lau
Jersey City, NJ

"We have the cheese to please" is the slogan of two New Jersey disk jockeys who go by the name of Swiss Emporium D.J.'s. Individually, they are known as Monteray Mark, "the macho nacho," and Big Gouda, "the fondue king." In keeping with their "light-hearted and tongue-in-cheek" approach, designer/illustrator Gloria S. Lau punctuated their business cards and invoice form with Swiss cheese holes. To avoid the expense of die-cutting, Lau preprinted the myriad holes and then used a hole punch to cut them out. All the text was contained in circles, like the bubbles of a cartoon or, of course, the holes in Swiss cheese. Lau used QuarkXPress for the layout and Photoshop to touch up the line drawing of a soigné mouse with a wheel of cheese on a record turntable. The design was offset with only one color, black, on a buff-colored, flecked paper.

When copywriter Lisa Katz needed a business card, she rejected all feline puns on her name as too predictable and rejected a straight typographic solution as "too normal." With a great sense of humor and a love of words, Katz hoped to communicate her wit and reinforce what she does: write. A cartoon found in a clip art book became the basis of the design with a beaming housewife serving up "fresh" copy to a hungry family. After finding the drawing, designer Guillermo Salazar scanned the image and converted it in Streamline 3.0, making the necessary alterations in Adobe Illustrator 6.0. A steaming portfolio was substituted for the original dish, and some of the expressions on the family were changed. Katz loved the concept and devised the text: The young son complains "But, we had copy yesterday."

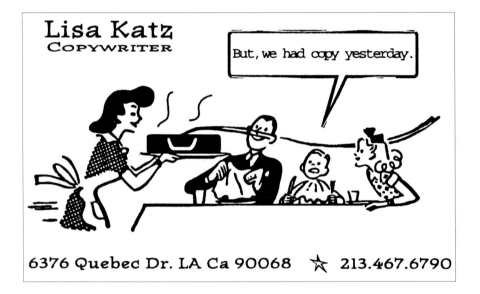

**Art Director/Designer:**
Guillermo Salazar
Los Angeles, CA

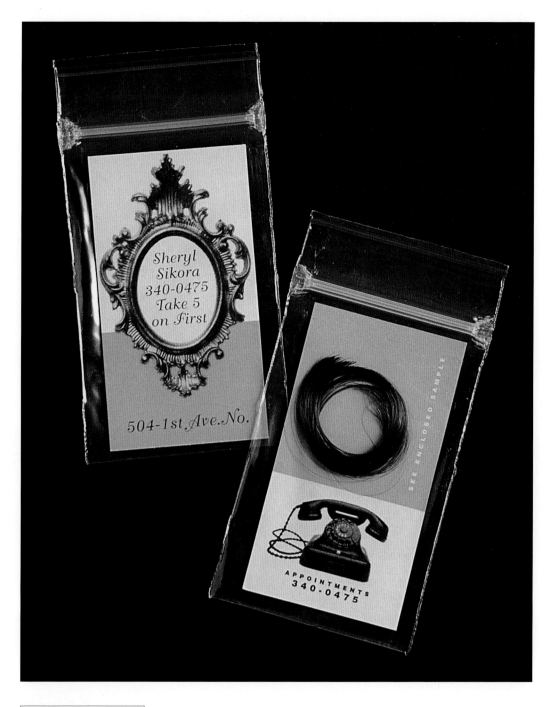

The audience for hairstylist Sheryl Sikora's business cards were "people with hair and a couple of bucks in their pocket," according to designer Steven Sikora. The challenge was to create a striking and humorous card that would replace the standard-issue business cards of Take 5 on First Salon and serve as self-promotion pieces. At first, the designer decided to print the contact information directly on "free samples," zip lock bags containing clippings from a bright red wig. Discarding this idea, he came up with a small-sized acid green business card, which contrasts with the red curl. A photograph of an ornate mirror from a royalty-free stock photography CD-ROM frames the address on the card. The reverse is devoted to various messages: One features a vintage telephone and the number to call for an appointment, a second offers a $5 refund for a referral, and the final touts "Quality Craftsmanship" with a handsaw. Designer Sikora admits that he had his doubts about customer reactions, but found that "even the most conservative clients thought the cards were a hoot."

**SHERYL SIKORA**

**Design Firm:**
Design Guys
Minneapolis, MN
**Art Director/Designer:**
Steven Sikora

For their first stationery project, "queen bees" Amy Bednarek and Laurie Okamura of the Hive Design Studio wanted to play on their company's name to project "an efficient and productive environment" that didn't lack humor. The resulting design combines a photograph of a honeycomb manipulated in Photoshop with images of bees, hives, and other elements created in Adobe Illustrator. The Hive's address and phone numbers are set in all-caps in a single line that meanders like a bee in flight. Yellow and black naturally comprise the color combination. One technical challenge was to select a paper for the letter-head that would not be too heavy, but opaque enough to allow for printing on both sides since the reverse was the honeycomb motif offset-printed in yellow. The printer chose Crane's Crest after testing a variety of papers. The Hive's wit and graphic ingenuity are apparent in every element of the design from the bumble-bee striped target of the company's name to the action lines emanating from the "stinger" of the *V*. How can clients resist the request to "give us a buzz?"

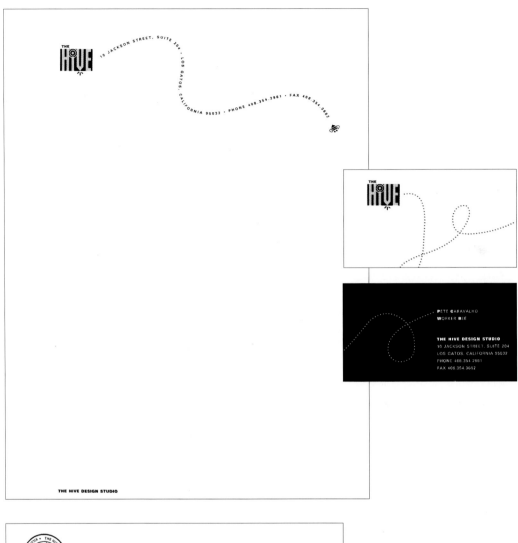

**Design Firm:**
The Hive Design Studio
Los Gatos, CA
**Art Directors/**
**Designers:**
Amy Bednarek,
Laurie Okamura
**Assistant Designer:**
Pete Caravalho

For cartoonist and humor illustrator Ann Reinertsen Farrell, it was her initials that sparked the inspiration for her first letterhead: A.R.F. The dog reference was irresistible, although it took a couple of tries to come up with a workable concept. Farrell explains that although the original idea "was to use the 'leash' as lines, as in lined paper, it didn't work. A dog barking at the mailman concept was also tossed." The final solution shows an eager pup straining at his leash and sniffing at the roughly drawn initials, an enhanced version of Farrell's own writing. The amusing illustration runs across the top of the stationery and is balanced by a single line of type with contact information. The project was simply executed: QuarkXPress and laser printing. In lieu of a design fee, illustrator/client Farrell and designer David Tran traded services. The fee was "transporting a fish tank 60 blocks on a Saturday morning," Farrell says. "I have a car. David needed a fish tank moved. We bartered. David was happy. I was happy. And we saved some homeless fish on the Upper East Side of Manhattan from certain death."

**Designer:**
David Tran
New York, NY
**Illustrator:**
Ann Reinertsen Farrell

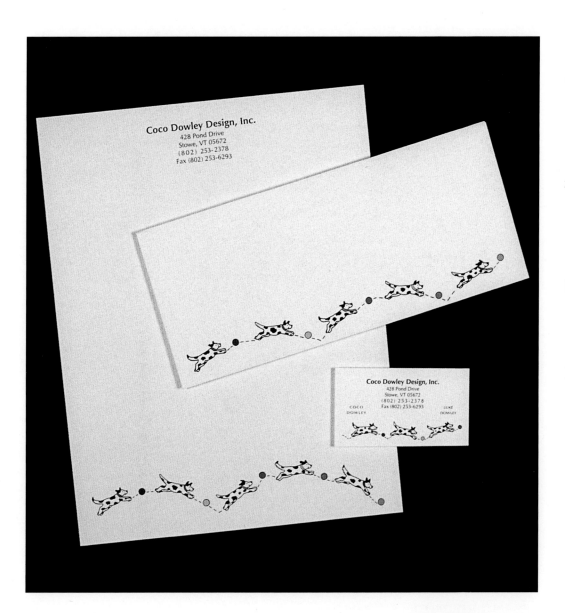

Coco Dowley, a Stowe, Vermont-based illustrator, creates whimsical characters for licensed products. She decided she needed a "fresh new look" for her letterhead and business cards, and opted for the motif of a running dog. Although color plays a key role in the charming, hand-drawn illustration of a string of spotted puppies chasing a bouncing ball, the job was printed in black only. Dowley colors all of the dogs' collars and balls by hand, personalizing each piece without being concerned about the cost. Dowley can change the hues at her whim or to suit her client's tastes. The effective and memorable design was produced for only $300 and has been a real hit with Dowley's clients.

# COCO DOWLEY DESIGN, INC.

**Design Firm:**
Coco Dowley Design, Inc.
Stowe, VT
**Art Director/Designer/**
**Illustrator:**
Coco Dowley

# THE FINISH LINE, LTD.

For the initial stationery system of The Finish Line, Ltd., a new company doing visual effects and post-production for television commercials, Witt/Rylander Advertising took a successful approach. The Finish Line takes its name from post-production work, often called "finishing." Although the firm employs state-of-the-art technology, the letter-head design emphasizes the human touch. The logo depicts a jockey riding home on a video cassette, an effect both playful and serious since completing a commercial within a tight time frame is "quite literally a race to the finish line," says copywriter Michael Rylander. For the stationery, illustrator Antar Dayal created an image that looks like a 19th-century, hand-colored engraving. The sketch was scanned and imported in Adobe Photoshop. Eighteen different color combinations were produced to arrive at the final logo. The stationery system was printed letterpress with four PMS colors. This rarely used technology adds to the antiquarian feel of the design, which never loses its humorous edge.

**Design Firm:**
Witt/RylanderAdvertising
San Francisco, CA
**Copywriters:**
Michael Rylander,
Tom Witt
**Illustrator:**
Antar Dayal

**Design Firm:**
W. Kimbell Design Lab
Santa Barbara, CA
**Art Director:**
Wayne Kimbell
**Designer:**
Jeanne Spencer

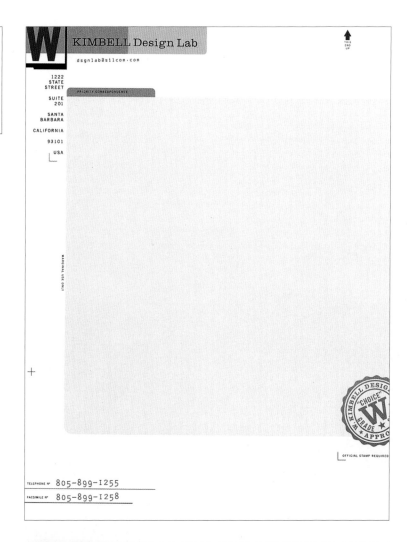

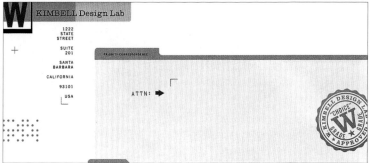

A quick glance at the stationery program of W. Kimbell Design Lab in Santa Barbara might lead you to think you were dealing with a science lab. Everything about the stationery reinforces that feeling, right down to the business cards. With their radius die-cut corners and hand-held Polaroid photos, they have been mistaken for official ID cards. The firm, which does graphic design for print, video, and Internet, is "more technologically savvy than most designers," explains design principal Wayne Kimbell, "so we chose to expand on the 'lab' theme." Among other details in the elaborate program, the logo was designed as an official-looking stamp, printed in purple off the edge of the paper, mimicking the slap-dash application of a rubber stamp. The note on the letterhead says "official stamp required" to make sure "our correspondence is taken seriously," says Kimbell.

W. KIMBELL DESIGN LAB

## STRATEGIC CHANGE MANAGEMENT

The new consulting firm Strategic Change Management helps large organizations manage internal change. Its services range from encouraging employee decision-making to assisting corporations and their employees cope with downsizing. Strategic Change asked After Hours Creative to provide an initial stationery system that communicated "change could be good, change could be fun," and that projected "a positive personality." As the firm's name was "a bit on the dry side," After Hours considered a number of symbols to enliven the letterhead, such as cocoons, yin-yangs, road signs, animals that metamorphose, and car hops' change machines. They settled on a simple but powerful idea: a quick-changing superhero. The image is a phone booth and the powerful legs of the "Man of Steel," flying off the edge of the business card, letterhead, and envelope. "The card alone stops potential customers in their tracks," says After Hours's Russ Haan. "It gives the company a very upbeat personality, yet still conveys smart, clever thinking—the kind of out-of-the-box thinking his potential clients want and need to successfully transform their enterprises."

**Design Firm:**
After Hours Creative
Phoenix, AZ

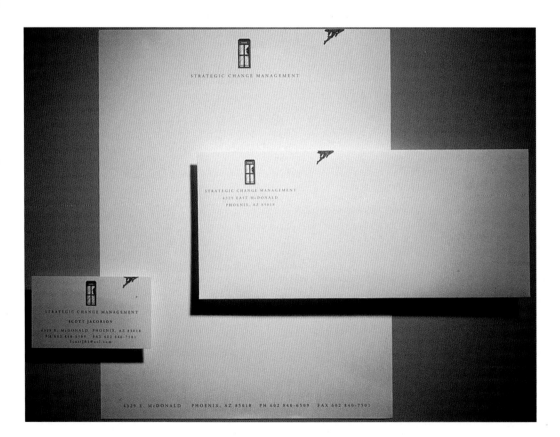

# COLOR

While white, ivory, and cream are still the primary colors for letterheads and business cards, many graphic designers are putting their color theory classes to use by expanding their color horizons. Whether it's a relatively simple single spot color, or 4-color printing with a complete palette, color can be the key element in a stationery program.

Lambert Design's new stationery system employs color conspicuously. The envelope opens to reveal a red interior as well as the bright yellow of the reverse of the letterhead. A white envelope and front of the letterhead balance the brilliance.

The color inherent in the client's name provided the design direction when Red Gold, the tomato grower and processor, asked Young & Laramore for a letterhead for casual correspondence. On a sheet of solid tomato red, a 2-color green stem is printed; the contact information is in gold. The act of unfolding this letterhead offers an amusing surprise.

Color is nearly as assertive in Kiku Obata & Company's stationery package. Red naturally goes with the firm's initials, and the hue is reserved for the full name on the letterhead and envelopes. For collateral pieces in the program, the initials within a larger circle appear as white on red.

With a name like Wood, color can add an unexpected touch. For her logo, Deb Wood of Woodworks depicts a black line drawing of a tree with a few carefully placed green leaves. However, the bright orange bark texture of the reverse of the letterhead and business card underline her creative abilities.

Color does not have to always be aggressive. Woodward Design's whimsical varsity letter logo for Landmark College's tenth birthday has all the delicacy of Leslie Woodward's original watercolor and pencil sketch. The pastel palette works perfectly for the celebratory symbol.

Color is also subdued in Kilmer & Kilmer's stationery package. The initial _K_ of the logo is made up of three simple shapes, each one rendered in a distinctive hue of the American Southwest—dusky rose, taupe, turquoise. Those same shades appear as design elements in the various components.

The role that color plays in Phoenix Creative's stationery design for the architect Carlos Mindreau is even subtler. By changing the color block behind his name from brick red on the letterhead to purple on the envelope to aquamarine on the business card, Phoenix has created a tantalizing visual shift, in keeping with the dynamism of Mindreau's own designs.

Although quiet, color is also essential in David Riley Associates' design for Photobank. While wishing to retain a reference to its previous identity, Photobank nonetheless wanted an updated look. Screening the image of slide mounts in pale green on the fronts and in photo-chemical purple on the backs enabled the various components of the stationery package to be read subliminally.

Color was used by Lynda Decker Design to differentiate the various activities of On Line Associates, a company providing Internet services. Each division shares the same graphic treatment, but, printed in tints of yellow, purple, and red, their independence is also indicated.

Color can also help communicate the personality of company or person. The deep hues of Simon & Cirulis's Russian Constructivist-inspired letterhead design for C. J. Design paired with the explosive yellow of the business card suggest the energy of the new company specializing in design and production services. The design firm The Salamander's equally rich but muted colors for The Underground Water People tell a very different story about the natural spring water bottler.

# KIKU OBATA & COMPANY

Proving that graphic designers make the most demanding clients, Kiku Obata & Company developed five different identity systems for itself before finally settling on one. The St. Louis firm focused its attention on three separate disciplines—print, retail, and environmental design—but eliminated a solution with three individual icons. Another concept featured three human stick figures with icons for heads. In the end, a typographically bold logo was chosen that is formed by the firm's initials casting a shadow. It illustrates the 3D design capabilities of Kiku Obata while establishing a strong 2D presence. The shadow was done in Adobe Photoshop by importing the logo from Macromedia Free-Hand. With the image skewed and the edges blurred, the logo appears to be casting a shadow. In addition to all of the standard elements in a stationery system, Kiku Obata designed disk labels with the brilliant red-and-white logo, hoping that service bureaus would be more likely to return zip and SyQuest disks.

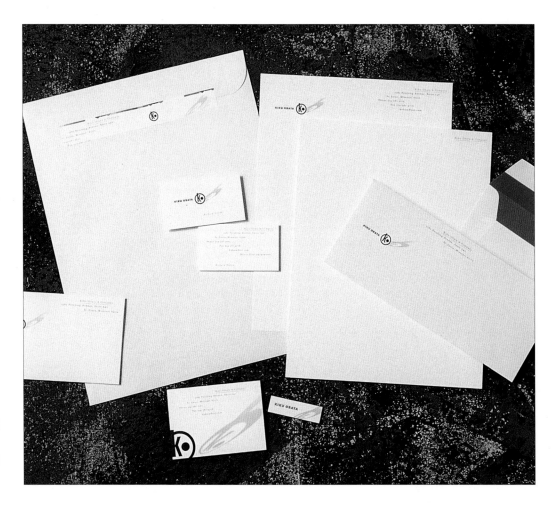

**Design Firm:**
Kiku Obata & Company
St. Louis, MO
**Art Director:**
Kiku Obata
**Designer:**
Rich Nelson
**Printer:**
Reprox of St. Louis

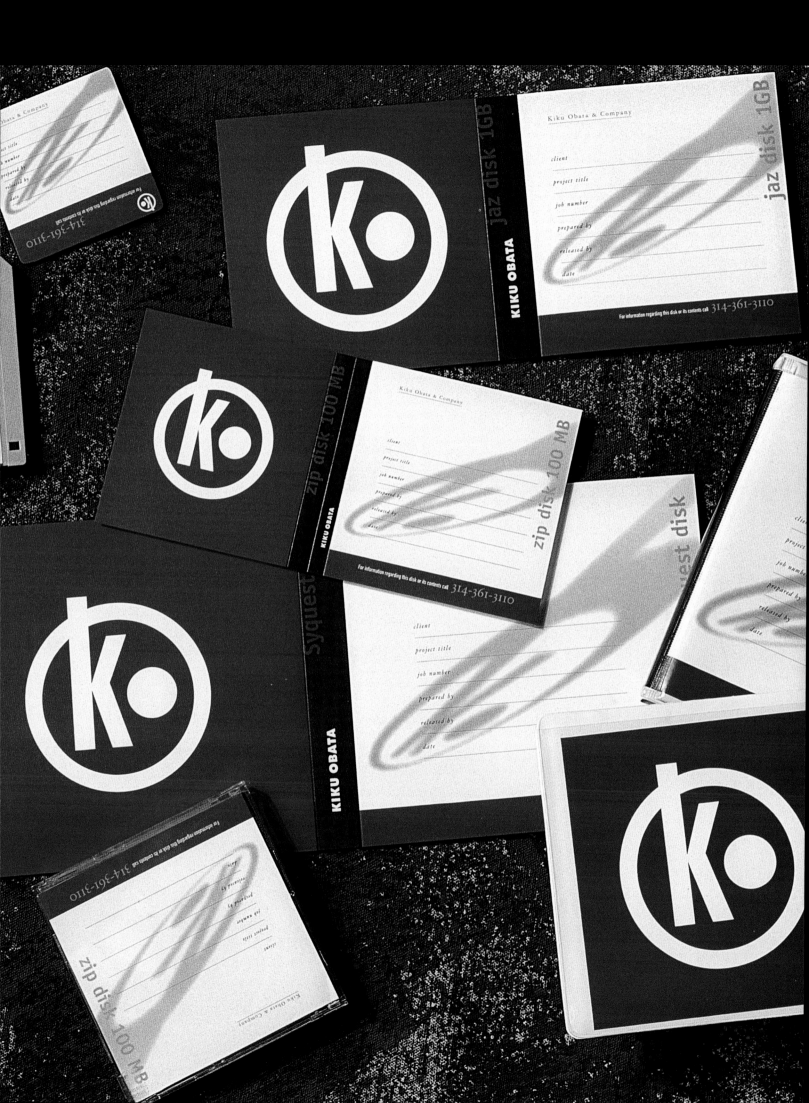

# BRAD GUICE PHOTOGRAPHY

Commercial photographer Brad Guice did not have a coordinated stationery system when he asked Cheryl Guice Advertising Design to create a unified and eye-catching look. Although a more conservative approach using earth tones and recycled papers was considered, the designers convinced the photographer that a more self-expressive approach was needed. The final design relies on neon brights, a direction suggested by Guice's previous promotions which employed Day-Glo envelopes. Adobe Photoshop was able to extract a sunflower image from one of Guice's own photographs, converting it to a gray-scale image which was blurred for use on the letterhead and on one of the two business cards. The design couldn't be comped because of the use of fluorescent inks. Relates designer Melissa Reischman, "We took a gamble and had the luxury of working closely with the pressman." Most of the fluorescent inks required a double hit on press.

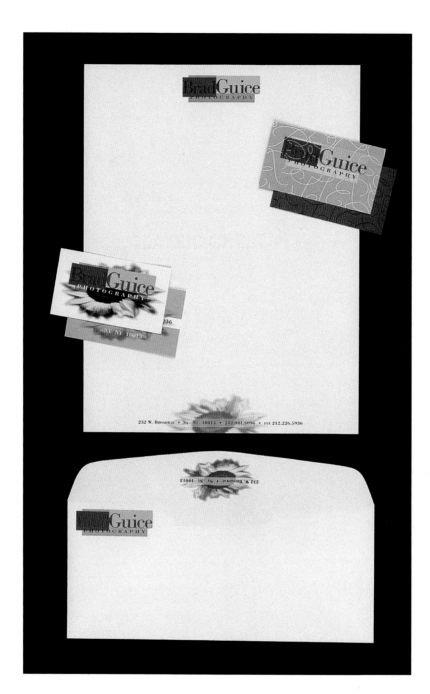

**Design Firm:**
Cheryl Guice Advertising
Design Los Angeles, CA
**Art Directors:**
Cheryl Guice,
Melissa Reischman
**Designer:**
Melissa Reischman
**Photographer:**
Brad Guice

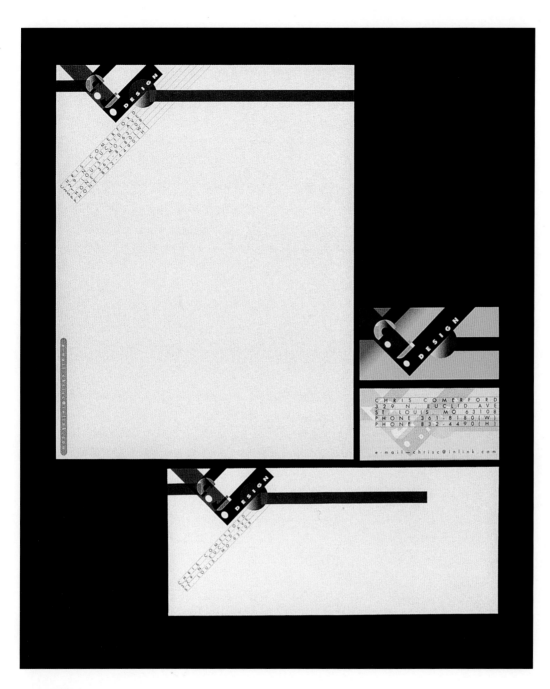

C. J. Design specializes in freelance design and production services. They asked Simon & Cirulis to devise a corporate identity package to target the creative marketplace. The designer initially considered working with woodcut illustrations, but felt they didn't accurately reflect the focus of C. J. Design. European posters of the 1930s and '40s eventually provided the impetus for the design solution. The bold shapes of the logo are reinforced by the almost aggressive palette: revolutionary red, imperial purple, pitch black punctuated with white on the letterhead. The business card is an explosive blast of yellow on the front and shadow on the reverse. The strong geometry and deliberately uneasy placement of the elements evoke the '30s-'40s without looking derivative.

## C.J. DESIGN

**Design Firm:**
Simon & Cirulis, Inc.
St. Louis, MO
**Art Director/Designer:**
Maris Cirulis

When The Underground Water People came to Grégoire Vion, they had some ideas about the logo for their new company that was marketing spring water from a deep well in Ketchum, Idaho. They were looking for a sense of magic, abundance, fertility, and the feminine force. (Their sketches included streams of water issuing from Mother Goddess figures.) Vion's first task was to talk the client out of using "naked bodies in contact with drinking water." He suggested a "more restrained approach with fewer visual elements to enhance legibility and be meaningful to a broader public." Working with Adobe Photoshop, Vion created a number of water images, and according to the designer, the "logo is a synthesis of this image bank." The bold illustration with spirals representing the spring-fed well and a crescent moon alluding to the goddess satisfies the client's brief in a simple yet powerful manner. The colors evoke the purity of the water and the earthiness of the source. The logo works well at any scale, including on labels with the water listed as an ingredient.

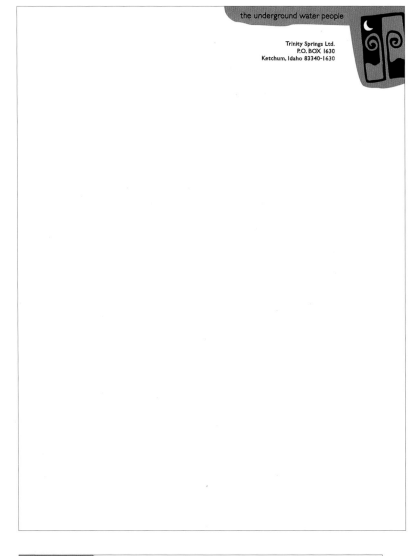

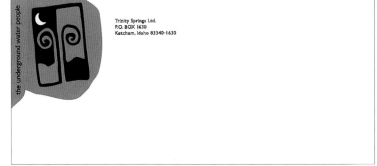

water from the underground

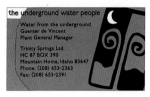

the underground water people

Water from the underground
Guenter de Vincent
Plant General Manager

Trinity Springs Ltd.
HC 87 BOX 390
Mountain Home, Idaho 83647
Phone: (208) 653-2363
Fax: (208) 653-2391

© The Salamander 1996

spring
Water rising, new growth,
new look

corporate identity research for the underground water people, part 1

**Design Firm:**
The Salamander
San Francisco, CA
**Art Director/Designer/**
**Illustrator:**
Grégoire Vion

On Line Associates includes On Line Clubnet and On Line Net Resources. On Line Clubnet focuses on providing Internet access services to consumers. On Line Net Resources addresses the business community, offering Web site design, programming, and database integration. The design challenge for Lynda Decker Design was to showcase the facets of Online Associates in an integrated logo. The identity needed to have impact on the Web and be flexible enough to grow with the company. Designers Lynn Decker and Bryon Weeks succeeded with their very first solution, which not only comes across well on the Web, but can also be animated. Decker used Adobe Illustrator to create the image of a central and dimensional sphere with lines made of progressively smaller spheres radiating outward. These lines also connect the interrelated but separate divisions of On Line. Each illustration is done in a tint of one of the primary colors. This communicates their independence while also relating them.

**Design Firm:**
Lynda Decker Design
New York, NY
**Art Directors/**
**Designers:**
Lynda Decker,
Bryon Weeks
**Illustrator:**
Lynda Decker

Realizing that his current stationery program did not communicate his individualistic personality, architect Carlos Mindreau challenged Phoenix Creative to create a new package. The stationery had "to reflect his style in a dynamic but quiet way on a modest design and printing budget," explains art director/designer Ed Mantels-Seeker. Phoenix Creative's solution utilizes composition and typography that suggest some of Mindreau's kinetic plan views and design motifs. Although not obvious at first glance, color offers a key to the success of this program. The design is printed in 2-color offset lithography on an unbleached, recycled paper stock. The second color comprises Mindreau's surname, the word "architecture," and city location which changes for each component. These elements appear in brick red on the letterhead, purple on the envelope, and aquamarine on the business card. Working with non-trapping colors and no bleeds or heavy coverage meant that the package could be printed at a quick, inexpensive printer.

**Design Firm:**
Phoenix Creative
St. Louis, MO
**Art Director/Designer:**
Ed Mantels-Seeker
**Production Artist:**
Brian de la Cruz

Although the stock photography agency Photobank wanted an updated identity system, it was reluctant to abandon images from its previous stationery. David Riley & Associates incorporated the screened slide mount motif as an almost subliminal image underneath the new logo: an abstract black square that reads as camera lens or box camera. Complementing the bold logo is a pleasing palette of subdued purple and green. Three colors, PMS 5645, PMS 5135, and black, were printed on 60# Porterra Text-Chalk for the letterhead and on 80# Proterra Cover-Chalk for the business and Rolodex cards. On the back of both the letterhead and business cards, the slide mount pattern was printed in a darker tint, PMS 5135 with 100 per cent on the margin surrounding the image. The client has had good response to the updated design from "what they call 'those who know good design as well as those who don't really have a clue.'" Riley is happy to "take that as a compliment, especially since the majority of their clientele are either graphic designers or hold creative positions of one form or another."

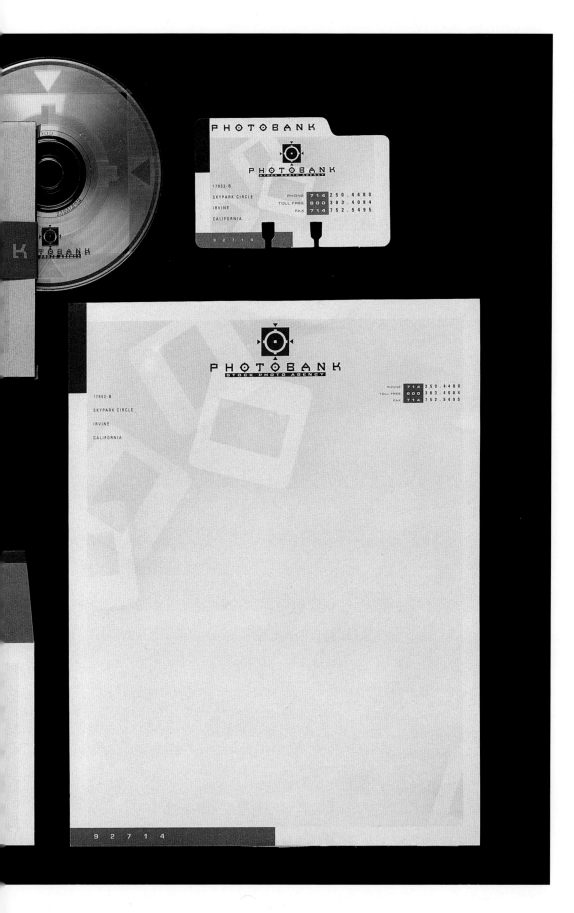

**Design Firm:**
David Riley & Associates
Corona del Mar, CA
**Art Director:**
David Riley
**Designer:**
Russell Heistuman

"Designing one's own stationery has to be the most difficult design challenge there is," says designer Randall Marshall of Kilmer & Kilmer. At the Albuquerque design and advertising firm, many different ideas and approaches were explored. "Ironically, the final design was initially eliminated as being tired and overused," confides Marshall. The new stationery exchanges a graphically bold design for one that is "a study in subtleties, graphically, typo-graphically, and in color," Marshall says. Looking at the dusky rose, the flecked taupe, the turquoise, one can easily see that Kilmer & Kilmer is based in the South-west. For the logo image, the three primary shapes were created on separate trans-parent layers using Adobe Photoshop. Then, each section was filled with a gradient and converted to the mezzotint using dissolve. The "eye chart" rendering of the phone number reiterated on the back of the business card was intended "to poke a little good-natured fun at those clients who have complained about the size of the type on our stationery," notes Marshall.

**Design Firm:**
Kilmer & Kilmer, Inc.
Albuquerque, NM
**Designers:**
Randall Marshall,
Richard Kilmer,
Brenda Kilmer

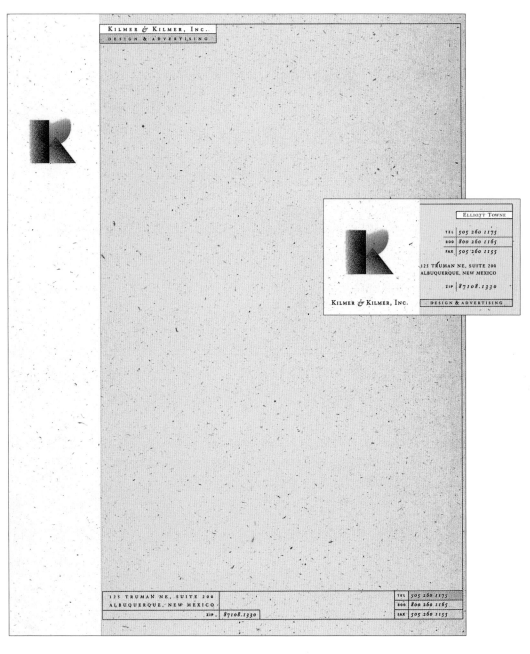

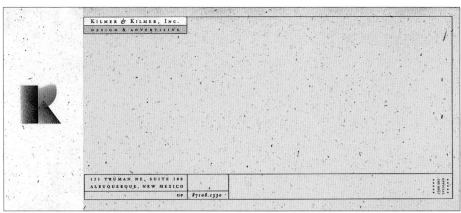

Landmark College

Tenth Anniversary

1 9 8 5 - 1 9 9 5

Rural Route 1

Box 1 0 0 0

Putney, Vermont

0 5 3 4 6

*Phone* 802 387 4767

*Fax* 802 387 4779

Landmark College in Putney, Vermont, recently celebrated its tenth anniversary. For a one-year promotion of special events, designer Leslie Woodward toyed with various birthday messages such as candles and ribbons, as well as the school's logo, a lighthouse. The college's lack of history or heritage indicated a less traditional approach. Eventually, Woodward settled on a playful take on the type reserved for varsity letters. She hand-painted artwork for the numeral 10 in watercolor and pencil in a delightfully exuberant, absolutely non-academic manner. Four-color printing was used to create this lighthearted logo, which was also silkscreened or etched onto giveaways for donors, speakers, and VIPS. For the stationery, the text was a QuarkXPress document with an FPO scan for the illustration. The clients "loved" the playful, colorful logo and "were sorry" to have to give it up at the end of the anniversary year, according to Woodward.

LANDMARK COLLEGE

Landmark College

RR 1, Box 1000

Putney, Vermont

0 5 3 4 6

Tenth Anniversary

**Design Firm:**
Woodward Design
Brattleboro, VT
**Art Director/Designer/**
**Illustrator:**
Leslie Woodward

When Deb Wood of Woodworks changed locations, she took the opportunity to change her stationery system. Specializing in graphic design, marketing communications, and advertising, she wanted her company to "stand out in the crowd." One carry-over from the previous letterhead was the tagline "Wood—a natural resource." For the new stationery, Wood aimed at something unexpected. For the front of the letterhead sheet, she sketched in FreeHand 3.1 a delightful line drawing that reads as a tree with a few strategically placed green leaves, but the reverse makes her design point. She scanned in a bark texture, which was offset printed in an assertive orange. The circular motif she had developed for the address information on the front is used for her motto: "a natural resource for your corporate communications needs." When the sheet is folded, the marketing message is the first thing the recipient sees. "I like the idea of taking advantage of this normally unused space," Wood says. Another unexpected touch was the square format of her business cards. "I like that it sticks out of a Rolodex file," Wood says. "Its unusual shape gets noticed."

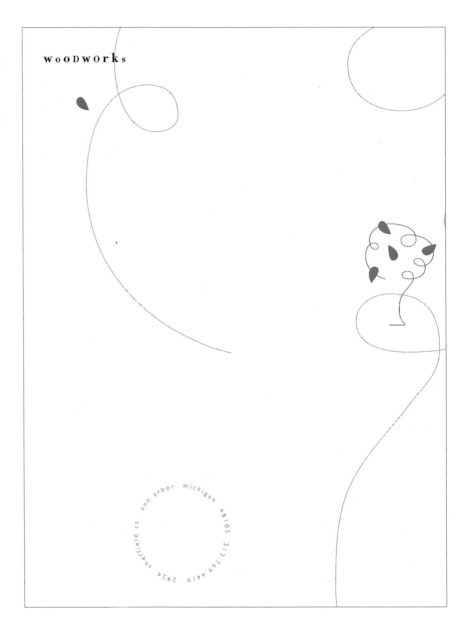

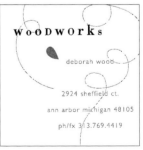

**Design Firm:**
Woodworks
Ann Arbor, MI
**Art Director/Designer/**
**Illustrator:**
Deb Wood

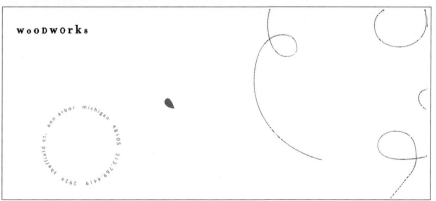

# RED GOLD

Red Gold, the Elwood, Indiana, company, grows and cans tomatoes—whole tomatoes, diced tomatoes, puréed tomatoes, tomato juice—and even makes ketchup. Young & Laramore, which has developed Red Gold's "Midwestern Tomatoes" brand, created this letterhead as a fun sheet to be substituted for regular stationery in casual correspondence. Its audience was intended to be "brokers, consumers, press, everybody," according to designer Chris Beatty. Using Adobe Illustrator, the designers created a stylized tomato stem. The 2-color green top was offset-printed on a tomato-red sheet, and the requisite address information was printed in gold. When the sheet is folded, it shows a crisp white reverse. When the recipient unfolds the letter, he or she gets a burst of color. As Beatty says, "This letterhead came kind of easy. They're tomato people; give them a tomato letterhead."

**Design Firm:**
Young & Laramore
Indianapolis, IN
**Art Director:**
Chris Beatty
**Creative Directors:**
David Young,
Jeff Laramore

How do you update a graphic identity that already turns design on its ear? Lambert Design's original stationery was oriented horizontally, and its business cards were long and lean. The answer: You throw a curve. Owner Christie Lambert created a new logo from her firm's initials by placing the letters inside an ellipse that recalls a detective's magnifying glass. The motif is repeated in a business card, die-cut in the shape of an oval, and along the right edge of the stationery. The logo wraps around the edge of the envelope and continues on the back. The ellipse was employed as the defining graphic element on a mailer sent to clients in the specialty foods industry. The mailer announced, "What's new? A new look, a new shape, a new, shorter name." The accordion-fold promotion included a new business card inserted into a panel with oval slits. Even the top of the detachable Rolodex card is curved. Varnished to prevent smudging, the red, yellow, and black of the offset-printed logo communicate the vibrancy of the company.

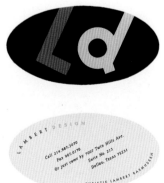

**Design Firm:**
Lambert Design
Dallas, TX
**Art Director**
Christie Lambert
**Designer:**
Joy Cathey Price

The new company Hot Link inspired some creative thinking at the design firm Sullivan Perkins. The business communications consultants were seeking to establish themselves as the link between clients and creative resources. One concept explored was a play on the company name, illustrating it as "hot link" sausage. Other ideas dealt with imagery to convey "linking" in a high-tech manner. What designer Rob Wilson came up with effectively describes the nature of the business: it communicates instantaneously. With the company name as the logo, a dotted line connects the *O* of "hot" with the dot of the *I* in "link." The complementary colors of orange and blue further this nexus. The vibrant PMS yellow on the back of the letterhead, on business cards, and on the interior of the envelope further reinforces the electric design message through color.

**Design Firm:**
Sullivan Perkins
Dallas, TX
**Art Director/Designer/Illustrator:**
Rob Wilson

# LITERATE DESIGN

Graphic designers have to deal with words on a daily basis, whether they are designing a book, a Web site, or a letterhead and business card package. Many stationery designs culled from the '96-'97 Regional Design Annuals get their impact from words. This approach can be termed "Literate Design." In some cases, designers created "Word Pictures," using images to illustrate the client's name or business activities. In others, the visual impact comes verbally with "Wordplay."

There are many ways words make a visual statement. For the pulmonary specialist Richard K. Oehlschlager, the design firm Schlagen! relied on a phonetic spelling of his name to aid potential patients or their referring physicians in pronunciation. MoJo Designs also turned to the dictionary to define "user interface design." Familiar conventions of verbal form helped these designers communicate their clients' messages.

While text might have seemed most appropriate in stationery packages designed for copywriters, freelance art director Michael Caguin also employs a verbal message. His almost generic-looking, black-and-white business card features the attractive sentiment: "An ego so small, it fits in your Rolodex."

For Jim Bowie, a Dallas-based commercial photographer, an image of his knife-wielding ancestor might have been a logical motif. Instead, the scrawled tagline "killer photography" became the focus for the stationery package designed by Right Angle.

Just as a word can be an inspiration for a design, a picture can spell out meaning simply and directly. Shelby Putnam Tupper named her business Shelby Designs & Illustrates. Her logo gives us a picture of a shell with a bee.

For the trucking firm Tires on Fire, Segura Inc. created a word picture that is quite literally a tire on fire. But it is also an elegant logo with the flames tamed into decorative elements.

Moving Design has conjured up an equally vital image for itself. The logo's energetic line-drawn figures rush around on the gridded surface of its updated stationery program.

Sometimes word pictures require some translation. Colleen Crowley of Crowley Communications used semaphore code to spell out her name. Though this is a straightforward and standardized way of communicating, people still ask her if the flag-holding figures really do stand for the letters of her name.

There were already verbal gymnastics going on with the spelling of the name of the Internet services provider Nvolve. San Francisco's Pentagram added a couple of red arrows to bracket the name and symbolize interactivity.

Graphic design is almost always about words and pictures. Sometimes they battle each other, but in these examples, a truce has been declared, leaving the client the winner.

For any letterhead or business card, words are essential to communicate the client's vital statistics. With "Wordplay," designers go beyond a skillful use of typography but stop short of illustration.

"Wordplay" is the ingenious incorporation of copy into the composition. The tagline "killer photography" in an appropriately demented, apparently hand-printed scrawl combines with blood splatters on commercial photographer Jim Bowie's letterhead designed by Right Angle in a comical mode.

Freelance art director Michael Caguin gives a modest assessment of his own ego: "An ego so small, it fits in your Rolodex." The generic look of his card backs up his claim. The card is regular size with black sans-serif type on white; only the cleverly worded text calls attention to itself.

Somewhat less subtle is Van Auken Margolis & Associates' exuberant "Eureka!" on its promotional business card package. The energetic rendering of the word encourages an enthusiastic response to illustration samples showcased in this unusual format.

The two sides of Brent Rogers' professional persona work together in Rolling Bones Letterpress' bi-directional design. Rogers is an artist and architect. One profession, set in larger type, gets top billing, while the other is overlaid in a smaller size. Those positions literally get flipped. In half of the print run, architect lands on top; in the other half, artist is ascendant.

Perhaps the most powerful word in a letterhead is the client's name. It can be a real inspiration, as it was to Roger Christian when he designed a system for Ronald G. Tietz, D.D.S. For the orthodontist with the career-linked name, it was a natural to create a logo that depicted the transformation of crooked "teeth" to the well-aligned "Tietz."

Sometimes it seems like the client's name is more liability than asset. Pulmonary specialist Richard K.

Oehlschlager was ready to change his name because of its apparent unpronounceability when Schlangen! solved the problem. Schlangen!'s Mark and Katherine Oehlschlager provided a phonetic spelling as the focal point of the doctor's letterhead and business card.

Just as Schlangen! took its design clue from the dictionary, so does MoJo Designs. Designer Liz Torke offers three definitions—dictionary-style—for MoJo, a user interface design company.

Words are an integral part of any letterhead or business card design. There's no reason they can't add intellectual content as well as visual interest, and still be playful.

**Design Firm:**
BlackBird Creative
Charlotte, NC
**Art Director/Designer:**
Patrick Short
**Photographer:**
Alex Bee

alex bee photography . 1425 rock quarry road suite 115
raleigh nc 27610 . f/821 4115

Alex Bee 919 821 1661

B b

Blackbird Creative avoided insect imagery for photographer Alex Bee's new stationery package, instead focusing on the letter *B*. "Flash cards came to mind as a strong vehicle for introducing his new style in a very simple, direct approach," explains designer Patrick Short. "We were reminded of the graphic box found on flash cards that contains the first letter form of the object/image. We developed Alex's logo into a stylized *Bb* reminiscent of these flash cards." Bee's promotions also employed the flash card device. His photographs of objects beginning with *B*—baseball, boots, brushes—were printed on Chrome-coated stock with 4-color photography. For the stationery, the graphically strong logo was printed in black with the letters dropped out. Rather than use a standard business-size envelope, BlackBird designed a 4" x 9 1/2" envelope with the flap, featuring the white-on-black logo, closing on the short side. Because it was essential that the black not bleed over the fold, the sheet was offset-printed first. The converter cut and folded the envelope. The printer then scored and folded the flap to insure proper registration.

alex bee photography .1425 rock quarry road suite 115. raleigh nc 27610 . 919 821 1661 f/821 4115

alex bee photography .1425 rock quarry road suite 115. raleigh nc 27610

B b

## JIM BOWIE PHOTOGRAPHY

Although the Dallas photographer Jim Bowie is a descendant of Jim Bowie of knife fame, he was uninterested in any design solution that referred to his forebear. However, he did want a bold new image that would reflect his own photographic style. After rejecting anything related to knives, or the Old West, designer Danica Boulet of Right Angle came up with a blood-splattered motif. It reinforces the tag line "killer photography" that appears crudely hand-lettered (but is actually set in Handwrite Ink Blot) on all of the elements of the stationery system. To get an authentic look, the art director "literally shed blood on this one! A small pin prick actually," according to creative director Cheryl Taylor. Adobe Illustrator and QuarkXPress were used to create the image from the actual blood drop. To contrast with the Classic Crest Brilliant White paper stock, the design was then printed with flat ink in a not-quite-dried-blood red, which keeps it from seeming too serious, more comic-book fantasy than tabloid reality.

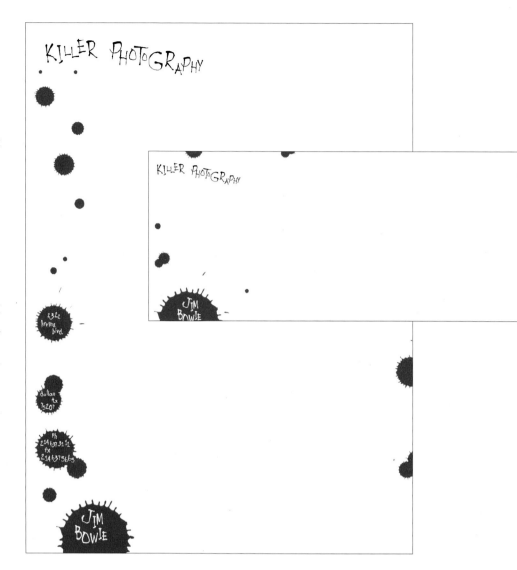

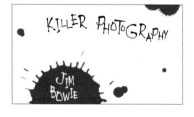

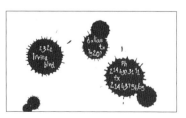

**Design Firm:**
Right Angle
Lafayette, LA
**Art Director/Designer:**
Danica Boulet
**Creative Director:**
Cheryl Taylor

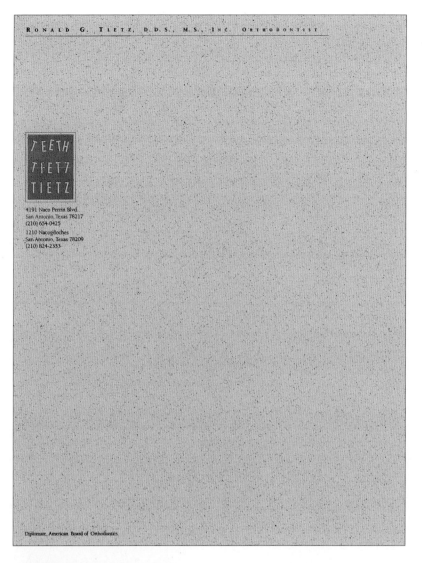

To replace a generic and uninformative letterhead and business card design, orthodontist Ronald G. Tietz wanted stationery to illustrate what he does: straighten teeth. Roger Christian & Co. devised a simple but striking design combining an imaginative use of typography with a happily compatible surname. Using QuarkXPress, creative director Roger Christian dropped out three lines of type in a color block with the proportions of a front tooth. At the top, the word "teeth" was set crookedly. In the second line, the letters, which are evolving into the dentist's name, are arranged at the same angles, but with a simple horizontal line running through them to suggest braces. At the bottom, the orthodontist's name is presented perfectly aligned. The grape rectangle offsets both office addresses, set flush left, ragged right, also a subtle reminder of what the good doctor does.

**RONALD G. TIETZ, D.D.S.**

**Design Firm:**
Roger Christian & Co.
San Antonio, TX
**Creative Director:**
Roger Christian
**Art Director:**
Katrina Amaro

## BRENT ROGERS

Brent Rogers is an architect and an artist. For his first stationery, it was important to show that his two related identities also exist independently. Dale Hart of Rolling Bones Letterpress in Seattle created an image that can be read in two ways. "Architect" is set in all-caps and the smaller, lower-case "artist," set in black and bracketed, is overlaid on the buff-colored type. Then the words are reversed with "artist" rendered in a dot pattern, dominating, and "architect" overprinted in parentheses. To reflect that these are areas of equal interest to Rogers, the letterhead and business cards were printed in two runs in Rolling Bones's letterpress shop. Half of them placed the architect-dominated image on the top with the artist over architect at the bottom. Halfway through the hand-fed print run, the sheets were flipped so that artist came out on top. Rogers' brief had been to "make it innovative and dyn-o-mite." The response to the package, according to Hart, has been "awesome."

**Design Firm:**
Rolling Bones Letterpress
Seattle, WA
**Designer:**
Dale Hart

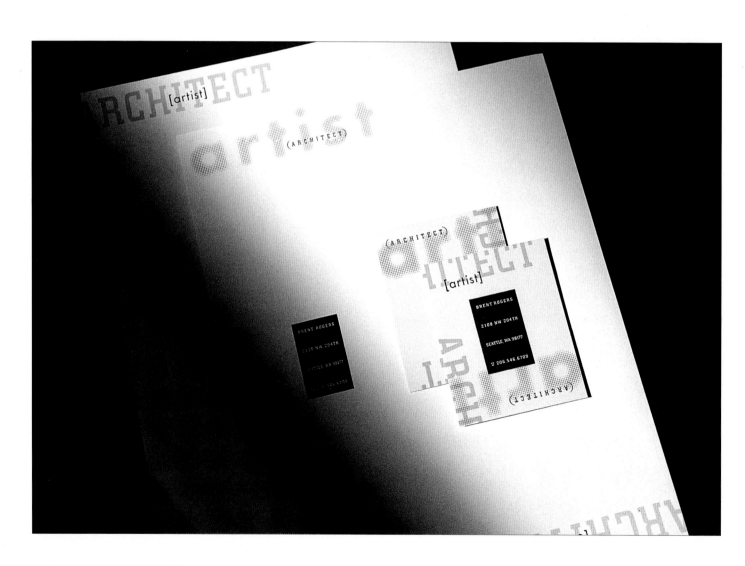

The initial business card for freelance art director Michael Caguin reads, "An ego so small, it fits in your Rolodex." Says Caguin, "I wanted to tell prospective clients or employers that I'm easygoing and personable, yet still creative. There are so many unpleasant people in the business. I'm not one of them." Caguin created the regular-sized card for under $150. His practical design solution pokes gentle fun at designers who gain attention with oddly shaped or over-sized cards. In keeping with this "modest" approach, Caguin set the tagline and his basic information in a straightforward, almost generic sans-serif type, and used 1-color printing on a 120# gloss stock, black on white with an all-black reverse side. Caguin states he had "fun coming up with a small space advertisement that just happens to be a business card."

**MICHAEL CAGUIN**

**Design Firm:**
Bob's Yer Uncle
Chicago, IL
**Art Director:**
Michael Caguin

---

# An ego so small, it fits in your Rolodex.®

Michael Caguin Art Director 312 388 9671

---

## VAN AUKEN MARGOLIS & ASSOCIATES

Van Auken Margolis & Associates in Rochester, New York, employed the term "Eureka!" to communicate the strengths of the graphic design and illustration studio. Principal Leslie Van Auken explains that requests for printed samples of their work prompted her to design a business card portfolio. The card, which has a chemistry theme, was intended to showcase the breadth of illustration the firm was capable of producing. Although the need for high-quality, 4-color reproduction at an affordable price suggested the small size, it also effectively demonstrates how the firm's illustration can be used in this format. All of the illustration was produced in-house, in Macromedia FreeHand, Adobe Photoshop, and QuarkXPress. By printing with another job on the same press sheet, Van Auken Margolis only had to pay for the filmwork, keeping production costs low. The piece was so successful that fold-out cards have become an annual self-promotion, allowing the firm to highlight different illustration and design styles and to keep in touch with clients.

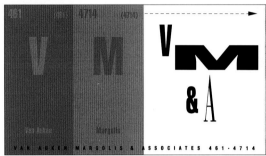

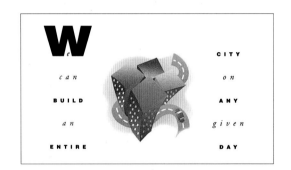

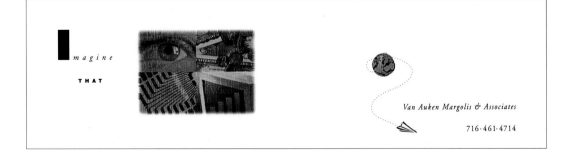

**Design Firm:**
Van Auken Margolis & Associates
Rochester, NY
**Art Director/Designer:**
Leslie Van Auken
**Illustrator:**
Amy Margolis

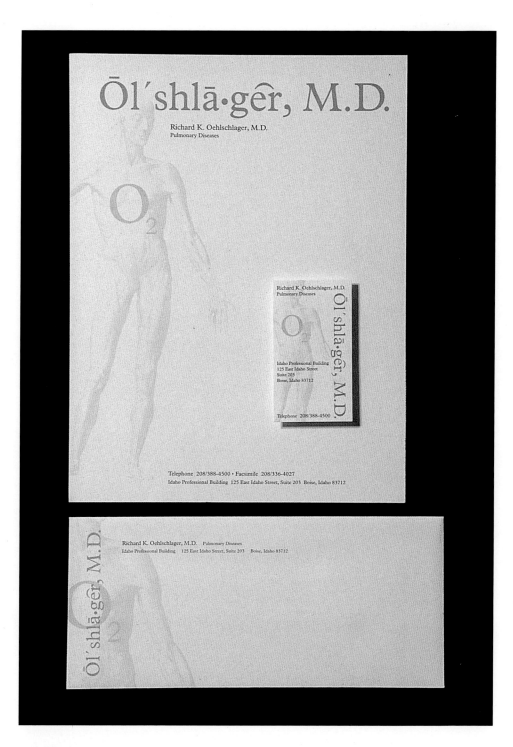

When Dr. Richard K. Oehlschlager, a specialist in pulmonary diseases, moved his practice to Boise, Idaho, he considered changing his name to circumvent pronunciation problems. Designers Mark Oehlschlager and Katherine Oehlschlager recall their client's fear that "the difficulty people have in pronouncing his name would discourage some referrals." Rather than abandon the name, the designers turned "Oehlshlager" into an integral part of the design. "A phonetic re-spelling of Oehlschlager converts the problem of its pronunciation into a gratifying moment of discovery, and in the process yields an elegant typographic element," they explain. To illustrate Oehlschlager's area of expertise, many symbols were considered, including an old-fashioned bellows and literal representations of lungs. Instead, the designers took a drawing by Albinus from a book of stock anatomical drawings. The typographic symbol for oxygen, $O_2$, was superimposed over the chest in place of the lungs. "The idea of the phonetic re-spelling and the theme of letters that it conjures," the designers report, "inspired us to avoid the typically cold and clinical look of most contemporary professional stationery, and instead reference a warm, humanist theme."

**RICHARD K. OEHLSCHLAGER, M.D.**

**Design Firm:**
Schlagen!
Sacramento, CA
**Art Director:**
Mark Oehlschlager
**Designers:**
Mark Oehlschlager,
Katherine Oehlschlager

## MOJO DESIGNS, INC.

The design objective for MoJo Design's new stationery was to avoid a sterile computer image and to maintain a sense of the company's purpose: user interface design for computers embedded in products such as VCRs and microwaves. To achieve that aim, Liz Torke created a whimsical logo of a magic hat with childlike stars and moon. A brushstroke arrow calls attention to three different definitions of the firm's unusual name. The letterhead was printed in black and one Pantone color; however, with a budget of only $400, it was not possible to offset print the envelopes. Instead, a rubber stamp was made, and the moon and stars are hand-colored by pencil. MoJo has had a good response to the rubber stamp, which has also been used for folders, boxes, presentation booklets, computer disks, and notepaper. "It's helped humanize our computer image," says Torke. "And it makes a personal connection with clients."

**Design Firm:**
MoJo Designs Inc.
Boulder, CO
**Designer:**
Liz Torke

# MoJo Designs

**mojo** (mo'jo) –
**1** of or pertaining to magic
**2** a cry for more, esp. in jazz or blues
**3** excellence in interface design

To:
FAX:
Total # of Pages:

From: Fax: (303)444-7876

MoJo Designs
P.O. Box 6037
Boulder, CO 80306
(303)443-5035

**MoJo Designs Inc.** p.o. box 6037, boulder, co 80306  **voice** 303.443.5035

customer
*fig. 1*

product
*fig. 2*

**Is your product a good
dance partner?**

customer
*fig. 1*

product
*fig. 3*

## Why MoJo?
A MoJo interface...
• is intuitive to learn
• is easy to use
• creates visual relationships
• shows you what's going on
• simplifies complex information
• conserves screen space
• makes people smarter
• is fun

## Why Now?
• competition is fierce
• people need good tools
• good design extends a product's life cycle
• a MoJo Interface creates an identity
• updating the interface is simple
• it's time

send it to
*Charm School*

When it comes to designing a memorable mark for a client, visually literate graphic designers may create "Word Pictures," an approach that involves employing pictures to literalize the client's identity. For a new trucking and moving company, illustrator Tony Klassen for Segura Inc. depicted Tires on Fire as—what else?—a tire flanked by flames. With subdued palette and decorative flourish of the flames, the image reads as classy, not obvious.

For a new upscale women's shoe store in an affluent Minneapolis suburb, the obvious symbol is a shoe, but what kind? Pointe Designs went through eight boot and shoe designs before settling on an elegant pair of high-heeled boots for TIP TOES. It may not be a perfect solution, but it certainly communicates what the pricey boutique purveys.

When Kenn Tompos of Straight Face Studio needed a new logo, the possibilities afforded by his studio's name seemed limitless. He opted for a restrained design with a contour drawing of his own face played off against straightforward typography. The design reflects Tompos's desire to keep "a straight face at all times, no matter how difficult that may be."

The possibilities also seemed limitless to Workhorse Design, Inc., when it designed its initial stationery program. The design firm came up with "30 to 40 comps," according to president Constance Kovar, before settling on what appears to be a perfect rendering of its name: the head of a sturdy horse with gear teeth for a mane. Workhorse hoped to appeal to communications, public relations, art, creative, and marketing directors and corporate executives. They've also discovered that they attract the horsey set, too, having designed several logos for the equestrian community.

The designers in this section don't only picture nouns. The designer of Design Moves, Ltd. has been joined by a male counterpart, and together

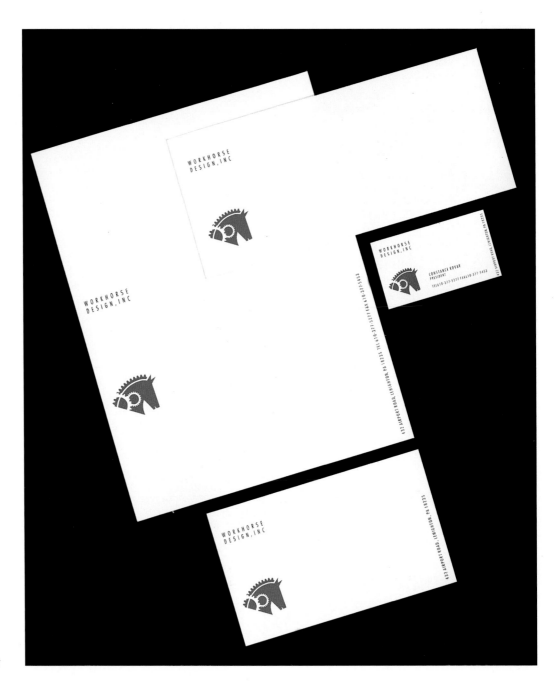

they race around the various components of the new stationery package. With hair streaming and arms outstretched, they make clear that speed is key for this Winnetka, Illinois, company.

Other designers spell out proper names. For Shelby Putnam Tupper's company, there's never been any question about her logo; she places

a bee on a shell.

Colleen Crowley wanted to communicate her name visually and unequivocally so she used standard semaphore language to underline it for her design company: Crowley Communications.

Design literacy means words and pictures, and often "Word Pictures."

**Design Firm:**
Workhorse Design, Inc.
Lehighton, PA
**Art Director:**
Anthony Taibi
**Designer/Illustrator:**
Constance Kovar

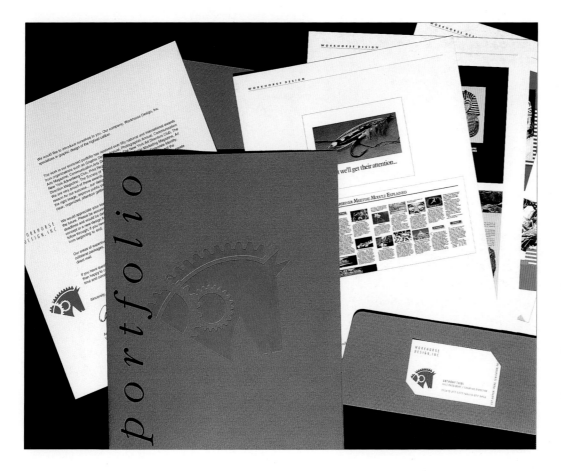

When Workhorse Design created its first stationery package, it wanted "a letter-head that would be clean, airy, and attractive, and immediately project a graphic design company image." The brief might have been succinct, but without "constraints on deadline or budget," recalls Workhorse president Constance Kovar, "We ended up with about 30 to 40 comps hanging up in our studio for weeks. Still not satisfied, we took out scissors and started cutting up the comps, moving the type and the mark around by hand until we came up with the final design." The solution was actually very simple, just two colors on a bright white stock with maximum white space and "judicious use" of Futura Light Condensed type in all-caps. The mark of a stylized horse's head with mechanical gear teeth for a mane was created in Adobe Illustrator.

Workhorse Design has received several commissions for logo and stationery design since introducing its own stationery. One unexpected and enthusiastic response to the logo has come from the equestrian community.

**WORKHORSE DESIGN, INC.**

For Design Moves, Ltd.'s new stationery, principal Laurie Mederios Freed wanted to illustrate what her graphic design firm is about. The basic element of a stylized figure had appeared in the previous design, but this time the figure, created in Adobe Illustrator, was skewed a bit to relate more fully to the company's name. Freed also added a male figure to show the addition of her new male partner. The original design had included a figure reaching for both an easel and a computer; Freed explains that the easel had been included to indicate "the artistic presence." It was deleted from the current design because she felt "most clients don't care about artistic presence these days." A variety of paper stocks was used to give a unique look to the stationery package. On the gridded graph paper of the letterhead, the logos run off the edge at the upper right and lower left. The placement conveys a sense of speed, which all graphic designers today report as a client imperative.

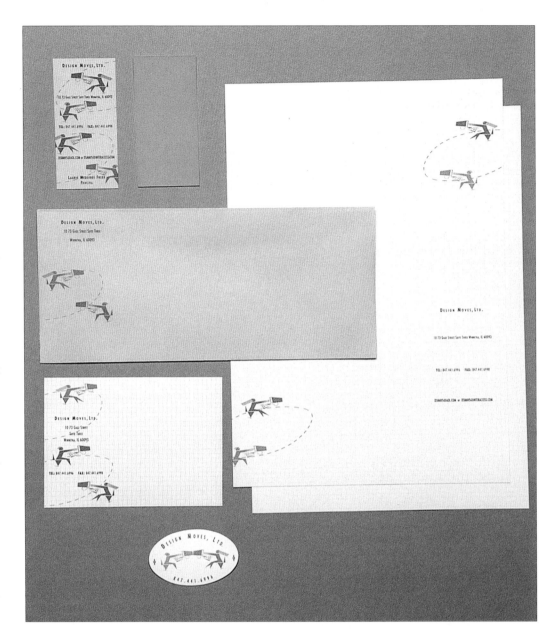

**Design Firm:**
Design Moves, Ltd.
Winnetka, IL
**Art Director/Designer/**
**Illustrator:**
Laurie Medeiros Freed

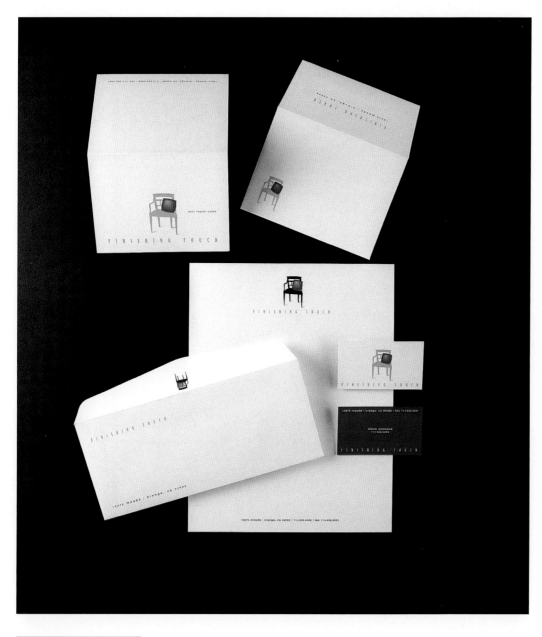

The assignment was to replace the purely typographic stationery system of the high-end interior design service Finishing Touch. The new stationery had to show that "the firm catered to both traditional and contemporary tastes," according to designer Jean Wei. During the design process, a variety of concepts were considered, ranging from abstract graphics to photorealism. The one consistent element was the image of a chair. It became the focus of a design that takes "a minimalist approach in order to evoke a timeless yet sophisticated look," says Wei. Using an actual chair as a model, Wei created the bold logo using FreeHand 5.5. "The chair and pillow suggest tradition while the bold colors represent progressiveness," she explains. The satin sheen on the pillow and the shadows beneath the chair epitomize the company's perfectionist attitude. The finish on Neenah's Classic Linen paper complements the pillow's sheen and adds a tactile depth to the design. The project actually began as an assignment for an extension class for Wei. After numerous in-house revisions at Eazell Peterson, the artwork was presented to the client. The only change made was the addition of the fax number.

**Design Firm:**
Eazell Peterson
Anaheim, CA
**Art Directors:**
Peter Ross, Jean Wei
**Designer/Illustrator:**
Jean Wei
**Printer**:
Bryton Printing

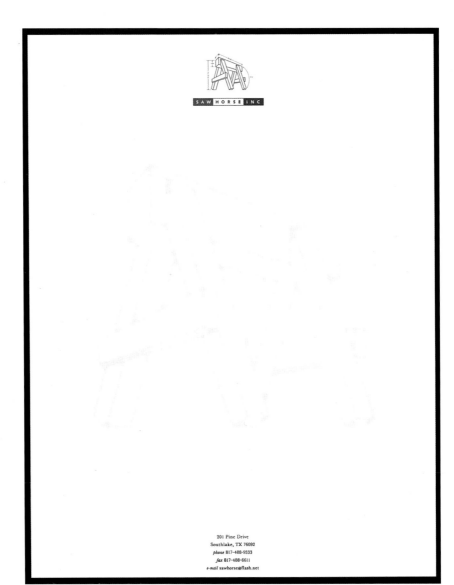

## SAWHORSE, INC.

When Sawhorse, Inc., a new company specializing in home remodeling and building, asked Dreier Design to design its first stationery system, it was seeking a look that would differentiate it from its competitors. Designer Kyle D. Drier played with images of saws and horses to illustrate the company's name. Finally, he settled on a schematic drawing of a sawhorse, complete with the formula for determining its proportions. The new stationery conveys a message about the combination of precision and esthetic sensitivity that Sawhorse brings to a project. The artwork was created in Adobe Illustrator. For the letterhead sheet, a faux watermark was done in Photoshop, and the image printed 3 per cent black on Star White Vicksburg, a crisp white paper. The striking black border and ersatz watermark of the sawhorse logo communicate a feeling of old-fashioned elegance updated with wit and practicality.

**Design Firm:**
Dreier Design
Dallas, TX
**Designer:**
Kyle D. Dreier

(nvolve)

nvolve,inc.
155 Bovet Road
Suite #300

(nvolve)

nvolve,inc.
155 Bovet Road, Suite #300
San Mateo, CA 94402
ph. 415.312.7880
f. 415.312.7878
mark@nvolve.com

Mark Houts
VP Operations

nvolve,inc.
155 Bovet Road
Suite #300
San Mateo, CA 94402

(nvolve)

A new division of IDG Interactive Service had only one requisite for their logo; according to the company CEO, it had to produce well on a golf ball. Not only does the new design, by Pentagram in San Francisco, succeed, but the flexible mark can also be animated on a computer monitor and works in more traditional print applications as well. As a part of IDG Interactive Services, which provides Internet access, Nvolve markets to young adults, 14 to 20, who use the Net. The arrows enclosing the company name serve to communicate interactivity. The image, created in Adobe Illustrator, was printed in a 2-color lithographic process on Coronado High Tech, which adds a contemporary, tactile quality to the system. Pentagram's solution is elegant and deceptively simple. The type consists of red and gray, with red emphasizing the company name, e-mail and Web site address. Subtle but effective, this approach calls attention to the contact information. On the business cards, the user's name is in red while the title is in gray.

**Design Firm:**
Pentagram Design
San Francisco, CA
**Art Director:**
Kit Hinrichs
**Designer:**
Erin Collom

## TIRES ON FIRE

For a new trucking and moving firm, the client asked Segura Inc. for an "intrusive package, one that would separate him from other trucking companies," explains principal Carlos Segura. Taking the design cue from the firm's name, Tires on Fire, illustrator Tony Klassen came up with a striking image: a tire surrounded by symmetrical flames. Instead of screaming reds and yellows, the palette used is subtle and subdued. The design, reminiscent of a decorative tattoo, was created in Adobe Photoshop, Illustrator and QuarkXPress and was printed in 4-color. The logo illustrates quite literally the company name. It also describes the company's business philosophy: fast delivery. And it adds a sophisticated, even elegant touch to the trucker's image.

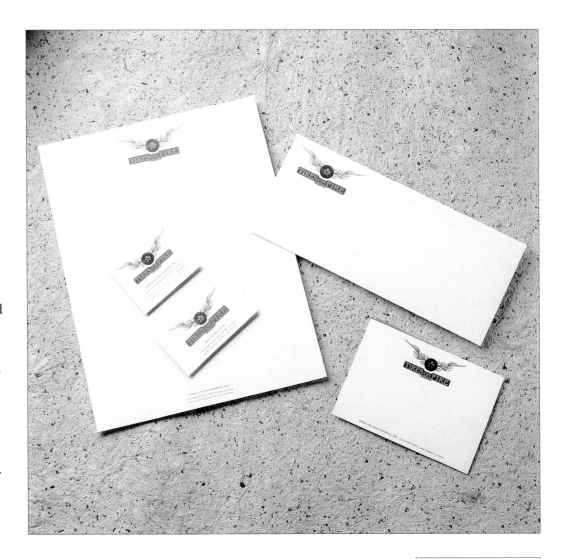

**Design Firm:**
Segura Inc.
Chicago, IL
**Art Director:**
Carlos Segura
**Designers:**
Carlos Segura,
Laura Alberts
**Illustrator:**
Tony Klassen

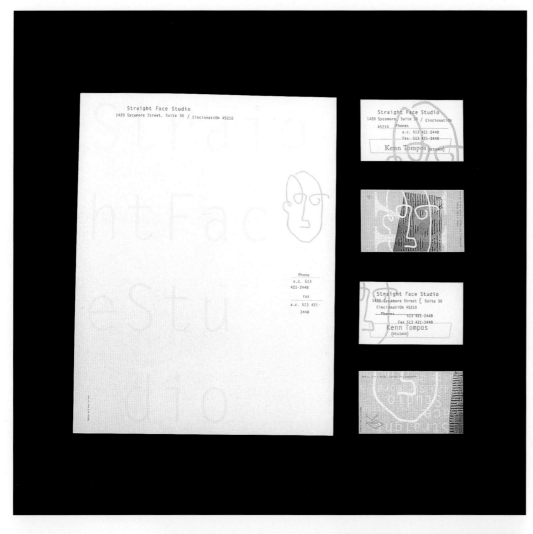

Straight Face's new logo is a hand-drawn face caricaturing Kenn Tompos, the studio's founder. "Since I'm a one-person design studio, I wanted to relate the studio name to me, to my personality, because when someone calls, they get me," says Tompos. In keeping with a lighthearted approach, Tompos designed two business cards which he calls "Face-Cards." A line of copy on the card encourages you to "Collect all 2 FaceCards." The cards were printed as part of an 11" x 17" sheet along with two 9" x 5 3/4" moving announcements, and a promotional bookmark. Tompos added a ("free!") third color to the 2-color offset job by adding his name to the business card and various comments to the announcement with a rubber stamp. "The overall restraint of the design plays off the idea of keeping a straight face at all times, no matter how difficult that may be," says Tompos.

**Design Firm:**
Straight Face Studio
Cincinnati, OH
**Designer:**
Kenn Tompos

When Shelby Designs & Illustrates moved, principal Shelby Putnam Tupper knew it was time to update her stationery. Instead of an entirely new look, she tweaked the existing design. Tupper changed the paper stock and decided on 3-color instead of 2-color offset printing. A variety of color combinations were considered before a pleasing palette of purple, green, and copper was selected. The logo remained essentially the same although the location of the screen-backed image of the bee on the shell was changed. Its position was carefully considered so as not to distract from the text that would be printed on the letterhead or envelope. To bring out the bee in the logo, it was printed in a metallic ink. To further emphasize the logo on the vertically-oriented business cards, a clear foil stamp was used, necessitating extremely tight registration. It's an elegant design but also a witty visual word play for Shelby Designs & Illustrates.

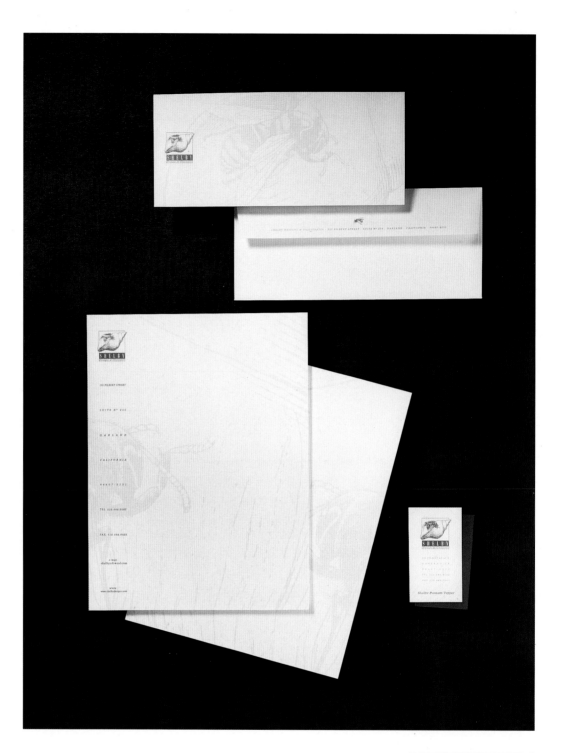

**Design Firm:**
Shelby Designs & Illustrates
Oakland, CA
**Designer:**
Shelby Putnam Tupper

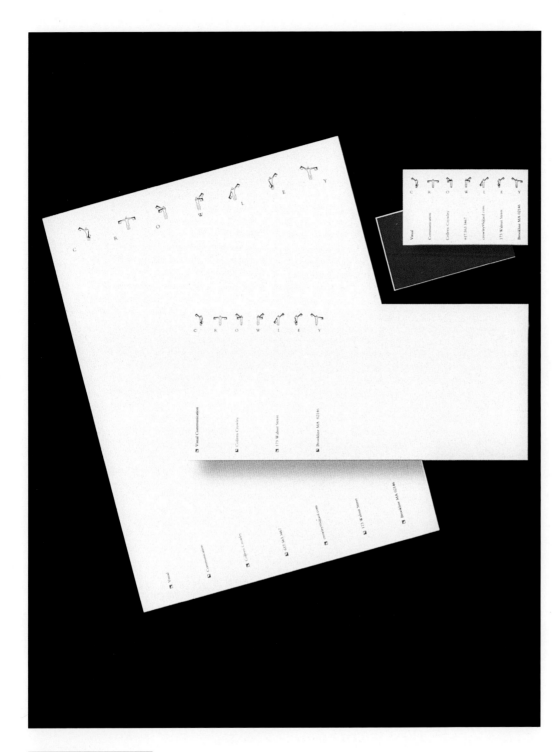

Colleen Crowley's intention for her company's first letterhead was "to create a unique and highly graphic interpretation of 'communication.'" Her solution was to use the universally recognized semaphore code to spell out her own last name. The original figures were derived from copyright-free semaphore code in the public domain, but Crowley rebuilt each figure in Adobe Illustrator. One unexpected problem occurred in production: It was difficult to trap the orange color inside the figures' flags during offset printing. The semaphore imagery seemed to Crowley to be a logical way of saying, "Hey, I'm in the business of communicating, but not necessarily 2D images on paper." She was intrigued with the idea of using very ordinary and immediate symbols: a man holding a flag. "It's still the best way to direct a plane on an airport runway," she notes. "No computers, nothing high-tech."

**Design Firm:**
Crowley Design
Marblehead, MA
**Designer/Illustrator:**
Colleen Crowley

For an upscale women's shoe store in the affluent Minneapolis suburb of Wayzata, Pointe Design was asked to create a "classy look," according to Bill Mann, creative director. The logo also needed to be easily reproducible, reflect the nature of the merchandise, and coordinate with the color scheme of the interior of the boutique. The designers eliminated silver and purple as the palette, a horizontal layout, and eight alternative boot or shoe designs, before they delivered the solution. Tim Lane drew the original illustration, which was scanned into Adobe Photoshop, outlined, and then brought into Adobe Illustrator 6.0 to produce a smaller file size and sharper image. Although the color was originally black, it was easy to change the hue when output in QuarkXPress.

**Design Firm:**
Pointe Design
Minnetonka, MN
**Art Directors/
Designers:**
Bill Mann, Jon Arne
**Illustrator:**
Tim Lane

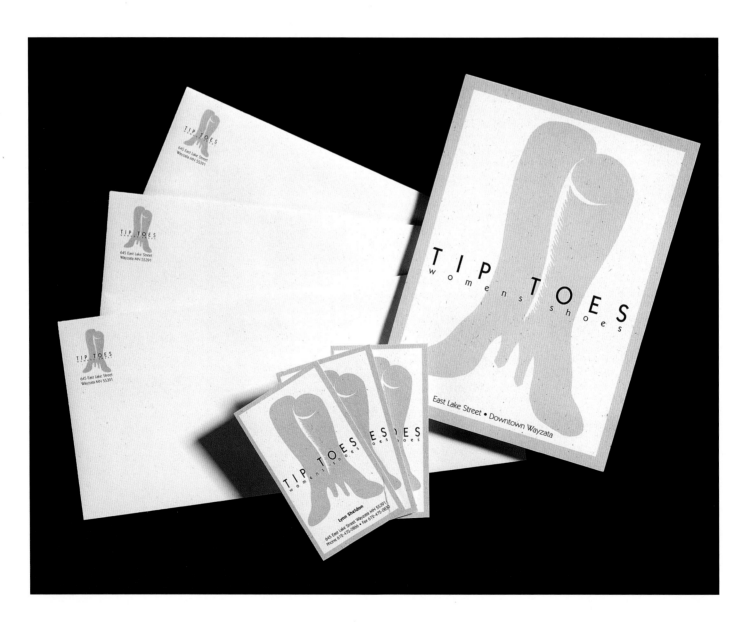

# SPECIAL EFFECTS

While computers have broadened the range of effects possible in printing, successful special effects don't always take high technology to achieve. They do require hard work, and sometimes hand work.

For The Finishing Touch, John Sayles devised a stationery system that tells and shows what the specialty bindery service does. The letterhead with its individually hand-stamped phone and address information also has a tag listing the company's handwork services. The business cards, also with rubber-stamped info, sport a plastic tape label for the employee's name and a glued-on metallic star. The stationery system is low-tech with high visual impact.

The same ad hoc quality is found in Vrontikis Design's letterhead and business card package for Greenhood + Company. The new media consultants expected their business to expand exponentially in its first 18 months and needed a flexible and economical stationery system. Vrontikis used laser printing and rubber stamping to create the stylish design inspired by Russian Constructivism. A pressure-sensitive label eliminates the need for printing number 10 envelopes. Instead, the label wraps vertically around the "waist" of the envelope.

Temporariness and economy were motivating factors for Russell Leong when Leong Design needed an updated business card. A chipboard-like stock was used for the card, an inch wider than a standard business card. A perforation makes the stub with "Additional Information" easy to detach. A slick, black keychain is attached through a hand-punched hole.

When designers use die-cuts and hole punches they add impact to their designs. For a new logo for June Corley Communications, Corley hand-punched a couple of holes to make the eyes of the face formed by her initials. The depth of the hole-puncher determined the placement of the eyes but didn't undermine the impact of the design.

The same strategy works for Paul Ison of Ison Design, although in this instance, the small circle dotting the *I* and creating the counter of the *D* is die-cut. The missing circle adds a third color to the 2-color design when a label is placed on a colored envelope or a different hued letterhead peeks through.

For Lanny Nagler Photography, a die-cut rectangle framed by his stylized initials becomes a slide mount and perfectly represents the commercial photographer. Foil-stamping adds to the trompe l'œil effect of the slide mount image.

When graphic designers create stationery packages for themselves or others in the design and printing industry, there is a temptation to add an "insider" element. For Barton Productions, which supervises print production, DiSanto Design added a decorative border to the elements of the system. To the knowledgeable, it is clear that the design came from an actual press sheet. To the uninformed, it simply reads as blocks of color.

Keech Studio's client base includes ad agencies and other design studios. When Brad Keech updated his logo using the studio initials, the blocky *K* inside a circle with the swash-like curves of the *S* emanating from it casts a shadow that reads as a registration mark. It's a familiar symbol to his design-savvy audience.

Blank uses another design trope for their first business card. Taking clip art, vernacular imagery, photography, and copyright-free designs, the three partners of Blank cast a nostalgic eye to earlier design. But the vintage look of printing with Benday dots is an effect achieved with up-to-date computer software.

The dictionary defines special as "distinguished or different from what is ordinary or usual." In the hands of these talented designers, the special effects are both unusual and compelling.

When Paul Ison redesigned the stationery package for his company, Ison Design, he wanted a "completely different design to reflect a more contemporary graphic image." The result is a straightforward presentation in which a single circular die-cut provides the dot of the *I* and the counter of the *D*. Using Adobe Illustrator, Ison created the bold letter-forms based on Bodoni and Futura. The hole adds the impression of luxury because of the die-cut's expense. On the tan envelopes the hole reveals the contrasting hue of the enclosed sheet, giving the illusion of an additional printed color. To economize, forms for confirmations, estimates, invoices, etc., were simply laser printed. The rest of the package was printed 1-color only—black. The use of various muted and natural colors—sand, stone, dusk— of the chosen paper, Quest, added a richness to the entire system. Because there was no label stock, a matching texture was created by scanning a light-colored sheet of Quest into Adobe Photoshop and then manipulating it to achieve the desired effect. Ison's design and paper choice creates an up-to-date look with minimal means and expense.

**Design Firm:**
Ison Design
Santa Ana, CA
**Art Director/Designer:**
Paul Ison

Just starting out, Blank's three partners needed to create a business card that represented the diversity of a studio that does print, packaging, environmental, exhibition, and motion design. Their philosophy is to push "the level of graphic design nationally." Using clip art, vernacular imagery, photography, and copyright-free designs as raw material, Blank created an engaging and entertaining business card. Adobe Photoshop was used to recreate the look of Benday dots, a vintage technology. Working with a budget of less than $1000 for four cards printed in quantities of 1000, Blank maximized the visual impact of the business cards. The goal was to look like a 4-color process, with metallics and varnishes. This was achieved through careful selection and by mixing three colors and working with pre-printed paper. Designer Suzanne Ultman believes "this piece offers levels of information that keep the user returning for further investigation. We like to think of our card as a piece of art with an ulterior motive."

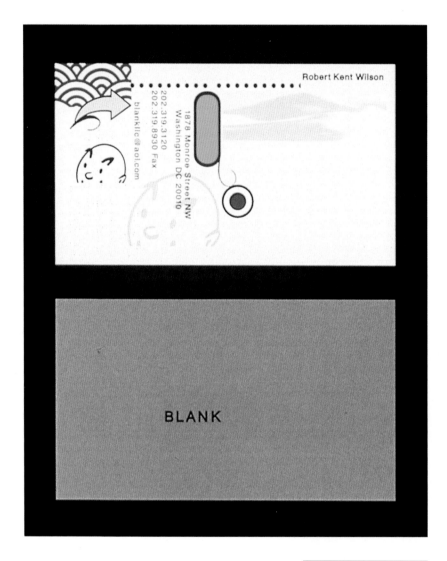

**Design Firm:**
Blank
Washington, DC
**Designers:**
Adam Cohn,
Suzanne Ultman,
Robert Kent Wilson

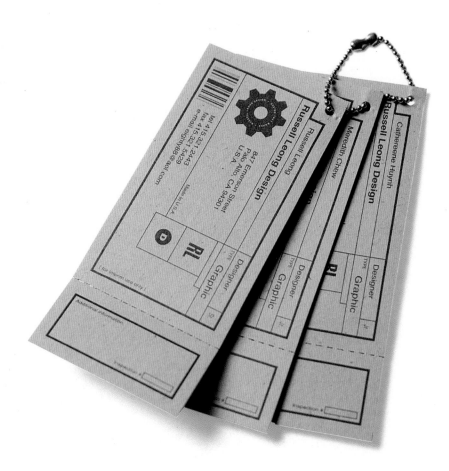

When Russell Leong Design needed an updated business card "fast!," he came up with "a utilitarian, temporary card to represent an office that produces 'design that works.'" Given the "interim use" factor, it was important "to keep costs to a minimum without sacrificing interest," the designer explains. The result is a 1-color offset lithographic solution. The composition and design elements allude to mechanical drawings and industry. A "bar code" calls attention to the basic conduits for communication: phone, fax, e-mail. Printed in black on a chipboard-like stock, the card conveys a no-nonsense approach to design, but one that also combines a bit of wit with utility. An inch was added to the length of the card for "Additional Information" and an inspector's number was added as well. A perforation done by the printer allows for the stub to be easily torn off so that the card can fit into a standard business card file. An in-house, hand-punched hole allows for the edition of a black keychain, for interest and "value," in Leong's view.

**Design Firm:**
Russell Leong Design
Palo Alto, CA
**Designer:**
Russell Leong

Greenhood + Company's initial stationery needed to be flexible because these consultants in new media technology expected to change locations at least three times in their first 18 months. To meet this need, Vrontikis Design Office designed a system that could be economically produced and easily changed. For example, no number 10 envelopes were printed; the pressure-sensitive address labels intended for larger envelopes are used on stock olive drab envelopes. The label wraps vertically around the envelope, adding an eccentric touch. The design itself, inspired by Russian Constructivism, is dynamic and simple. Comprising both high- and low-tech production processes (laser printing and rubber stamps), the design subtly alludes to the early 20th-century art movement. The *N*s of the tagline, "NEW MEDIA & TECHNOLOGY," are reversed, evoking the Cyrillic alphabet. The simple bars of color set off the company name, recalling the abstract canvases of the avant-garde painters of the Russian Revolution. The design was produced in Adobe Photoshop. Principal Petrula Vrontikis reports that the stationery system "has won every competition entered and the client is happy. I suppose that's as good as it gets."

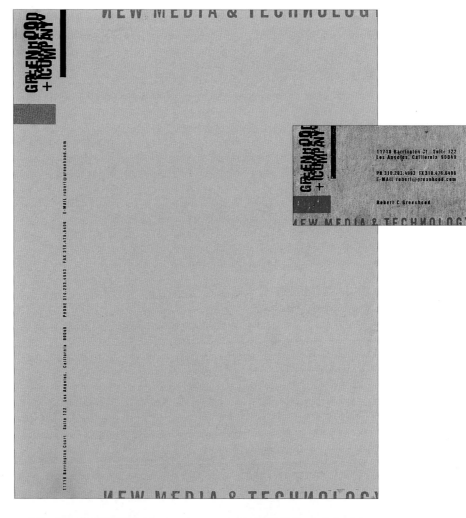

**Design Firm:**
Vrontikis Design Office
Los Angeles, CA
**Art Director:**
Petrula Vrontikis
**Designer:**
Samuel Lising

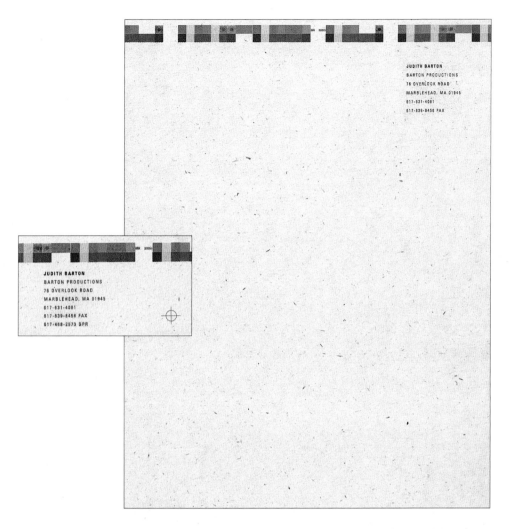

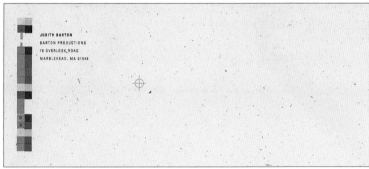

When Judith Barton established herself as a freelance print production supervisor, she wanted a letterhead design that would convey the nature of her business in a unique way to her audience of graphic designers, print buyers and printers, and advertising agencies. Rose DiSanto of Boston's DiSanto Design fufilled this brief, supplying a design that is appealing visually while alluding smartly to Barton's business. The decorative border at the top of the letterhead, mailing label, and along the right side of the envelope is copied directly from an actual press sheet. Designer DiSanto simply recreated it in QuarkXPress 3.31. Registration marks, familiar to those in the graphic design and printing industries, are used to mark the placement for addresses for the labels and envelopes and as a decorative motif on the other parts of the stationery package. In keeping with Barton's area of expertise, the stationery was offset-printed using four flat PMS colors.

**Design Firm:**
DiSanto Design
Boston, MA
**Designer:**
Rose DiSanto
**Print Production Supervisor:**
Judith Barton,
Barton Productions
**Printer:**
Hanson Printing
Company

Unaided by computer, John Sayles created a custom look for The Finishing Touch. The Des Moines company specializes in finishing and hand-work bindery services including gluing, taping, assembling, labeling, and eyeletting. Their logo, hand-drawn by Sayles, features a bold character with his finger on a bow. It is printed on the letterhead, but the pertinent address information is rubber-stamped. A miniature shipping tag listing the company's services is attached with an eyelet. The logo appears offset-printed on the business card, and the phone number is rubber-stamped. A metallic star is glued on each card, and the employee's name is stamped into a self-adhesive plastic label. Because The Finishing Touch's business is handwork, "they didn't balk when I came up with this rather involved process," Sayles explains. "The individual parts themselves are economical and readily available—they 'assemble' the components of their letterhead during down times or as needed, so it works very well for them."

**Design Firm:**
Sayles Graphic Design, Inc.
Iowa City, IA
**Art Director/Designer/**
**Illustrator:**
John Sayles

# LANNY NAGLER PHOTOGRAPHY

Replacing a letterhead and business card that he's used for 21 years was not an easy decision to make for commercial photographer Lanny Nagler of Hartford, Connecticut. After all, his father, now a retired commercial artist, had designed the original logo using his son's initials in a stylized type treatment. But the response to the change has been positive. Even his father likes it. The new logo, designed by Ritz Henton Design Group, is a foil-stamped and die-cut image of a slide mount and still alludes abstractly to the photographer's initials. Like a slide mount, the foil is slick white. There is even a copyright notice with Nagler's name. A clever die-cut takes the place of a slide image. The tactile quality of the foil stamping is reinforced by the engraving of the address and telephone information.

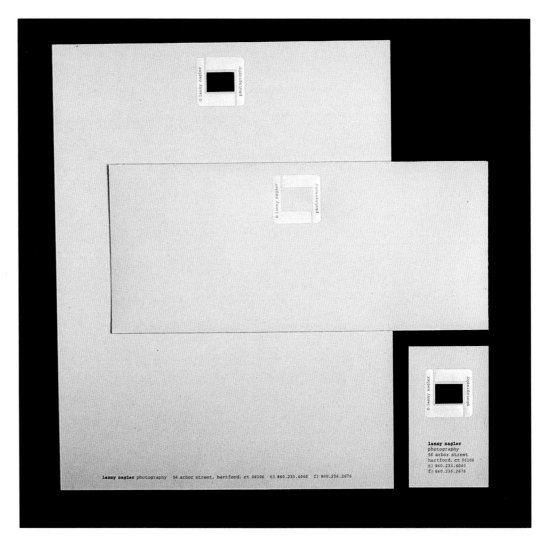

**Design Firm:**
Ritz Henton
Design Group
West Hartford, CT

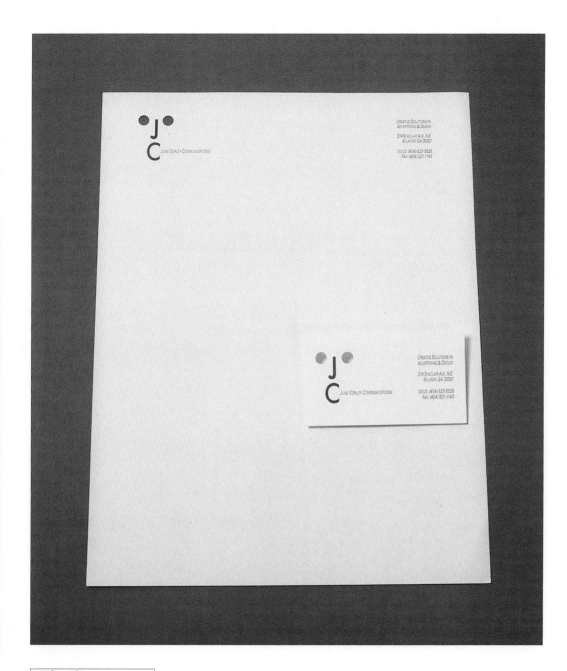

After using her previous design for 12 years, June Corley decided it was time for an update. As she played around with her initials, a "face" suddenly appeared. She reinforced this visual by making the *C* red and spelling out the company's name as if it were coming from a "mouth." The "eyes" are simply holes. Rather than go to the expense of having a die-cut made, Corley hand-punches them on her stationery, business cards, and crack-and-peel labels, having printed light circles as guides. The depth of the hole puncher dictated the placement of the "eyes." When the adhesive label is used on colored envelopes, Corley gets the appearance of three colors with only a 2-color printing job.

**Design Firm:**
June Corley
Communications
Atlanta, GA
**Art Director/Designer:**
June Corley

**JUNE CORLEY COMMUNICATIONS**

Keech Studio does design, high-end production, photo manipulation and retouching, and illustration. For their updated stationery, the goal was to communicate their specialties to a sophisticated market of advertising agencies and design studios. The new logo is a blocky *K* in a circle with the suggestion of an *S* casting a shadow that reads—to the knowledgeable audience—as a registration mark. For designer Brad Keech, it "reinforces the precision nature of our work." The shadowy mark is printed in a delicate lavender on the front of the white stationery sheet. In the corresponding position on the back, it appears faded out against the printed grayed green, which matches the band at the top on the front. The same gambit is employed on the envelopes with a green-gold band at the top carrying over to the flap. The interior of the envelope is a mauve-pink that is repeated on the crack-and-peel label used in-house. All the artwork was created internally using Adobe Illustrator and Photoshop. A deluxe package with up to four colors used on individual parts of the stationery system, it effectively communicates its message of sophistication.

**Design Firm:**
Keech Studio
Denver, CO
**Art Director:**
Brad Keech
**Designers:**
Brad Keech,
Eric Winslow

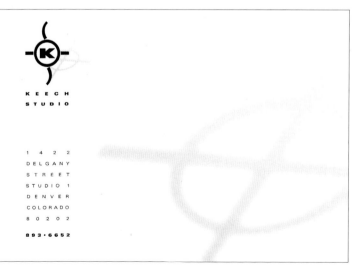

Working with large real estate developers and financial organizations, Ira Glasser wanted to show that he was a creative problem solver. To replace his rather pedestrian stationery system, he called in Sackett Design Associates, whose first solution involved a very complex, die-cut pop-up that was rejected in favor of a simpler design. Blocks of color are balanced against blocks of sans-serif copy, except for Glasser's name, which is set in a friendlier serif face. The arrangement of blocks could be called "Mondrianesque," though the hues are anything but primary. In addition to black, two colors of ink were used: a metallic steel gray and a luminous green. They add a luxurious touch of contemporary sophistication. A die-cut was used on the business cards. The card can be folded and two of the constrasting blocks pop out to create two planes of a cube. Sackett produced a stand-out design with a notable palette, a couple of die-cut slits, and innovative thinking, which is just what Glasser hopes to communicate to his clientele as a creative management consultant.

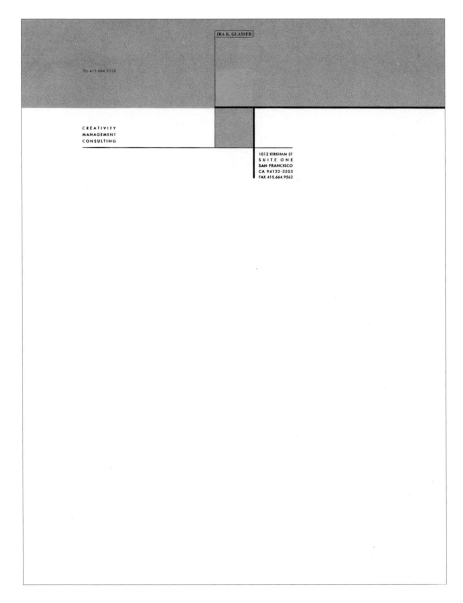

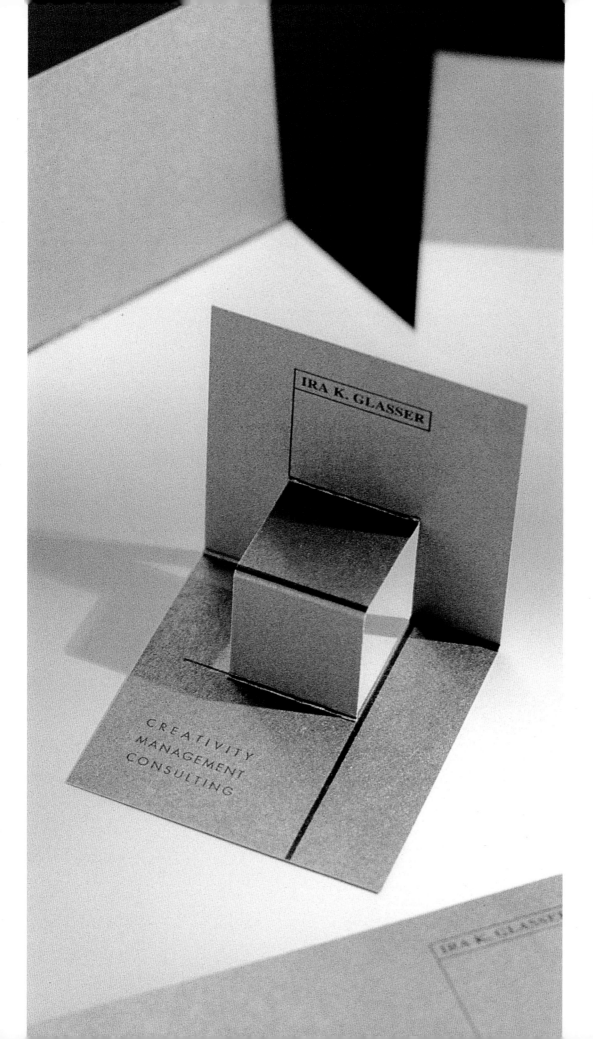

IRA K. GLASSER

CREATIVITY
MANAGEMENT
CONSULTING

**Design Firm:**
Sackett Design
Associates
San Francisco, CA
**Art Director:**
Mark Sackett
**Designers:**
Mark Sackett,
James Sakamoto,
Wayne Sakamoto

# CLAUDIA McGEHEE ILLUSTRATION

Designer and illustrator Claudia McGehee sees her signature technique of scratchboard illustration as "illustration for all seasons." Reflecting her "love of drawing organic things in a down-to-earth yet professional way," the theme of the four seasons showcases her style for a new stationery system. McGehee experimented with various seasonal symbols—flowers, birds, insects, fruits, trees—before making her final selections. For the letterhead, she chose a bird's nest, a bouquet of daisies, an arrangement of oak leaves and acorns, and a snowflake to represent the seasons of the year. For the number 10 envelope, she simplified the summer and autumn symbols to a single daisy and a lone acorn. McGehee also did four separate business cards, each featuring a different season. Using black ink on the rustic recycled Beckett Concept/Natural Cream paper, she picked bold sans-serif typefaces (Neuland, Neuland Light, Rusticana Roman) to complement the earthy look of her illustrations. In keeping with the promotional theme of the stationery package, McGehee delights in handing out the business cards "in season."

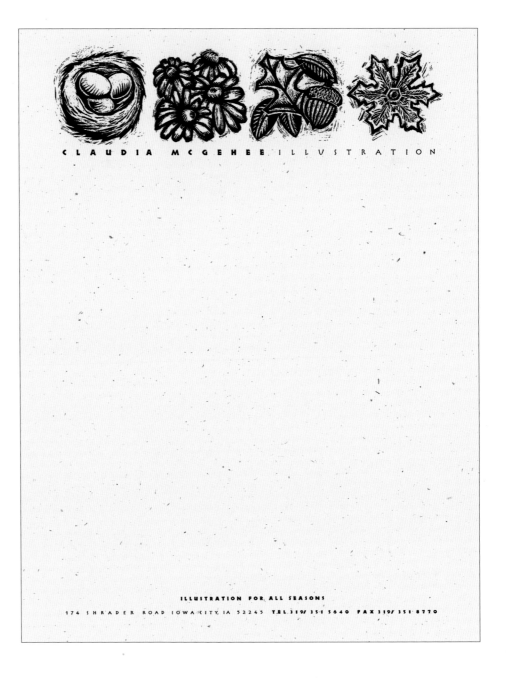

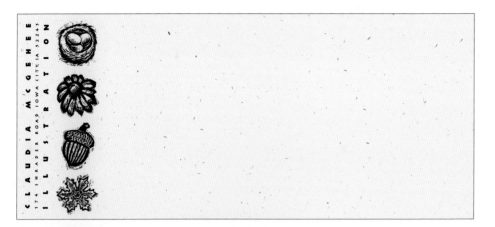

**Design Firm:**
Claudia McGehee
Illustration
Iowa City, IA
**Designer/Illustrator:**
Claudia McGehee

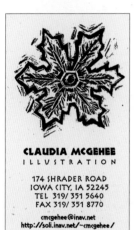

**CLAUDIA McGEHEE**
ILLUSTRATION

174 SHRADER ROAD
IOWA CITY, IA 52245
TEL 319/ 351 5640
FAX 319/ 351 8770
cmcgehee@inav.net
http://soli.inav.net/~cmcgehee /

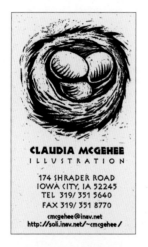

**CLAUDIA McGEHEE**
ILLUSTRATION

174 SHRADER ROAD
IOWA CITY, IA 52245
TEL 319/ 351 5640
FAX 319/ 351 8770
cmcgehee@inav.net
http://soli.inav.net/~cmcgehee /

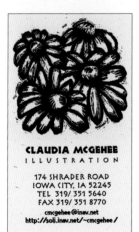

**CLAUDIA McGEHEE**
ILLUSTRATION

174 SHRADER ROAD
IOWA CITY, IA 52245
TEL 319/ 351 5640
FAX 319/ 351 8770
cmcgehee@inav.net
http://soli.inav.net/~cmcgehee /

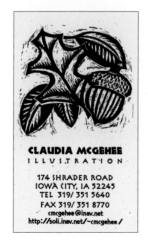

**CLAUDIA McGEHEE**
ILLUSTRATION

174 SHRADER ROAD
IOWA CITY, IA 52245
TEL 319/ 351 5640
FAX 319/ 351 8770
cmcgehee@inav.net
http://soli.inav.net/~cmcgehee /

# A-HILL DESIGN

When A-Hill Design's lease ran out before it could find a building to purchase, the Albuquerque studio had two weeks to come up with an interim stationery program. "Because of a limited time frame," designer Emma Roberts Wilson explains, "we solved this one instantly." The solution was to design a single pressure-sensitive label that could be used on everything from letter paper to envelopes to mailing tags and business cards. The new design replaced an outdated look that was clean and corporate. It had served "to lend credibility to a young company," Wilson explains. "Now that we are more established, we wanted to let our hair down and let our personality show through." Expected to be temporary, the design also needed to be economical. Printed offset in PMS 130 and black on a dull white label stock, 1000 labels were produced for $227. Then A-Hill "hired a high school girl to stick the labels on everything!," Wilson says.

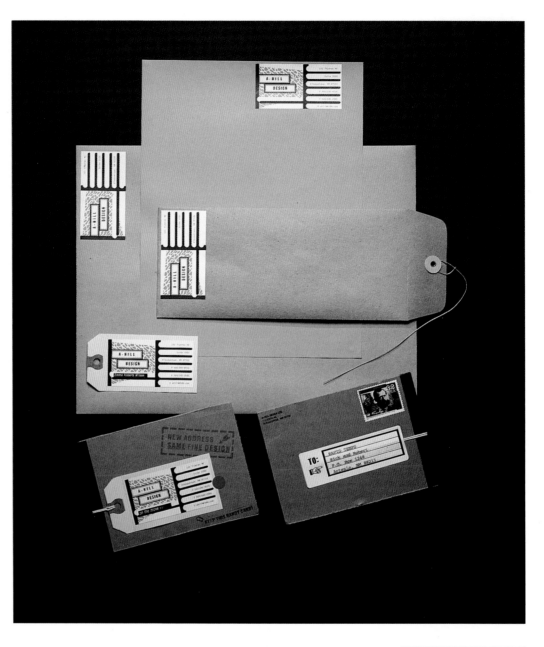

**Design Firm:**
A-Hill Design
Albuquerque, NM
**Art Director/Designer:**
Sandy Hill
**Designer/Production:**
Emma Roberts Wilson
**Printer:**
Bare Bones

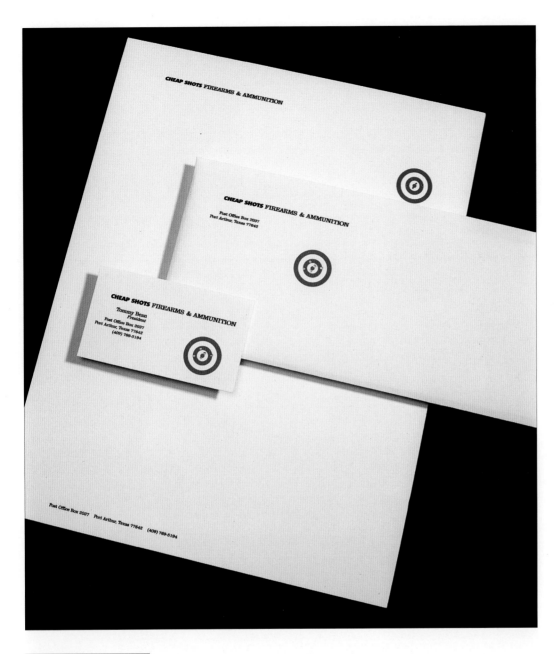

How do you design a logo and letterhead for a firearms dealer without using a gun? That was the question that Tommy Bean posed to Michael Lee Advertising & Design. The answer: Create a blood-red target peppered with holes. Using PC CorelDraw 5, Lee drew the arresting image and, with a custom die-cut, shot it full of holes—five to be exact. The logo was offset by a simple typographic rendering of the new company's name. "Cheap Shots" is set all-caps in a bold sans-serif with "Firearms & Ammunition" in a lighter-weight serif face, also all-capitals. The line of type is long and lean, like the barrel of a rifle, and offers a perfect formal counterpoint to the circular target. The 2-color offset printing and custom die-cut production came to just under $700 for the letterhead, envelope, and business card.

**Design Firm:**
Michael Lee
Advertising & Design,
Beaumont, TX
**Art Director:**
Debby Stasinopoulou
**Designer:**
Michael Lee
**Printer:**
Becker Printing

TOMMY BEAN, CHEAP SHOTS FIREARMS & AMMUNITION

# PATTERSON & COMPANY

"Present a clean, sophisticated, creative image, and appeal to the graphics industry" was the brief given to Sullivan Perkins for the initial letterhead and business card package of Patterson & Co. As a new printing consultant, Patterson wanted to communicate its expertise clearly to all business contacts. How better to do this than through a sleek, refined, and innovative stationery design employing a subtle special effect? Designer Kevin Bailey offered a variety of designs before the client selected a striking logo paired with direct and stylish typography. Bailey combined a lowercase *P* with a lowercase *C* as the company's identity. This was centered in an embossed circle to add impact. Although not large, the mark, printed in crayon-bright hues—buttercup yellow, kelly green, French blue, and red-orange—is the center of attention in each component of the package. Bailey's deceptively simple solution inspires confidence in the new business.

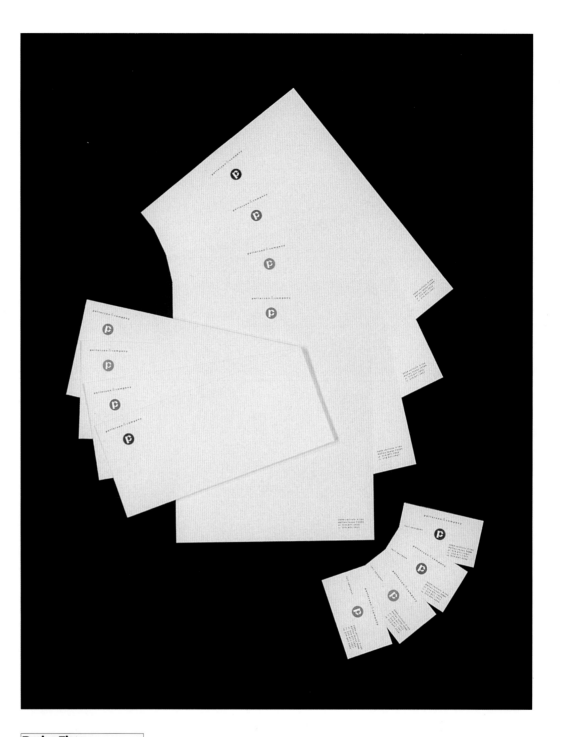

**Design Firm:**
Sullivan Perkins
Dallas, TX
**Art Director/Designer:**
Kevin Bailey